PRAISE FOR

"Lee Drexler has been my friend and an ardent supporter of the National Arts Club for more than thirty years. During those years, I have enjoyed hearing her stories about the arts scene. She also arranged for the donation of a number of paintings, sculptures, rugs, furnishings, and objets d'art to the club. She organized two major art shows at the club: One Hundred and Fifty Artists from North Carolina and Works of Living African American Artists, honoring Maya Angelou, which were both very successful. I give her a topnotch appraisal."
—Aldon James, President, National Arts Club

"Lee Drexler's stories of fabulous finds and famous and interesting people never fail to entertain and inform."
—Luis & Lucé Fortuño, Governor and First Lady of Puerto Rico

"I read Lee Drexler's book about her varied experiences as appraiser to the rich and famous with real interest and enjoyment. It's a great read, filled with valuable advice and quite believable—often remarkable—stories. And I loved the fact that her authentic voice comes through with all its intelligence and character."
—Niles Eldredge, Curator, American Museum of Natural History

"I have known Lee Drexler and Jim Cohen for a number of years and have been impressed and entertained by their stories about art, antiques, and related tax issues."
—U.S. Senator Joseph I. Lieberman (ID-CT)

Fabulous Finds

How Expert Appraiser Lee Drexler Sold Wall Street's "Charging Bull," Found Hidden Treasures and Mingled with the Rich & Famous

J. Lee Drexler &
James R. Cohen

Quill
Driver
Books

Fresno, California

Fabulous Finds: How Expert Appraiser Lee Drexler Sold Wall Street's Charging Bull, Found Hidden Treasures and Mingled with the Rich & Famous

Published by Quill Driver Books
an imprint of Linden Publishing
2006 South Mary, Fresno, California 93721
559-233-6633 / 800-345-4447
QuillDriverBooks.com

Quill Driver Books and Colophon are trademarks of
Linden Publishing, Inc.

ISBN 978-1-610350-13-6

135798642

Printed in the United States of America
on acid-free paper.

Library of Congress Cataloging-in-Publication Data

Drexler, J. Lee.
 Fabulous finds : how expert appraiser Lee Drexler sold Wall Street's
Charging bull, found hidden treasures, and mingled with the rich &
famous / J. Lee Drexler & James R. Cohen.
 p. cm.
 ISBN 978-1-61035-013-6 (pbk. : alk. paper)
 1. Drexler, J. Lee. 2. Art--Valuation--United States. I. Cohen, James R.
II. Title. III. Title: How expert appraiser Lee Drexler sold Wall Street's
Charging bull, found hidden treasures, and mingled with the rich &
famous.
 N8675.D74 2011
 709.2--dc22
 2011002709

To our children, Terri and Brett
And our grandchildren,
Sonia, Jacob, Gabriel, and Benjamin,
And our nephew and niece, Bill and Michelle
And their children, David, Lea, Katy, and Jack.

Contents

Preface

This book is written for anyone who has bought, or one day will buy or sell, fine art, furniture, antiques, jewelry, or collectibles. That means almost everyone! This book will protect you from being taken advantage of by providing important facts and information, wrapped around interesting stories about some of the fascinating people I have met during my over thirty-five years of appraising. Although you won't become an instant expert by reading this book, I hope that by the end of it you will have learned enough so you will never be cheated.

Foreword

I have known Lee Drexler and her husband, Jim Cohen, for over 20 years. Throughout the 20 years I have known them (and, I am told, for many years before), both of them have been fascinated with and involved in the always exciting New York art world.

The National Arts Club, of which I am President and CEO, was established at the end of the 19th Century, the oldest arts club in the United States, with more than 1,500 members. I am happy to say that Lee and Jim have been among our most enthusiastic and involved members.

Lee has been telling interesting stories about her exciting career in the fine arts world for all the years I have known her—her stories are always entertaining and informative. Luckily for all of us, she has decided to set out her favorite stories, for all of us to enjoy. Her husband, Jim, has polished them up to add his own special wit and charm and, since he is a well known tax attorney, to also add some useful and easy to read advice to collectors on tax and estate aspects of collecting and disposing of their treasures. In the book, you also get to meet some of the famous and interesting people with whom Lee has rubbed shoulders in her appraisal career.

In 1993, Lee organized a show at the National Arts Club on the arts of North Carolina, a show which included crafts, paintings, and sculptures from the top 150 living North Carolina artists. At

this show, we honored Maya Angelou, and the Governor of North Carolina, Terry Sanford, attended. The next year, Lee ran the first show on African-American art (before it became a super-popular area of the arts) and brought to our club the artwork of every well known living African-American artist. At this show, Maya Angelou again was our honoree and Oprah Winfrey, Shari Belafonte, Ruby Dee and many others attended. It was a great success and Lee did an excellent job.

Jim, a super-lawyer and senior partner at Kleinberg, Kaplan, Wolff and Cohen, is also a songwriter who has written over thirty songs, some published. He and Lee have written two musical plays, "Soldier's Song" and "My Bear Friend, Ted."

I thoroughly enjoyed reading *Fabulous Finds*. It is entertaining and highly informative about the art market today. My appraisal is that this book earns top marks. If you are interested in the art market, in some intimate looks at the lives of the rich and famous, in some practical advice about buying and selling art, or would just like a good read, I highly recommend *Fabulous Finds* to you.

Aldon James
President, National Arts Club, New York City

Introduction

It was March 17, 2008, and I was at Sotheby's Auction House at Seventy-Second and York in New York City for its Asian Contemporary Art sale. I was not a casual spectator. A painting by Zao Wou-Ki, a twentieth-century Chinese artist, that I had discovered in a client's apartment was going up for auction.

The beneficiary of an estate owned the painting. Her mother, who had recently died, had owned the painting for many years. She and her daughter had believed that the painting was worth $7,000; the price for which it was insured. I had surprised, shocked, and delighted the daughter and the attorney for the estate when I gave them the exciting news that the painting was, in fact, worth hundreds of thousands of dollars. At my suggestion, the owner was now selling it at the auction. The dramatic moment when my discovery would be validated or debunked was about to arrive! I had appraised the painting for $650,000. Finally, this was the adrenaline rush scene where I would discover the outcome.

Sitting in Sotheby's, one of the two largest auction houses in the world, is exciting for any art lover. For me, with my judgment and reputation on the line, it had become edge-of-the-seat dramatic. The bidding for the Zao Wou-Ki painting started at $200,000 and increased by $5,000 increments. The frenzied bidding took place so quickly, with the speed of the Kentucky Derby, that in no time, the price had more than doubled. By the end, the bids bounced

back and forth in a tug of war between two avid (one might even say rabid) collectors. Forget the Kentucky Derby; this was more like Wimbledon, only instead of batting a little yellow tennis ball back and forth, the two combatants were busy smashing bids at each other for hundreds of thousands of dollars. The bidding finally stopped at $590,000, putting a spectacular $590,000 in the seller's hands for a painting she had originally thought was worth only $7,000. (As usual, Sotheby's charged a commission to the buyer, in this case about $100,000, so the final cost to the buyer was $690,000.)

In the normally subdued auction room, people clapped and cheered to have witnessed such a tense proceeding. Half of them clapped because they were happy that the suspense was over; the other half cheered the outcome and the boldness of the two final bidders. As for myself, I was delighted that my client was going to reap the financial rewards, and that a valuable piece of art had been unhidden. Professionally speaking, this was also an affirmation of my professional ability that my appraisal had turned out to be so accurate.

This is part of the great thrill of being an appraiser, the treasure hunt aspect of finding an unexpected gem and, best of all, surprising the owners with a value that is often well beyond what they had ever imagined. Going into many different homes, making great discoveries and helping people realize riches they had never dreamed of is part of the fine art of what I do—something that, I'm proud to say, is done by only a very small number of people around the world.

It would be a wonderful fairy tale if all the stories I have to tell had the same happy endings, like this Zao Wou-Ki story. Not surprisingly, however, sometimes instead of the frog turning into a prince, a prince turns into a frog. There are pieces of art that families treasure—paintings, carpets, jewelry, and antiques—and often they do turn out to be the treasures they expect. Unfortunately, from time to time, either because of an honest mistake or outright

fraud, the treasure turns out to be of very little value, and it is my job to set things straight. It's a sad but necessary part of my job as a professional appraiser of fine art. And as part of my job, I have seen many plot twists and turns: the dealer who sold the bad piece takes it back and returns the money; or my client keeps the piece but the dealer refunds part of the purchase price; or there is outright theft but, hopefully, it is covered by insurance.

My name is Lee Drexler, and as an appraiser, I put a value on all kinds of things people collect: fine art, furniture, furnishings, antiques, jewelry, and other collectibles. I think my job is as exciting as the very finest treasures I discover. However, my job is not just about the treasures. One of the best parts about what I do is that, as people show me their collections, they often share their lives with me as well. I love the huge variety of items people own and collect—from fabulously valuable sculptures, gems, and artwork to ordinary knickknacks—and, equally, I love their stories.

I have been in three or more homes a week for over thirty-five years. During that time, I have met a cast of characters—many rich and famous, many unique and fascinating, some memorably eccentric—that could fill more than a few novels. Among these personalities were the lovely Candice Bergen, who offered me a cup of tea and made me feel like a guest in her home, and a billionaire's wife who begrudged me a few pieces of lettuce for a sandwich I had brought for lunch. And of course, I could never forget the tall and willowy trophy wife, years younger than her husband—who much to my surprise and chagrin, showed up for part of the appraisal absolutely butt-naked. It has been a vast and often fascinating collection of people, their stories, and their treasures. I have selected the stories to share with you that have resonated for me in some particular way. I hope they will strike a note for you as well. I will also share an insider's view of the art market with you in ways that will make you a savvier collector or, at least, help you appreciate and gain a different slant on the many valuable and not-so-valuable items that people collect.

1. Fabulous Finds

Predictions are always risky. For example, at the end of the well-known film *Butch Cassidy and the Sundance Kid*, the two heroes are in a cave planning their future, unaware that the entire Mexican army is waiting in ambush outside. Unfortunately, those men's plans and predictions for their future are abruptly ended in the ambush. Despite that movie's ending, I will venture to make a prediction: I predict that my career as an appraiser will continue to fascinate and energize me for many years to come. My goal in this book is to share my excitement with you.

Zao Wou-Ki

One of the reasons I am motivated to go out the door each morning is the possibility that today will be the day I make another Fabulous Find. To best illustrate this point, let's go back to the day I became involved with the Zao Wou-Ki painting with which this book begins.

Zao Wou-Ki is a Chinese-French artist born in 1921 in Beijing, China. He studied art and calligraphy in China until 1948, when he went to Paris to study. His work, influenced by Paul Klee, is very abstract, using large masses of color so the interplay of light structures the canvas. Zao Wou-Ki often names his paintings with the date they were finished.

This particular workday started out for me like many others. When someone dies, the things they own need to be valued, so that

a proper estate tax return can be filed, so that any property that will be sold is sold at the right price, and, if there is more than one beneficiary, so that the assets will be distributed among them fairly.

I do appraisals for a number of different purposes—more on that later. In this case, an old lady had died; she had one daughter who was the sole beneficiary of the estate. The estate was being handled by an attorney, who was also the executor of the estate, and who had retained me to do an appraisal. The appraisal was routine, certainly not the setting one would expect for a Fabulous Find. The decedent (legalese for someone who has died) had lived in her Park Avenue apartment for over thirty years.

The apartment seemed stuck in a time warp. The furniture was from the 1950s and had never been re-upholstered; likewise, the walls had not been painted in fifty years. I find this situation is not uncommon. Older people often like to live with their memories. For them, re-upholstering a chair may mean covering up the memories of people who had often sat there, loved ones whose spirits they feel remain behind in the broken-down easy chairs and unpainted walls. If they paper over the walls or re-upholster the cushions, they fear that these memories will become lost to them.

Although the decedent's daughter and the attorney of the estate were both fairly certain that there was nothing of any real worth in the apartment, I was hired by the attorney-executor, Gary Kissin, on November 29, 2007, just to make sure. I have worked for Gary, a fine attorney and gracious gentleman, for over twenty-five years. Fortunately for his clients, he is very careful.

Fortunately for Gary, so am I.

I walked into the apartment and immediately saw the painting on the wall, hanging over the fireplace. It was a muddy, abstract mix of brown and green colors To many, it might have looked a bit like green mold.

The painting had a certain translucent beauty to it, very peaceful, perhaps even meditative. For me, paradoxically, it produced an opposite reaction: excitement and anxious anticipation. I had

recently appraised a painting by Zao Wou-Ki that summer in the Hamptons. Therefore I was very familiar with his work and suspected that this piece might also be by him.

I walked over to the painting, saw the signature "Zao" on the right-hand side, and knew that my hunch was right. It had to be by Zao Wou-Ki. It was dated '55, and I knew that during 1955 he was painting in Paris. Coincidentally, my late cousin Patty Cadby Birch, an art dealer, had represented him in her Paris gallery in the 1950s.

I asked the daughter if she knew that she had inherited a valuable painting. She had no idea. She showed me the insurance list of everything in the apartment. The painting was separately listed as "by Zao" and insured for $7,000, a mere fraction of its worth.

Other experts might have accepted this value and thought the painting was by an unknown artist called Zao. Fortunately, I knew his work, and not just from the coincidence of having recently

Zao Wou-Ki

appraised another Zao Wou-Ki, or from the fact that my relative had dealt in his paintings many years ago. Zao Wou-Ki is an extremely popular artist, particularly among the new Chinese millionaires. Twenty years ago, people barely knew who he was, but today his popularity and prices rival many of the second-tier Impressionists like Signac, Vuillard and Bonnard. I visit many art galleries, attend many art auctions every year, and fanatically keep up with what is happening in the art world.

My mind raced with possibilities. I told my client the painting would be worth at least $400,000 and that I would go back to my office and provide her with a more accurate appraisal the next day. If my preliminary thoughts about the painting's value were even half-right, it was still grossly under-insured. However, I told the daughter and Gary that I would rush to get the price to them by the next day, so that they could then immediately get proper insurance on it.

Back in my office, I looked at all the paintings by Zao Wou-Ki that had recently sold at auction, comparing them with the photo I had taken (to do an appraisal, it is helpful to have a photo of the work you are appraising, so I always take a photo). To accomplish this, I use ArtNet.com and ArtFact.com, vast Internet databases of information for the art expert, literally my lifeline to the world of art. When I do this kind of research, I use my expertise to find a similar painting—comparable sales (or "comparables")— that recently sold at auction. Locating good comparables is not easy—it takes experience and judgment to figure out what is most comparable to the piece you are appraising. In a perfect world, I could find a painting like the one being valued that was the same in every way—by the same artist, on the same medium (oil on canvas, oil on board, watercolor, etc.), the same size; painted the same year, with a similar subject (still life, interior, figure, scenery, coloring, etc.). Well, guess what? It's not a perfect world, and lots of judgment comes into play in using comparables. In this case, the Zao Wou-Ki painting I was appraising was painted in 1955, was an oil on canvas, and was 28 by 35.4 inches.

I used the following three Zao Wou-Ki paintings, the ones nearest in size, date, and color that I could find, as comparables:

A. Title: *Ville Chinoise (Chinese Village)*
 Painted in 1955
 Oil on canvas: 21.3" x 25.6"
 Signed and dated '55
 Put up for sale at Sotheby's London, February 28, 2008
 Estimated: $293,484–$391,312
 Bought In: Did not sell

B. Title: *Le Jardin Abandonne (Abandoned Garden)*
 Painted in 1955
 Oil on canvas: 21.3" x 25.6"
 Signed
 Sold at Sotheby's Paris, December 12, 2007
 Estimated: $292,354–$438,532
 Sold for $351,602

C. Title: *23.3.68*
 Painted in 1968
 Oil on canvas: 35" x 51.2"
 Signed
 Sold at Zhong Cheng Auctions, December 9, 2007
 Estimated: $819,970–$1,154,033
 Sold for: $958,758

The three paintings were quite different from each other, with a wide range of colors and sizes, but with the photo I took I could make appropriate comparisons. I felt that they were similar enough to the painting I was appraising, titled *Quand il Fait Beau* (*When the Weather Is Nice*), that it should sell at auction for $650,000. It was larger than the first two comparables and smaller than the third one, with lots of other factors too complicated to discuss here, so I appraised it accordingly. I called Gary Kissin at nine o'clock the next morning and told him my results—a value of $650,000. He asked

me to fax him my appraisal immediately so he could get insurance, and by ten o'clock, he had the painting insured for $650,000. After that, he wanted to remove it from the unoccupied apartment as soon as possible.

Even with insurance on the painting, Gary didn't feel safe. The daughter, who had inherited the painting, wanted to sell it right away, and she and Gary asked what I recommended. I called Meity Heiden, the head of the Asian Contemporary Department at Sotheby's, and told her of my finding. She was very interested and the next day came to the apartment and took the painting herself to Sotheby's.

Sotheby's photographed the painting and included it in the catalogue. It was estimated to sell for $450,000–$550,000. Four months later, as depicted in the dramatic scene at the beginning of this book, it was sold for about 20 percent over Sotheby's estimate. Actually, the seller received the $590,000 (the hammer price, which is the price announced at auction), and the buyer paid $690,000 (the $100,000 difference being Sotheby's commission), so my appraisal of $650,000 turned out to be exactly accurate (between what the buyer paid and the seller received).

Everyone was thrilled with the results, especially me. It sold for about 100 times what the owner believed it to be worth. It's not every day you get to discover hidden treasure as part of your job!

Changing Someone's Life

In 1998, I was asked by a client to go up to Westchester County (north of New York City) to appraise her antique collection before she moved to Florida. She was a tall, slim, elegantly dressed woman in her seventies. She wanted to sell a number of things before the move. As she was no longer working and had been a widow for a number of years, she really needed the money. When I walked into her home, I immediately saw a big, beautiful watercolor, from the early-twentieth century, of a mysterious-looking woman dressed in a long, yellow dress. She was standing in a park in New York City. The painting had a little brass plaque on it that showed that it was called *Madison Square*, which was the park in which the woman in the painting was standing.

Appraisers often love history, and as you will see throughout the book, I especially love to talk about historical facts that are pertinent to a particular story. A little, interesting, historical tidbit: Madison Park, also called Madison Square Park, is located between Madison and Fifth avenues, between Twenty-third and Twenty-sixth streets in Manhattan. The park is named after James Madison, the fourth president of the United States and the principal author of the Constitution. The park also lent its name to the sports arena Madison Square Garden. It has been a public park since 1847 and is still one today.

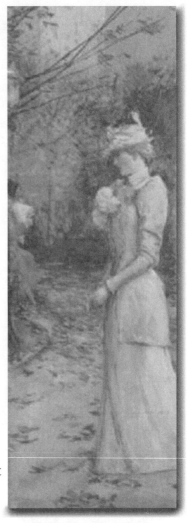

In this picture, called *Madison Square*, the pretty woman is standing in the park, with many leaves swirling around her. I asked my client if she could give me any information about the painting. She said it was by Childe Hassam and said, "I think it has some value. I hope it's worth $25,000." I told her I would take my photo, do my research, and get back to her soon.

Childe Hassam (1859–1935) is one of the best-known American Impressionist painters of the late nineteenth to early twentieth century. He studied in Paris. Most of his scenes are romantic—beautiful women, beach scenes, landscapes, and most importantly, his New York City paintings with American flags flying. I researched the picture the widow owned and called her with the results. I told her it would sell

Childe Hassam painting

for over $500,000! This information just about knocked her on the floor. Ultimately, at my suggestion, she sold the painting at Sotheby's for $553,000. Afterwards, she told me that this "Fabulous Find" really changed her life, allowing her to live decently in Florida.

Smelled a Rat

In February of 2009, I did a really interesting appraisal for Tim Rockwell, a very charming and good-looking man in his forties. Tim runs a fishing business in Rhode Island. His elderly aunt, a resident of New York City, had recently died, and she had named Tim as executor. Tim's deceased relative had a substantial art collection. It quickly became clear that Tim was a good business person but was very unfamiliar with the art market (there is not too much art on fishing boats) and rarely came to New York City. So handling the decedent's art collection in New York City was a real problem for him. With apologies for the pun, you might say that he was totally out to sea.

The appraisal went extremely well. Ultimately, Tim wrote me a wonderful, truly spectacular letter. With his permission, I copied it on my website, www.EsquireAppraisals.com, and below:

May 18, 2009

I recently had the dubious privilege of becoming the executor of an estate in New York City. The decedent was a close relative. Being a family member from out of town, rather than a local professional, I was somewhat adrift, both in the process and in the city.

When I was floundering around, wondering how to get the tangible property of the decedent appraised, someone recommended Lee Drexler of Esquire Appraisals. On the strength of this recommendation I hired Lee. I am ever so glad I did.

In plowing through the decedent's files I had come across a previous appraisal which had been done for insurance purposes, by a qualified appraiser, a few years back. I provided this to Lee with the thought that it might be of some use.

Lee smelled a rat; something was not right.

Lee meticulously cross-referenced the previous appraisal with the evidence before her. She found the rat; she discovered

that the previous appraiser had misattributed a painting and had vastly undervalued it at $500. Lee valued the piece at $7,000.00; the price at which it was later sold.

A second piece had previously been valued at $20,000. Lee valued this piece at $75,000.00.

This second painting, on Lee's recommendation and via her arrangements, is now at Sotheby's for sale in a fall auction. It is estimated, by Sotheby's, at exactly the value which Lee placed on it.

I am grateful for Lee's knowledge and professional dedication. I am also grateful for her willingness to put me in contact with other professionals who helped me work through an unfamiliar process in an unfamiliar place.

I found Lee to be reasonable in her fees and accurate in her work. And, last but not least, she is just plain fun to work with; a real pleasure. I cannot recommend her highly enough.

<div align="right">

Tim Rockwell

</div>

As Tim said, he knew that his deceased aunt had some good paintings and furniture because, three years earlier, a well-respected appraiser had done an appraisal for his aunt for insurance purposes. This appraiser correctly said that a number of pieces the aunt owned were valuable, and that overall it was a valuable collection.

Since I was told that the respected appraiser (I was not provided with his name) had done the insurance appraisal, I decided to use his appraisal as a starting place and guide. The appraiser had described the items very thoroughly, and for the most part I agreed with the valuations. But appraisers need to be wary—even apparently unimportant items should always be checked. The prior appraisal stated that there was a watercolor on paper 25½" high x 19½" wide, depicting a temple and a building facing a cobblestone courtyard with a group of people wearing kimonos and looking at the temple. The appraiser described it as an unsigned Chinese

painting worth $500. However, having been to Japan and recognizing the Japanese style of temple and the Japanese dress, I knew it was a Japanese painting. I looked for the signature and saw it was signed Bunsai, who was a Japanese artist whose formal name was Loki Bun'ya and who lived from 1863–1966. Based on comparable watercolors by him that had sold at auction, I valued the painting at $7,000.

That is the price it later sold for.

In Tim's aunt's collection, there was also an oil painting by Ernest Lawson (1873–1939) depicting a banyan tree in a rural Southern setting, which the appraiser had valued at $20,000. I know Lawson's work very well, but he is not nearly as well known as other American Impressionists. His work falls between Impressionism and Realism. He mainly painted landscape scenes, and his views of Northern landscapes are generally more valuable than his Florida scenes. However, this was a large painting and quite beautiful and I felt it would be worth at least $75,000. I photographed the painting and told Tim I would go back to my office, do the necessary research, and call him as soon as I had all my information. Before I left, I finished appraising the furniture and assorted bric-a-brac.

Back in my office, after checking on Art Net, I found comparables for the Lawson painting ranging from $75,000–$150,000, but because of the recent drop in the art market, I decided to value

Ernest Lawson painting

it at $75,000. I called Tim, excited by the news. He was delighted but said, "I have no idea how to sell this valuable painting. What do you think is best?" I suggested he call Dara Mitchell, the head of Sotheby's American Painting Department. I have known Dara for years and she is very smart and competent. Tim had her come over the next week, and she arranged to take the painting to auction at Sotheby's for the fall of 2009 sale. Tim was very happy, and I was thrilled to have made another discovery.

Did I "smell a rat"? This was Tim's choice of words, not mine. The phrase is a little over the top, perhaps, suggesting something intentionally improper. I am not suggesting anything like that. The point here is that, given that I had been told that the prior appraisal was done by a professional, I had every reason to rely on it. Fortunately I did not, as the prior appraisal was off by about four times, and so this became another "Fabulous Find."

Salomon Brothers

An insurance agent for Marsh (a leading insurance broker) asked me to do an appraisal so that the art and antique collection at Salomon Brothers, the world-famous financial firm in New York City, could be properly insured. This was in the 1980s, back before Salomon's acquisition by Citibank. Salomon Brothers was, at the time, one of the leading bond trading firms in the world—the inspiration for the books *The Bonfire of the Vanities* and *Liar's Poker*. So, at the insurance agent's request, I went to the New York headquarters of Salomon Brothers.

There I saw some very fine paintings, bronze sculptures, and Federal furniture (furniture made in the U.S. from 1790 to 1825). I learned that the firm had mostly bought the items from top antique shops in the 1930s, when antiques were much less expensive. The pieces were of superb quality.

None of the items had been appraised since they were purchased.

There was a beautiful pair of American Federal mahogany console tables c. 1810. (By the way, you will sometimes see dates like "c. 1810" used here. The "c" is short for "circa," Latin for "about";

so when something is "c. 1810," it was made circa, or about, 1810, but not necessarily exactly in 1810.) The tables rested on a pair of extraordinarily lifelike, hand-carved eagles.

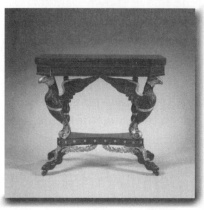

American Federal console table

In one of the offices there was a beautiful, bronze cast titled *Bronco Buster*, depicting a cowboy on a rearing horse. The sculpture was by Frederic Remington, perhaps the best-known American sculptor.

As an aside, Remington had quite an interesting life. Born in 1861 in Canton, New York, he started out as an illustrator. He inherited some money when his father died in 1880, and he used it to "Go West Young Man" for several years. While working as a hired hand—sometimes as a cowboy and sometimes as a sheep rancher—he made many sketches of cowboy life in an Old West that was soon to disappear. After coming back to New York in 1885, he first became known as a newspaper illustrator for *Collier's Weekly* and *Harper's Weekly*. He eventually cast a number of these sketches in bronze, becoming very well-recognized during his short lifetime; he died of appendicitis in 1909, at the age of forty-eight.

Certainly *Bronco Buster*, a good example of Remington's work, was a valuable sculpture. It was his first sculpture—technically difficult, as the horse seems almost balanced in midair, rearing on its hind legs. When

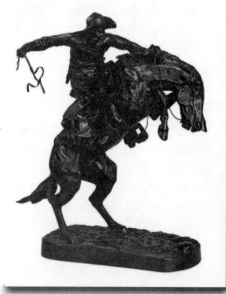

Frederic Remington sculpture

Remington first created this sculpture, he did a clay model and then a plaster cast; and from the cast he created bronze copies, which he later sold at Tiffany's.

What was particularly interesting about this appraisal is that although Salomon Brothers was, at the time, one of the top business establishments in the world, filled with very knowledgeable business people, they were knowledgeable about business matters but not at all knowledgeable about art. Therefore they had no idea their collection was hugely valuable. Because my appraisal produced so many pleasant surprises in New York and because I had discovered so many items of significant value there, the firm decided to fly me to their Chicago office to appraise its contents. I flew out on an early flight and was in the Salomon Brother's Chicago office by about ten o'clock that morning.

In contrast to what I discovered in the New York office, the situation in the Chicago office was pretty humdrum—there was lots of stuff in a large office complex but nothing particularly valuable or interesting. However, near the end of the day, when I reached the last of many conference rooms, I saw a painting of great beauty. It was a painting of a large sailboat on a big, blue, empty sea with a brilliant sun shining on the sails. Immediately, I thought it was by Montague Dawson (1895–1973), an English artist who became perhaps the greatest painter of the sea and sailing ships in the first part of the twentieth century. He was the son of a yachtsman and the grandson of the marine artist Henry Dawson (1811–1878). Montague served with the Navy during World War I. His artwork was featured in the newspaper the *Sphere,* and in 1922 he was named the official artist for an expedition to the South Seas. During World War II, he was a war artist, still working for the *Sphere.* His work was collected by presidents Dwight Eisenhower and Lyndon Johnson and the British Royal Family.

As I approached the painting, I saw it was, indeed, signed by Montague Dawson. It was a gorgeous painting, worth many thousands of dollars, and it was hanging there uninsured. No one at this large, sophisticated financial institution knew that they owned this

piece. Of course, they were very happy to learn about it and about the valuable pieces in New York, and subsequently had them all properly covered under their insurance policy. I heard that they ended up bringing the Dawson painting back to the main New York office, where it was later prominently displayed.

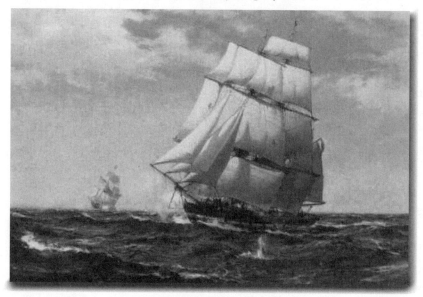

Montague Dawson painting

It's always fun when I make a discovery of high value that no one knows about. It is particularly enjoyable when I do so for folks who may be very savvy business people in their own line of work, but not in *my* world, the art world.

A Collector's Fabulous Find

I have a client who really had a stroke of good luck as a collector. Let's call him "Mr. G." (for good luck). He told me this story: Mr. G. was walking on West End Avenue, on the Upper West Side in New York City, and saw a sign in a church advertising a tag sale of furnishings and art. As a collector of fine art and someone who was knowledgeable about modern art, he said he always loved attending tag sales and auctions, and thought he would just pop into this

one and see what it had to offer. Upon entering the church, he told me there was a long table and on it, among a pile of clutter, he saw three colorful, inflatable, plastic sculptures, each one signed by Niki de Saint Phalle, a well-known contemporary artist. He noticed that these sculptures were selling for twenty-five cents each.

Niki de Saint Phalle was born in 1930 in Neuilly-sur-Seine, near Paris. During her teenage years, she was a fashion model; at the age of sixteen, she appeared on the cover of *Life* magazine and later on the November 1952 cover of *French Vogue*. In 1961, she became famous for her "shooting paintings." This is the way her "shooting paintings" were made: containers of paint would be laid on a wooden baseboard, and then the paint containers and the baseboard would be covered with plastic and placed on a blank canvas. After raising the blank canvas, de Saint Phalle would shoot at it with a .22-caliber rifle and the containers would spill their contents onto the canvas. This painting style was completely new, and she traveled around the world, becoming famous. She stopped making these "shooting pictures" in 1963 because, she said, "I had become addicted to shooting, like one becomes addicted to a drug."

After the "shooting paintings," de Saint Phalle started exploring the various roles of women. She became extremely well known for making life-size dolls of women in different poses, which she called "Nanas." The dolls reflected her view of women's unequal position in the world. Many museums and sculpture gardens around the world exhibit her sculptures of very large women in unusual poses.

Niki de Saint Phalle also made a large number of similar, but much smaller, pieces. The ones Mr. G. was looking at were deflated and crumpled up, but they would have been just six inches high if inflated. Mr. G. had just seen very similar inflated plastic sculptures for sale in Paris for $500 each a few months before. He immediately bought these three items for the impressive total price of seventy-five cents and then asked the question that would make him over $150,000: "Do you have any more of these?" The woman manning this particular table said, "As a matter of fact, we have lots of them."

She took out from under the table an ugly box filled with 143 of these plastic sculptures, each signed by Niki de Saint Phalle. The big, old box had the name of the artist's sister, Elizabeth de Saint Phalle, with her address on it. The sister must have lived nearby, and somehow these pieces ended up at the church without anyone realizing what they were worth. Mr. G. bought the rest for $25 (about seventeen cents each) and, a few months later, flew to Paris, where he sold forty of the pieces, which had cost him about $7, for $16,000, over 2,000 times what he paid for them! He has kept the remaining hundred or so pieces. (When I was at his home doing an appraisal, eBay had a few comparable pieces for sale, listed at $1,000–$1,500 each. See my photo at left.) Mr. G. is planning to sell his pieces slowly, over time, in which case he should get $100,000 to $150,000 more, all on his $25.75 purchase.

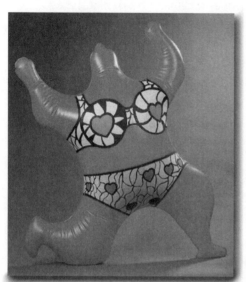

Nicki de Saint Phalle plastic sculpture

Finding valuable stuff at junk-pile prices is every collector's dream, although this particular story would be a sweeter tale if it were a dealer and not a church that had mispriced the items. Of course, if the church had called in an appraiser before it held the sale, the church would have reaped the benefit instead of Mr. G.

I never buy from my appraisal clients. It would be a conflict of interest to do so. But, I have personally bought lots of paintings, sculptures, and artwork at auction and from dealers. So far, like most people, although I have made some very good purchases, I've never had, nor expect to have, anything approaching Mr. G.'s luck selling something for thousands of times over its purchase price.

While we are on the topic of buying art, it is, of course, as I just mentioned, a conflict of interest for me to purchase anything from a client for whom I do an appraisal. You can't objectively tell someone what something is worth and then buy it from them. Your job as an appraiser is to value items at the correct price. Your interest as a purchaser is to buy items at the lowest price. The two jobs just don't go together. On the other hand, from time to time, an appraisal client of mine asks me to act as an art consultant for them and help them purchase antiques or artwork to add to their collection. It's a change of pace from my appraisal work and is often very interesting. I have made some very good purchases for clients at auction, privately, and at dealer's galleries. But I never expect, for myself or anyone else, to equal Mr. G.'s good fortune.

Painting by Valtat

I received a phone call one day from an older man named Mr. Eldred. He told me he wanted the contents of his apartment appraised for insurance purposes. I told him my fee and he said he was a senior citizen who had just retired the previous week and asked if I could do it for less. Well, he sounded very nice, and I'm a soft sell for older people since I had wonderful grandparents. So I agreed to do the appraisal for a reduced amount and set a date.

When I arrived at his apartment, I met two delightful people: Mr. Eldred and his wife. Mr. Eldred was white-haired and seemed to be in his eighties. He stood erect but walked slowly. He told me stories about the good old days, walking down Fifth Avenue with the famous financier and statesman Bernard Baruch, both men wearing spats and carrying canes. He had a dry and charming sense of humor. His wife, sweet and bubbly, looked like she was in her seventies. They were so much in love and took such good care of each other, it was beautiful to see. They had a magnificent large Persian Kerman rug (called "Kerman" because it was made in the town of Kerman in Persia, which is now Iran). The rug had a delicate beige background, with a central, pale medallion and a pale blue-and-apricot colored border. I valued it at $7,500. They had a

number of other good pieces, including a sterling silver dresser set, a sterling filigreed wedding basket, and a number of paintings. One painting immediately caught my eye. It was a beautifully painted scene of a still life of flowers and fruit, signed "L. Valtat." Louis Valtat was a Frenchman who lived from 1869 to 1952 and who was a precursor of the Fauvist movement in the early twentieth century in Paris. He painted with pure colors and a fine sense of the curved line. His prices started rising after 1950. I had appraised a Valtat just six months before and was very familiar with the current prices for his paintings. When I told the Eldreds that the appraised value was $50,000, they became extremely excited. I did too. Even though I have been doing this for many years, I always get excited when I tell people that something they have is worth much more than they think. Mr. Eldred had bought this painting over thirty years before for $200 and had no idea it was worth any more than he had paid.

Because Mr. Eldred had just retired and they were not wealthy people, they decided to sell the painting. It eventually sold for $55,000 at auction. I took great satisfaction from having helped

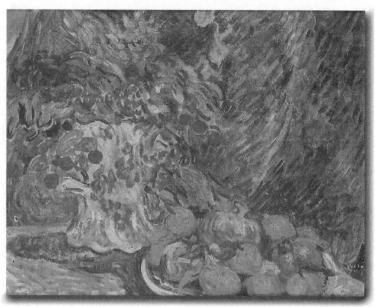

Louis Valtat painting

them discover, as Mr. Eldred said, "found money." The last time I saw them, they were driving to Texas to visit their relatives. Oh— Mr. Eldred finally told me their ages: He had just passed ninety and Mrs. Eldred was over eighty. They were truly a remarkable couple.

As you can tell from my stories, I love my work. I've appraised diamond rings that people thought were glass and glass rings that people thought were diamonds. I've seen magnificent works of art that have never been exhibited in a museum, and I've met many special people. I feel very fortunate to work in a field I truly love.

So "Fabulous Finds" is an always exciting and not infrequent part of my professional life. While many aspects of my appraisal world interest and excite me, this part—there's "gold in your attic" or "diamonds in your basement," that "who hah!" moment—is always a little different and always wonderful!

Every tale has a beginning, so it seems to me that I should tell you something about myself and how I got into this interesting and pretty unique business of valuing stuff—art, antiques, and so on. But first, let me relate to you a tale of a *very* famous bull.

2. The Charging Bull

A few years ago, I was retained by Dale Robertson, then a stranger to me but now a good friend, to do a really unusual appraisal. Dale usually originates real estate and corporate project finance. In this case, outside her usual line of work, she was representing Arturo DiModica, an Italian artist who created a famous sculpture, the huge, bronze bull at Bowling Green Park in New York City, named *The Charging Bull*, considered one of the five icons of New York City and a top tourist attraction. The front cover of *Fabulous Finds* (this book) is a photo of me standing in front of this unique sculpture. Dale asked me to appraise the bull at "fair market value"—the price at which it could be sold. When an item is truly unique, like this bigger-than-life-size bull, of course, it is impossible to find an exact comparable item that has been sold upon which the fair market value can be based.

As I discuss later (in Chapter 5: Unusual Appraisals), I had appraised Houdini's Water Cell Torture Chamber and Helen Keller's memorabilia. This kind of appraisal is based upon what other important icons have sold for, like Kennedy's golf clubs, various famous guitars, swords, and sports memorabilia. Although *The Charging Bull* is a well known work of art, the artist, Arturo DiModica, is not very well known in this country and had no auction record for me to find prices of comparable works. In my appraisal, I had to use an amalgamation of many unique items

and then determine a price based upon the bull's fame, size, and artistic quality.

The story behind *The Charging Bull* is really funny. Arturo DiModica cast this huge, bronze bull about fifteen years ago and decided, without permission from anyone, to add it to the New York City scene. One day he put it on a flatbed truck and had it driven to Wall Street. There it was taken off the truck and put on display. The next morning, all of New York was talking about this sixteen-foot bull that suddenly had arrived to everyone's amazement. In about two weeks, Mayor Koch decided the bull had to go and ordered a flatbed truck to pick it up off New York City property and take it to a "pound" (really to a storage place for seized cars and trucks), where they would keep it until the Mayor made a decision on its fate. The newspapers headlined the story and all of New York was abuzz. In the few short weeks the bull had been there, many

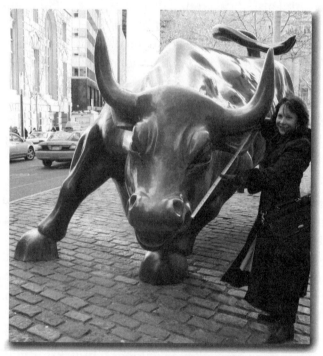

Lee and *The Charging Bull*

New Yorkers had grown to love the bull and now made a big fuss to get it back. It seems Mayor Koch decided that if Arturo paid a fine of about $2,500 to get it out of the "pound," then Arturo could return the bull to its outdoor display in New York City. However, by agreement, its location would have to be changed from Wall Street to a nearby spot at Bowling Green Park. Arturo agreed to all of these stipulations, and the bull was once again brought by flatbed truck, this time to Bowling Green Park, where it has remained ever since.

During those years, *The Charging Bull* became more and more famous and eventually became one of the most important icons of New York. A few years after my first appraisal, Arturo had generously decided to organize an art school in Sicily (where he lives), and he decided to use the bull to help fund the school. He asked me to appraise the bull at its "fair market value," for purposes of sale, with the proviso that whoever bought *The Charging Bull* would ultimately donate it to the City of New York.

I met Arturo in a Starbucks located just opposite *The Charging Bull*, and he told me the history of this work and something of himself. While we perched on the stools, drinking our café lattes, we finalized the agreement for me to appraise *The Charging Bull*. Ultimately, I completed the appraisal, determining a very substantial price, and I thought my matador days were over.

Three months later, to my surprise, Dale Robertson called again and asked if I could now act, not as an appraiser, but rather as an art consultant and help sell *The Charging Bull*. Dale assured me that Arturo had the right to sell the sculpture; in his agreement with the City, he had kept ownership of *The Charging Bull*. He wanted to sell *The Charging Bull* promptly and privately, but insisted on retaining the provision that the buyer ultimately had to give it to New York City. I told Dale that I would be happy to help sell *The Charging Bull*. From time to time, I act as an art consultant, helping clients to purchase or sell works of art—but never at the same time as I am appraising an item. (It would be a conflict of interest to do both at the same time—when I did the appraisals for Arturo, I had no idea

that I would later be asked to help with a sale.) I was truly delighted to have this opportunity—after all, this 7,100 pound, 11-foot-tall and 16-foot-long bronze sculpture is both a popular tourist destination which draws thousands of people a day, and also one of the most iconic images of New York, symbolizing "Wall Street" and the Financial District. Adrian Benepe, the New York City parks commissioner, said in 2004, "It's become one of the most visited, most photographed and perhaps most loved and recognized statues in the city of New York. I would say it's right up there with the *Statue of Liberty*." So of course I was thrilled—who gets a chance to help sell the equivalent of the *Statue of Liberty*?

I decided that the fastest and most private way to sell this remarkable sculpture would be through Sotheby's private-client group. From time to time, people want a sale to be completely private. For some people, selling under the name "anonymous" at auction is the best route to take. But, for example, there could be a famous heirloom identified with a particular family that the family does not wish to have sold, even anonymously, at auction. Of course, there are many situations in which there is a need to keep a sale totally private. For such situations, Sotheby's runs a fine, private-sale division, headed by Stephane Connery. I had worked with Stephane before and I found him to be a competent and charming man and a delight to work with.

Of course, Stephane knew about *The Charging Bull* and was delighted that I asked him to help sell it. He said we (Sotheby's and I) would act as partners in the venture. To go over all the points of our agreement, we had lunch with Dale Robertson at Petaluna, a nice Italian restaurant near Sotheby's where a lot of the Sotheby's staff lunches regularly. Stephane, acting for Sotheby's, and Dale, representing DiModica, agreed upon a very substantial price at which to offer the statue for sale (a price somewhat higher than my appraisal done about three months before). Thereafter, matters moved swiftly. Amazingly, Stephane found a buyer within a week to purchase *The Charging Bull* at the offering price. This large sum would be of great help to Arturo's charitable and educational

vision—assuring the continuity of his art school in Sicily. Everyone was thrilled. The buyer, a major real-estate mogul (and a highly philanthropic man), agreed with the proviso that the work would be left in its place at Bowling Green Park and donated to New York City, thereby preserving a major New York City icon and symbol of the power of Wall Street at its home in Bowling Green Park, while helping present and future generations of Italian art students.

Indeed, when you purchased this book, you too helped Arturo's art school, because a portion of the proceeds of sale of this book benefit Arturo's art school. In addition, if you would like to be further help to his art school, you can learn more about the school and make a contribution to it on its website: www.ChargingBull.net.

The artist recently made another monumental bronze statue—*The Shanghai Bull*—about the same height, length and weight as *The Charging Bull*, but colored red, with its tail raised and head facing right. Since May 15, 2010, it has been located on the Bund in Shanghai, where it is seen by about half a million people a day!

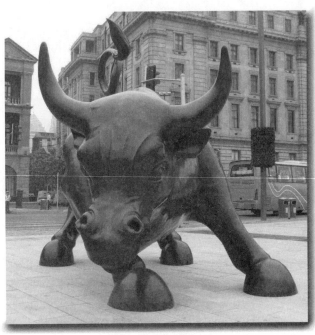

The Shanghai Bull

DiModica will be putting out an edition of 50 pairs of *The Charging Bull* and *The Shanghai Bull*, each 28 inches high, being sold by a gallery in New York. The pair should be fun to see in the entrance of a hedge fund manager's office, on a Wall Street executive's front or back yard, or, who knows, at the entrance to a bull ring!

At the time of this writing, the purchaser of *The Charging Bull* has not determined whether to donate the sculpture to New York City quietly or with great fanfare. We're still waiting to see. We were all very happy with the outcome—after all, how many true stories could there be about a famous 11-foot-tall, 16-foot-long bull—and that's no bull!

3. Beginnings

When I was a little girl growing up in the 1950s in Leonia, New Jersey, a suburb of New York City, I had an elderly neighbor, Mrs. Loisier, who had a huge collection of wonderful antique dolls. She literally had hundreds of these dolls in a small doll museum in the basement of her home. These were mostly French antique dolls in full dress from the 1890s. The dolls were very human looking, with porcelain heads, glass eyes that opened and shut, and long, silky lifelike hair. I found them intriguing. She also had mechanical dolls. When you pressed the chest of my favorite, the German music boy doll, the arms moved and cymbals crashed.

Mrs. Loisier loved to show the neighborhood kids her collection and tell stories of her youth when she rode in a horse-drawn buggy and had no electricity in her family home. Instead, she told us, her family used kerosene lanterns and read by candlelight. She was a strange old dame and sort of antique herself. She was in her seventies, so she was born sometime in the 1880s. She grew up at the end of the nineteenth century and just stayed there, sort of frozen in time. Skinny, about five feet tall, she dressed in pleated and frilly organdy dresses, like she was about to go have tea with Queen Victoria. She had never had children, was fussy, and always worried we might touch something. But in the late 1940s and early 1950s, we neighborhood kids were the only ones interested in her description of her life growing up and her guided tour of her antique doll

collection. For sure, I was the neighborhood kid who was her best audience. I did lots of other kid's activities—went horseback riding, played cowboys and Indians with my friends (I was always the Indian!), read lots of books, and went to school. But I spent more time at Mrs. Loisier's home than any other neighborhood kid, listening to her stories about her life in the nineteenth century. My father, earlier in his career, had been an agent for the U.S. Department of the Interior, trying to help Native Americans (he, of course, called them "Indians") protect their legal rights. Not surprisingly. I was raised on stories of Indian tribal life. Mrs. Loisier also had a fantastic collection of nineteenth-century Native American dolls and clothing made of deerskin with beautiful beading. This part of her collection amplified my interest in the life of Native Americans, inspired by my father's bedside stories of the Old West.

Little Lee, 1951

So Mrs. Loisier was my living, antique guide into a prior time and place, and I loved it. I didn't know it way back then, when I was only six years old, but truly the pattern of my professional life had begun. As I grew up, I continued to be interested in art and antiques, regularly going to the museums and antique shows that are one of the great features of the New York area. In college I studied art and French at Tufts University. In 1963, during my junior year, I went to Paris for the year. I was fortunate enough to study art and antiques at all the great museums in Paris, particularly the Louvre and the Musée des Arts Decoratifs (a separate part of the Louvre that focuses on furniture and furnishings), as well as the great museums around Europe including: the Prado, the Tate, the Victoria & Albert, the Uffizi, the Vatican, and the National Art Museums of Greece, Belgium, Holland, and Germany.

After graduating, I married Jim Cohen, an estate and tax lawyer, and soon after we had two children, Terri and Brett. Today, Terri

is a grade school teacher and Brett is a hedge fund manager. I am proud of both of them, and they have given Jim and me four wonderful grandchildren.

Soon after I married, I took courses at the New York School of Interior Design. I started working as a decorator but did not particularly enjoy it. One night in 1968, my husband started talking about an appraisal he had used recently from a well-known appraisal firm. Because the appraisal had not been done properly, it created many problems for Jim in handling the IRS audit of his client's estate. My husband said, "You are very well organized, love antiques and fine art, and have a great memory [three qualifications necessary for an appraiser]. Why don't you consider becoming an appraiser?" I at first said no. I didn't even know what an appraiser did. My husband persisted, suggesting that I first apprentice with a few top appraisers for a period of years, and then when I was ready, I could start working on my own.

At first, I thought the idea was crazy, but the more I thought about it, the more I liked the idea. I had been brought up in a business atmosphere as a child. My father, Eli Drexler, worked as a top executive in the film business. My mother, Bea Drexler, unlike many wives of successful men back in the 1950s, worked too. She ran a very popular day camp, Candy Mountain Day Camp, which over five hundred children attended each summer. I had helped out at the camp since I was five years old, watching my mother multitask. So the idea that I could be married, have children, and run my own business seemed natural to me. When my husband suggested that I start my own business, I knew I would be able to do it. Most importantly, it was in the art field, an area in which I had been interested since I was six years old. I still can replay the scene in 1968 in our home in Mamaroneck, New York, as clearly as if it happened yesterday. Over forty years later, my husband still says the idea for my appraisal business was the best suggestion he has ever made to me.

I started out by calling numerous well-established appraisers. In the early 1970s, there were not too many appraisers and

virtually no women appraisers. There were also no appraisal courses of study available. Later on in my career, I taught a course at Hofstra University entitled The Appraisal of Fine Arts and Antiques. In the early 1970s, however, the only way to become an appraiser was to apprentice with an appraiser and take fine art courses. I contacted numerous older men who were appraisers and found three willing to be my mentors while simultaneously working for me on any business I could bring to them. These men were tops in their profession, but they were not particularly focused upon getting new appraisal business. For three years, I did not do any appraisals myself, but I managed to get business for them by writing letters to law firms, banks, and insurance companies. As I found people who needed appraisals, I simultaneously marketed the services of my three wonderful mentors. At the same time, I learned everything I could about the appraisal business from them. Fortunately, these

Lee in 1971, overlooking Florence

lovely, older men liked me and liked sharing their knowledge.

One of the men, Charles Brouda, was the former owner of an antiques auction house and, at that time, the owner of a large Westchester County (New York) antiques store. Another of my mentors, John Lamarr, was a former cataloguer for Parke Bernet (predecessor to Sotheby's); he had a Ph.D. and was a teacher at the New York School of Interior Design. The third appraiser, Bob Tyrer, was working at a very active auction house.

I ran the company, which I called Esquire Appraisals. In those early years, my husband used to joke with me that my business card

should read "Esquire Appraisals, Inc., Lee Drexler, Apprentice and President." What was interesting was that because Esquire Appraisals, Inc., was my own company (my husband thought up the name, because my clients were mostly attorneys—generally referred to as Esquire), my clients paid me right from the beginning, and then I paid my mentors for their appraisal work while learning from them. I always went with them on the appraisals and took notes; then my secretary would type up the appraisal. I would get it copied, put it together, bill the client, and finally collect the fee.

Right from the beginning, I was delighted to learn that, after receiving the fee for the appraisal, paying my mentor, my secretary, and subtracting all the costs associated with a business, I still had a small profit at the end of the first year. In all of my years since, I have continued to have at least a small profit. But I don't believe there are many other appraisers out there who started out as president and apprentice of their own company, and I realize my great good luck in being able to do so.

As I previously mentioned, my maiden name is Drexler. Joanne is my first name and Lee is my middle name. However, at the time I started, there were virtually no female appraisers. When I started out, I was sending letters to attorneys and insurance agents and signing them Joanne Lee Drexler (like many women, I used my maiden name for business). However, after the first month, I still had no responses. I wondered if the problem might be that there were virtually no women in my business. You don't have to be a rocket scientist to figure out "Joanne" is not a man. As a practical person, I decided to change the signature on my letters to J. Lee Drexler, so it was not obvious that I was a woman. As soon as I made this change, I was flooded with responses! Once I started talking to a person on the phone, I was able to convince them to use Esquire Appraisals and the three gentlemen who worked for me. I was always a good saleswoman. (Starting from the time I was seven, my mom gave me a dollar for each parent I took on a camp tour who subsequently registered their child in the camp.) Once these attorneys and insurance agents talked to me, they

realized they had no problem with hiring a woman to do the job. (Of course, it never should have been an issue.) The name J. Lee Drexler worked for me and, to this day, all my clients and business associates call me "Lee." This sometimes gets confusing in a mixed business and social situation, where some people are calling me

"Lee" and others are calling me "Joanne." Today, more women than men are in my business. But it's an interesting social commentary that to start my business, I had to do so using a unisex name.

As the years went by, I became more expert in all of the different areas of the decorative arts and paintings, and three years after I started my business, I began doing the appraisals by myself. If there was anything I didn't know, I always consulted a specialist. I have never stopped studying or traveling around the world and, after visiting over eighty countries, I am well versed in art objects and jewelry from all over the

Lee and Jim in 1971

world. I've been in every great art museum in the world and I continually attend auction exhibits and art and antique shows to keep abreast of the change in values. I also took courses at the Gemological Institute of America (GIA) in diamonds, pearls, and colored stones (which means rubies, sapphires, emeralds, and any colored stones, besides diamonds, that are used in jewelry) and received my diamond and pearl certificates.

Seven years after I started my business, I was asked to write a column on antiques and fine arts. This led to a number of radio and TV shows, which certainly helped my business. From the beginning to the present time, I have continued studying, learning, and traveling to different museums and auctions, and I have had the opportunity to meet so many famous and fascinating people. I've been in some of the most beautiful homes in the world and have been privileged enough to meet some of the world's wealthiest and most

famous people in their own homes. It has been an exciting career, a great big, champagne cocktail, and I am going to share some of my stories with you—the ones that, for me, have bubbled to the top.

About seven years after I had started appraising, my business had become extremely active. Although I was doing several appraisals a week, I was still an unknown to the general public. I had a dear friend, Bunnie Strack, who had just become a widow, had two young children, and didn't know what to do with her life. She later became a successful stock broker and married a great guy, Carl Sutter. So now, my friend, who decided "Bunnie" did not sound like anyone's investment advisor, is known as Angela Sutter. Angela and I and our husbands have taken many trips together to lots of wonderful places—Europe, Thailand, Burma, South Africa, etc., and are still doing so twenty years later. As she is very bright and personable and loves antiques and fine arts, I thought she might like to come along and see what an appraisal was like. I figured it would get her out of the house and perhaps introduce her to an area of work she might like to go into. Besides all that, it would be a fun day for me as well. Bunnie decided to take me up on my offer and she went to my client's apartment with me.

I introduced Bunnie as my assistant to my client, Mrs. James, and then started appraising all the artwork and furniture in her apartment. Mrs. James had some nice Hudson River School oil paintings, painted in the late nineteenth century, and a beautiful, eighteenth-century, French walnut linen press with a warm brown patina that actually glowed in the room. I also appraised a good deal of silver and crystal. (Bunnie measured and weighed everything for me and was a real help.) Then, with the job finished and just as we were walking out the door, Bunnie asked Mrs. James what work she and her husband were involved in. I had already put my coat on and was waiting in the hall. I was impatient to leave and wished that Bunnie would just stop being so darn charming and leave with me. She was really enjoying herself because, since her husband's death, she had not been out much in the business

world. Mrs. James said that although she did not work, her husband did. He was the producer of Channel 2 CBS news.

When I heard this, my impatience with Bunnie immediately evaporated. I walked back into the apartment and said, "Gee, I'd love to get on a TV show discussing appraising. Very few women do this, and I think it would be something of interest for the general public." Mrs. James thought about it for a minute. "You're right," she said. "It would be great for the public-interest section. I'll call my husband and ask him to get you on the show. He'll contact you." I left there thrilled, walking on air, and it all happened because Bunnie asked that question.

And I *did* get the phone call from the assistant to Mrs. James' husband and went on to do a TV show in the home of one of my clients, Mrs. Hilda Koch, who at that time had a beautiful Fifth Avenue apartment filled with fine furniture and very fine paintings. A dynamic woman by the name of Trish Reilly ran the interview, showing Hilda Koch's fine arts as I described them (in an early version of the *Antiques Road Show*). I knew my segment of the show was quite successful because afterwards I received lots of calls from people asking me to do appraisals and also from many other television and radio shows. I was later on *What's My Line*, CNN, a few cable TV shows, Channel 13 Auctions, and over twenty-five radio shows. All this exposure helped my business a lot.

Although I didn't realize it at the time, I was working hard at marketing my business. Soon after these appearances, I got a call from the *Gannett* chain newspaper and ended up writing a syndicated newspaper column on antiques, fine arts, and foreign travel for six years. Life is so funny. Sometimes one little question can really change your life. All of this came from that one question Bunnie asked. (Sorry Bunnie, I just can't think of you as "Angela," even though it is your real name.) After all of this media exposure, I became very well known in my field. It was a tremendous help. Thank you, Bunnie!

4. *Stuff of the Rich and Famous*

I have done appraisals for many world-famous people and many fabulously wealthy people. I always find it interesting meeting and talking to them. Generally, they're like everyone else, and share many of the same problems and anxieties.

Famous Tenor

A number of years ago, I was doing the appraisal for a world-famous opera singer for the second or third time. He and his wife, who functioned as his business manager, had a large collection of fine furniture, jewelry, and paintings. I spent most of the time with his wife going over everything. She is a completely devoted wife, involved in his career, raising their children, and organizing his life. As I walked into their beautiful apartment, his wife greeted me at the door. We entered the living room, where the famous tenor was working on a piece at the piano. He just nodded to me, and his wife and I went to the other rooms to work on the appraisal. She said, "Everyone envies me, my travels, fame and fortune, but my life isn't easy." She explained to me that everyone wanted her husband's time and presence, and she consequently didn't get to spend much time with him. As well, she was completely involved in helping organize and manage his career, and had very little free time.

There was a painting hung over a couch of him singing with four famous and beautiful female opera singers in a romantic pose.

FABULOUS FINDS

Fortunately, his wife was not a jealous woman, because most wives would not be happy with a picture of their husband surrounded by four beautiful, seductive looking women. When we were discussing restaurants in New York, she said they could only go to the restaurants that stayed open late especially for them (he never ate before he performed) and at restaurants that didn't allow cigarette smoking, which bothered his voice. (I did this appraisal at a time when most restaurants had a smoking section. The change, some years later, to smoke-free restaurants must have been very beneficial for him.) While he continued practicing at the piano in the living room, I went through the jewelry collection in the bedroom with his wife. I examined a beautiful pair of 18-carat, yellow-gold cuff links set with sapphires and diamonds, given to him by an opera lover as a present. "Imagine," his wife said, "these people hardly know him, and yet they give him incredible presents. It's amazing!" I valued the "little trinket" at about $7,000.

Her life was scheduled to the hilt, traveling from one place to the next with rarely any time to relax. I certainly agreed with her that her life wasn't easy. She was a highly competent and organized woman for whom I had a great deal of respect as she had accepted her situation and dealt with it very effectively. I felt he was lucky to have such a supportive wife. Finally, I had finished every other room and had to do the living room while he continued practicing. Then, I finished everything in the living room except the numerous valuable items on top of the piano. It was funny, this meeting with him, because he was seated at the piano playing away and singing scales. There were a number of bronze statues and other art objects sitting there on the piano that I needed to appraise while he was playing and singing. He was extremely charming and courteous and said that it was fine for me to appraise these objects while he was practicing. So for a half hour or so, I was in the presence of this world-famous opera star while I appraised bronze statues, crystal vases, nineteenth-century English tea caddies, and small, Tiffany, leaded lamps, all perched on top of the piano, while he was singing "do, re, me, fa, so, la, ti, do." It was a fun, but surreal experience, and a real thrill for me.

The Prince

I did an interesting appraisal in a magnificent apartment in Manhattan for a well-known prince. We don't have titles in the U.S., so of course, he was from a far-off land. He had a fine collection of French Impressionist paintings (including a beautiful Renoir) and some beautiful eighteenth-century French furniture. He was having the apartment completely redone, and everything was being moved out and put in storage so the fine arts and antiques would be safe during the renovation. I appraised the items so that they would be properly insured while they were moved to storage, stored, and then moved back. The items had all been appraised fifteen years before, but now the appraisal needed to be updated to reflect the current replacement value. (For insurance policies with replacement value coverage, items are insured and appraised at replacement value; not the fair market value at which the item would sell, but rather the significantly higher value it would cost to purchase the item in a shop. The difference is the profit the dealer makes when he buys or sells an item.)

After I appraised the Renoirs, the Pissarros and the signed French furniture, I stopped to talk with the two housekeepers (I never met the prince). They had a terrific deal: They lived in this spectacular apartment all year long, but only had to take care of the prince when he was in New York City, which was not more than twenty-five to thirty-five days a year. When he was there, however, they were on twenty-four-hour-a-day duty. It seems the prince liked to eat at three o'clock or four o'clock in the morning. Whenever he was hungry, he would buzz the housekeepers, and they would bring the food to the bedroom (he loved to eat on his bed), where he would then have a full meal. They always had to bring him four meats, four salads, four vegetables, and four desserts, and he would pick what he wanted. Since they never knew exactly what time he would call for his food, and because they always had to serve him within fifteen minutes of his call, they had to have food on the stove at all times, which would then be thrown out if it was not eaten within a certain time. During the time he was in residence, they

worked straight through the day and night. But as it was only for a short time, they didn't complain. Often the food bills just for the prince were $2,000 for the week. As his apartment only had three bedrooms, when he visited, he was the only one who stayed there, accompanied by a few security men. His wife, the princess, and her entourage stayed at a nearby top hotel, where they took over an entire floor.

The housekeepers told me a funny story. One night at 3:00 A.M., the prince called to say he wanted dinner, starting with caviar. The housekeepers did not have any caviar in the apartment, and one replied, "Sir, I'm sorry but we don't seem to have any caviar here." The prince answered quite angrily that he always kept caviar in all of his many homes. Well, as the housekeepers didn't want to get him upset, they quickly called room service at the hotel where his wife was staying. They explained the urgency of the situation, and someone from room service handed two jars of caviar to one of the princess's staff who, at three o'clock in the morning, ran ten blocks up the streets of New York to the apartment of "His Majesty" to give him the caviar. The prince received the caviar within fifteen minutes after his request, so they managed to avoid an international, gastronomic faux pas.

In appraising the furniture for the prince, I had to deal with a unique situation. He was redoing the apartment and told the decorator that everything was to be re-upholstered with exactly the same fabrics that had been originally bought twenty years before, but, of course, they would be brand new now. Since twenty years had gone by, most of the fabrics were no longer available to be purchased. The decorator had to go to the fabric houses (all the fabrics the prince had requested were expensive French brocades and silks) and find out what it would cost to re-weave the exact same fabric. Almost all of these fabric houses had a minimum order of one hundred yards to re-weave cloth from an old pattern. The decorator asked the prince if she could purchase a very similar fabric—one currently available—although not precisely the same. The prince said absolutely not, each piece had to be exactly the same. So, in a

situation where, for example, a stool only required two yards of silk fabric that cost $50 per yard, they had to order a full ninety-eight additional yards, bringing the cost of the fabric to re-upholster this one stool to $5,000 instead of $100. This very unusual lifestyle had to be factored into the replacement value appraisal I was doing for the prince.

The prince's artwork was very impressive. But most impressive of all was my discovery that there are some people in the world who wish to and can afford to live in a style reminiscent of Versailles. I had thought this lifestyle ended when Marie Antoinette lost her head.

Candice Bergen

We all know people (you may be one of them) who know and love actors and actresses. For me, however, it has always been that unless an actor or actress is really well known, I may not even recognize his or her name.

But in 1979, when I was asked to do an appraisal for Candice Bergen, I knew who she was, and I was thrilled to have the opportunity to meet her. It was right before she starred in the award-winning role in the television series *Murphy Brown* and just before she married Louis Malle. But she was already a very well-known movie and television actress and regarded as a great beauty. At the time, she was living alone in her New York apartment where I met her. Her manager had arranged for me to do an appraisal of the contents of her apartment so that they could properly insure the items.

I arrived, as scheduled, at 9:30 A.M. I rang the bell, and there she was! She was dressed in a Bohemian, long, multi-colored "peasant" skirt with a rope belt, a long-sleeve, a white blouse, and was wearing very little or no makeup. Even so, casually dressed and makeup-free, she was drop-dead gorgeous! I walked into her apartment, and her first words were, "I'm so glad you came. Please come in and make yourself comfortable. Can I get you a cup of tea?" I couldn't believe that here was a famous movie star going way out of her way to make me comfortable in her home. It was so nice to meet a famous person who was not a "legend in her own mind." She did

make me a cup of tea, and then we walked around the apartment, where she pointed out her Tiffany floor lamp, her collection of rugs and pillows, and her collection of Oriental art, all later shown in *Architectural Digest*. (By the way, I never publicly disclose the name of someone and his or her stuff unless that information has already been made public, such as in an article in a magazine.) It was a real pleasure working for her. She has a well-deserved reputation as a "class act." She was completely relaxed and just so nice to be with. At the end of the day, she even autographed a few pictures of herself for me to give to my children. The next movie she made was called *Rich and Famous*. She was so nice that she even, without knowing it, gave me the idea for the title of this chapter.

Rock Star

According to Chinese philosophy, we live in a word of opposites: yin and yang. Well, if Candy Bergen was the yin, this next star was surely the yang. Or perhaps, she was the smile on the face and he was the pain in the ass.

We meet now one of the most famous rock stars—a member of an American rock band known to everyone (except me) in the early 1980s, when I did this appraisal. At the time, the name of this singer and guitarist, then about thirty years old, was one that any-one who listened to rock music would know. In contrast, I didn't know anything about rock music and had never heard of this rock star when his agent called and asked me to appraise the contents of his apartment for insurance purposes.

The rock star lived in a fantastic apartment in New York City— all very modern, with great architectural details, such as columns surrounding a hot tub fit for a Grecian god and walls with a special finish sprayed on them so they looked like they were made of little pebbles, similar to the interior of a cave. As I said, at the time, I had never heard of this rock star. However, as soon as I arrived at his home and saw this huge multimillion-dollar apartment, I realized, if this all came from his music, he must be a very famous person.

He had mainly modern paintings, fine Baccarat crystal, one Tiffany lamp, and the biggest collection of boots that I had ever seen. One whole dressing room was devoted to these boots, made of ostrich, leather, alligator, and lizard. He had paid over $5,000 a pair for some of the more unusual pairs. I certainly realized how famous he really was when I stepped into his bathroom. There were five Gold Records (for songs that sold over one million copies) hanging on his bathroom wall. When I stepped out of the bathroom, I said, "I don't know any of your songs. I'm a classical and folk music fan. But I guess there are a thousand women in New York who would give their eye teeth to be in your apartment at this moment." He responded, "That's for sure! But you certainly do know some of my songs—what about this one?" He began to sing a song I had never heard. I said, "I'm sorry, I never heard that one." He looked rather frustrated. "What about this one?" he said, and he began to sing another song. In truth, I had never heard that one either, but I didn't want to hurt his feelings, so I said, "Oh yes, I know that one." He seemed much happier after I said that.

I continued doing my appraisal of the contents of his apartment. When I walked into the bedroom, which had a big, round, black bed, he jumped onto the bed and looked at me in an amorous way. I said, "I'll be finished with this room in just ten minutes and then you can take your little nap." He responded, "I wasn't planning on napping." I said, "Well, I have to work quickly. My husband is waiting for me to meet him for lunch," and left the room. I guess I should have been flattered, but I was not. He assumed he would just jump into bed and I would jump right in with him. Anyway, on leaving, I mentioned I had a fifteen-year-old daughter. He said, "Don't bring her here for my autograph." I assured him, with a smile, that the last thing I would do would be to bring her to his apartment.

Riviera Lifestyle and a Big Mistake in Paris
Now let's move on from the brash and famous musician to a charming, super-wealthy, and knowledgeable art collector. It started with

41

a call from her secretary about doing an appraisal. When a secretary calls, it is usually for a VIP. In this case, it was for the wife of a man who, at that time, was a billionaire, as reported in *Forbes*. The lady—let's call her Mrs. Smith—had eight homes. Eventually, I appraised the contents of all of them except her home in Hawaii. I appraised the contents of a mansion in upstate New York, an apartment in Manhattan, a triplex in London, a duplex in Paris, and three beautiful homes in Cap Ferrat. Cap Ferrat is a magnificent place with some of the most expensive homes in the world—a "suburb," if that's the right word for a playground for billionaires, on the French Riviera.

Mrs. Smith was a charming lady who had an interest in many different types of art and antiques and consequently collected some of practically every type. She had modern paintings and bronzes, nineteenth-century French Impressionists, English and French eighteenth- and nineteenth-century furniture, and many objets d'art (just a French and fancy way of saying art objects). One whole room in one of her Cap Ferrat homes was filled with nineteenth-century Victorian papier maché furniture, including a papier maché bed and bureau. This furniture was very popular in the 1860s–1880s. Papier maché furniture is always black lacquered, surprisingly sturdy, often painted with flowers and inlaid with mother of pearl. It was generally made in France and was regularly used for clocks and chairs; but it was pretty unusual for it to be used for beds and bureaus like the ones Mrs. Smith owned. For all the hundreds of thousands of items I have appraised, certainly this sturdy, attractive, antique bed, ultimately made out of paper but worth about $5,000, is one that stands out.

Wherever I went to do the appraisals, my client and her secretary were very helpful and made me feel at home. I was flown from one place to the next, picked up by Mrs. Smith's private limousine, and taken by her out to dinner at wonderful restaurants. It was a really glamorous way to travel for work, and as a bonus, between appraisals, I was able to visit my friends in London and Paris and enjoy the warm weather of Southern France during a particularly cold February in New York.

When I got to Paris, an interesting thing occurred. I walked into the living room of Mrs. Smith's duplex, and there, in the center of the room, was a very beautiful Boulle desk. André Charles Boulle (1642–1732) was a leading French cabinet maker, who made elegant furniture (either in tortoise or ebony) and inlaid it with elaborate, filigreed brass design; the desks were generally large, solid pieces, designed for wealthy noblemen. Boulle furniture has always been valuable and highly sought after. It was continually reproduced—more in some periods than in others—from the seventeenth through the nineteenth century. Because the work is so labor intensive, there have been few reproductions done in the twentieth century. Boulle furniture was also out of style in the eighteenth century, so most reproductions were done in the nineteenth century. An appraiser must be able to detect the difference between Boulle originals from the seventeenth century and the reproductions from the nineteenth century. In order to do this, the appraiser must check to see if the wood is hand-planed or machine-planed, if old hand-wrought nails or new nails were used, and if the drawer sides are uneven (it was not possible to have perfectly even drawer sides in the seventeenth century). An appraiser also needs to check to see if there is shrinkage in the wood. (Wood shrinks over time, and wood from the seventeenth century usually shows substantial shrinkage.) An expert should not have any trouble telling the difference between an original piece from a seventeenth-century and a nineteenth-century reproduction. The difference in value is huge— it can be as much as five to fifty times.

When I saw the Boulle desk from across the room, I said right away to Mrs. Smith's secretary, "That is a nineteenth-century Boulle reproduction." I felt the shape and style of the desk were not typical of a seventeenth-century desk. It was too dainty—more like a Victorian lady's desk, a style of desk that did not exist in the seventeenth century, when Boulle was working. The secretary said, "I'm sure you're wrong. Mrs. Smith paid $85,000 to one of the finest antique shops in the world." She told me which shop it had been bought from, and I was amazed. This shop is still considered to be

one of the best in the world; it has been in business for over one hundred years and is well known as having been the purveyor of fine furniture to royalty. The secretary showed me a beautiful document, which was written on parchment in a gilded leather book, from this famous shop that stated that the desk was one of the finest seventeenth-century Boulle desks ever made and that it could even have been used by Louis XIV himself. With this mellifluous description in hand (I could almost feel King Louis XIV breathing over my shoulder), I felt I should do a more detailed check. So I got underneath the desk, removed the drawers, and gave the desk a complete examination. As I suspected, the desk was obviously a nineteenth-century reproduction with even some small, twentieth-century repairs. I valued the desk at $20,000 for its replacement value (a cost to buy it from a shop).

As you can imagine, the secretary and Mrs. Smith were very upset to hear my report, particularly because the $85,000 she had paid was so much more than I said the desk was worth. She felt, however, that before presenting my report to the antique shop, they needed a second opinion. She called in a French appraiser, and he was so afraid, when he heard the antique shop's name, that he arrived with four other experts in tow. Within ten minutes, the five of them agreed with me about the date but felt that $30,000 was the proper replacement price. These types of desks are more expensive in Paris than in New York, and I was using New York prices. We made a claim to this famous shop for $55,000 (the difference between the $85,000 Mrs. Smith had paid and the $30,000 it should have cost if it had been properly identified). My client decided she wanted to keep the desk, and in about six months, based upon my appraisal and that of the other five experts—and without a lawsuit—my client received a check for $55,000 from the shop. It was hard to understand how a top antique shop could have made a mistake like this. Louis XIV had long since turned to dust before anyone sat in front of this particular desk, and the shop should, and perhaps *did,* know the desk was a reproduction. In any event, it is a good example of why, when you are going to buy

expensive antiques or fine art, you should have them examined by an appraiser who has no relationship to the seller and who will not receive any benefit if the item is sold. For the same reason, appraisers should be paid on an hourly or flat-fee basis, instead of being paid based upon the values they determine. This story also shows that it is not just the downtrodden but also the "up trodden" who can be taken advantage of and should take care.

Famous Clothing Designer Oleg Cassini

About thirty years ago, I did an appraisal for the then world-famous clothing designer Oleg Cassini. (He died in 2006.) I met him at his magnificent home, which was decorated like a medieval castle. He was about five foot ten, tall, handsome, charming, and as you would expect for a clothing designer, beautifully dressed in casual sports clothes. His living room had a sky-high ceiling, tapestries hanging on the walls, a fifteenth-century triptych (a painting, typically on wood, in three sections) of the Madonna and Child, lots of imposing seventeenth-century furniture, and an unusual collection of medieval suits of armor rarely seen in a home.

Mr. Cassini took me to lunch and gave me some interesting background about himself. He came from a wealthy and noble Russian family that had lost most of its money. He told me that, after the family money was mostly gone and before he had become a wealthy and well-known designer, his mother had told him that to make a success of himself, he needed only two things: a good tennis racquet and a fine tuxedo. With these, she had said, he would fit into society, playing good tennis and dancing divinely! I'm not sure this advice is too useful today, but it certainly made for interesting luncheon conversation.

Jim Henson and the Muppets

It is not everyone who has the chance to meet, much less appraise, a living, breathing Muppet! A number of years ago, I appraised the contents of the home of Jim Henson, the puppeteer and creator of the Muppets, at the Sherry-Netherland Hotel in Manhattan, where

he was living. His apartment was filled with eclectic items from all over the world. He had art deco furniture, assorted paintings, and an unusual, bronze, serpent-shaped lamp. He was a quiet, almost shy, and lovely man, very polite; he told me that, notwithstanding the many things he had accomplished, what made him happiest were his five wonderful children, all of whom he said made him very proud. There were a few Muppets in the apartment. At one point, he picked up one and, standing behind it, spoke to me as if he were the character as he manipulated the puppet. I saw the transformation: gone was the quiet man and, in his place, was a funny, outgoing Kermit the Frog. I had a conversation with Kermit, and I am sure that it is the one and only time I had a conversation with an object that I was appraising.

Tragically, a few years later, Jim Henson died suddenly at age fifty-three from a virulent pneumonia. I then appraised the contents of his homes in Connecticut, Malibu, and New York for estate tax purposes. This was a very sad task, as I could not stop thinking about the vital person he had been such a short time earlier. His death was a terrible loss for everyone. I think of Jim Henson as a wonderful person who left a legacy for all of us of light-heartedness and tolerance of our differences. He was a real gentleman, and I will always remember the day I spent with him doing an appraisal at his home.

What's an Oscar Worth?

I appraised the contents of both homes of a world-famous song-writer who had a mansion in Westchester and a townhouse in London. At the same time, I had to appraise the Oscar that my client had won as well. (If you have ever watched the *Academy Awards* show on TV, you know what the Oscar looks like: a gilded, bronze statue thirteen-and-a-half inches high, weighing about eight-and-a-half pounds). The statuette depicts a naked knight holding a crusader's sword, standing on a reel of film. The first awards were presented on May 16, 1929, at the Hotel Roosevelt in Hollywood. Supposedly, Margaret Herrick, an Academy secretary, said that the statue resembled her Uncle Oscar, and the name stuck. At the time

I did the appraisal, the cost for the Academy to buy an Oscar statue from the company that made them was only $1,500. However, this client's Oscar was awarded for a famous song he had written, and had his name and the name of the song on it. No Oscars awarded after 1950 can be sold. The artists who receive them agree to never sell them. However, there is a grey market and one was reported to have sold for $1.5 million.

To appraise the statuette, I had to evaluate what that particular Oscar by this well-known composer would cost if someone had the opportunity to buy it. The statuette was worth far more than the $1,500 it would have cost to buy the exact same statue from the company that makes them. (That's because it was known to be a collectible item.) While, no doubt, people have acquired collectibles for centuries, it has become a really hot area in the last twenty-five years. The prices for collectible items are simply based upon who owned them. President Kennedy's golf clubs—a collectible—sold at auction for over $750,000. As a used set of golf clubs whose owner was not famous, they would have been worth approximately $500. In addition, the Franklin Mint bought a strand of Jacqueline Kennedy's Majorcan pearls (man-made) at auction for over $200,000. This seemed like a crazy price to pay, as the pearls would not have cost more than $200–$300 if they were brand new from a store without the aura of the famous Jackie O. behind it. Still, the Franklin Mint reproduced them and sold an unbelievable number of pearl strands modeled from Jackie's set. They were no different from any other strand of man-made pearls, but each strand of "Jackie's pearls" sold for hundreds of dollars. In a very short time, the Franklin Mint had made a huge profit. Their decision to buy Jackie O's pearls ended up being a brilliant investment.

It is very difficult to appraise ordinary things that famous people have owned because the items are of limited intrinsic value; instead, it is the degree of the potential buyer's infatuation with the famous person that decides the price. When Sotheby's sold President Kennedy's golf clubs and Jackie's pearls, they had estimated the golf clubs to sell for less than $3,000 and Jackie's pearls for less than

$1,000. However, at auction, the items sold at far more than two hundred times the estimate and more than six hundred times the cost if they had been bought new! Fortunately, with many more comparables available now than twenty-five years ago, when collecting famous people's junk was just catching on, the task of appraising these collectibles, with a famous person's "fragrance" clinging to them, has been made much easier. My client's Oscar for his hit song was worth about $10,000.

Jacob and Alice Kaplan

When I was a relatively young appraiser, with only eight years or so of experience under my belt, an insurance company called and asked me to go to Alice and Jacob Kaplan's home to appraise their extremely large and very varied collection of art. They had a world-class collection, and it was a great honor to be picked for this job. Jacob Kaplan had owned Welch's Grape Juice, and his wife, Alice, was a big collector of American folk art, Oriental and African art, and fine seventeenth- to twentieth-century European drawings. I worked for them for over twenty years and then, sadly, appraised their estates when they died. I learned a lot from Mrs. Kaplan because she was such a great lady.

When I first entered their huge Park Avenue apartment, I was a bit timorous because they were such important people and I was a relatively inexperienced appraiser in my early thirties. No matter, Mrs. Kaplan immediately put me at ease with her first question: "What would you like for lunch and what time would you like to eat?" She was a woman of great dignity and warmth. When I meet famous and wealthy people today, I always feel that if Alice Kaplan could treat me with kindness and politeness, then they can too. Fortunately, I have found that most of the famous and very wealthy people I have done appraisals for over the years have been a pleasure to deal with. But Alice Kaplan really set the bar high for everyone.

Mrs. Kaplan walked me around, describing how and why she had bought one painting or another. One Ammi Phillips painting, of a

woman with her little son, was a particular favorite of hers. Ammi Phillips was an American artist (1788–1865) known for his charming, primitive portraits of children and attractive young women. A "primitive" painting is one done by an artist who did not formally study art, but whose natural, artistic skill is so charming and appealing that the artist's lack of formal training is not a negative. A few examples of "primitive" painters are Ammi Phillips, Grandma Moses, and Henri ("*Le Douanier*") Rousseau. Alice told me that she had bid for that Ammi Phillips painting of the woman and her little son at auction, but stopped at $75,000 because she had agreed with her husband not to spend more than that amount. The painting eventually sold for $85,000 to a dealer, and Alice went home empty-handed. She tossed and turned all night long and, the next morning, decided she just had to have the painting. So she called the gallery and offered them $100,000, thinking $15,000 would be a pretty good profit for them for less than a day's work. To her surprise, the gallery said no! They told her that unless she paid $160,000, they would not sell the painting to her. She was furious but decided she still had to have the painting. She did end up paying $160,000 for the painting, but she never had anything to do with that art gallery again. She told me that, thereafter, although she knew that her husband was a great businessman, she would not take his advice on art purchases. This painting—which hangs in a museum today—is worth well over $1 million.

Over the years, I appraised and then reappraised her and her family's collection in New York and at the family compound in East Hampton. One item I particularly remember was an African tribal mask carved by the Fang tribe in the seventeenth century. This mask had been used for tribal and religious purposes for many years. So many people had touched it over the years that during the summer, it virtually oozed oil. Some rats had also gotten to it, so it was partially rat-eaten. The mask was, to me, ugly and frightening. Generally, however, except for some rat nibbles, this rare piece was in good condition. Virtually no seventeenth-century Fang masks available for sale were as finely carved as this

one, and the comparable ones were all in museum collections. The last time I came to appraise the mask, I told Mrs. Kaplan that it had increased dramatically in value and was now worth over $500,000. The family decided they wanted to sell the mask and asked for my help. I felt they would get the best price at Sotheby's, but I decided to first check with art galleries. I put the word out that this famous mask was available, and I started getting calls from primitive-art dealers from all over the world—Belgium, France, South Africa, and so on—offering prices up to $650,000. Soon thereafter, at my suggestion, the mask was sold at Sotheby's for $735,000, after commissions. This was more than the highest price a private bidder had offered. My client and Sotheby's were very happy with the results. Because Sotheby's had done such a superb job featuring the mask on the cover of their catalogue, every collector of primitive art in the world had a chance to see it.

Today, every time I go into museums and see things I appraised for the Kaplans, I feel a little extra-connected to history and to this lovely and charitable family. For example, I have seen the large, bird-shaped weathervane and the Angel Gabriel weathervane at the American Folk Art Museum in New York City; and the Ammi Phillips painting of a

Angel Gabriel weathervane. *Courtesy American Folk Art Museum, New York*

woman and her child at a major museum. The Kaplans were great collectors whose collected works will live on forever in museums.

Herzman—the Joy of Collecting

Soon after I became an appraiser in the 1970s, a widower—a gentleman by the name of Stanley Herzman—called me to appraise his late wife's estate. He was in his early seventies and very sad. He was charming, but so overwhelmed by his wife's death that I hoped I

could say something to cheer him up. I also appraised his own collection of fine arts and antiques. His particular collection included a number of fine, Chinese porcelains, including small Tang pottery horses, dating from the sixth to the ninth centuries, and beautiful monochrome (one color) Chinese porcelain vases from the eighteenth century. I asked him where he had bought these items and he said, "Oh, I got them for almost nothing during World War II when I was in China in the 1940s. I always liked them. Do they have any age or value?" Well, I got extremely excited because virtually no one buys Chinese porcelains, particularly sophisticated monochrome vases, without some background in this specialized area. With no knowledge, he had picked up these high-value pieces because he had a good eye and, as he said, he "just liked them." It was amazing that he had done this and still had no idea that, at the time I first met him, each of these pieces were already worth many thousands of dollars. (He had paid less than $500 for all of the pieces.) I told Stanley that anyone who had such an innate ability should educate himself about Chinese porcelains (take classes, go to museums, read books, go to dealers and auctions). I thought that doing this would be stimulating for him and might help get him out of his depression. He enthusiastically took my advice and became completely immersed in the study of Chinese porcelains. He became a leading collector and ultimately became a leading donor to museums.

Within a few years, Stanley met and married his second wife, Adele, a lovely woman. He and Adele were happily married for over fifteen years, until her death. If you go to the Metropolitan Museum of New York City, at the top of the stairs on the right, you will see a large glass case filled with Chinese porcelain with the sign "The Collection of Adele and Stanley Herzman," the contents of which he donated only a few years before Adele died. Stanley lived to be ninety-six years old, and till his death remained actively involved in buying and donating Chinese porcelains. Throughout the twenty years I worked with him, I went to Stanley's apartment at least once or twice a year to appraise the things he had bought, for insurance or donation purposes. These were magnificent pieces bought in

New York, Hong Kong, or London. I always felt it was a privilege to see and touch these beautiful pieces before they were placed into museum glass cases.

As an aside, I regularly do many appraisals for donation purposes. I have been doing these appraisals for over thirty-five years and have familiarized myself with all the IRS requirements. In fact, the IRS themselves once hired me to challenge a large donation of art and antiques that they felt, and I agreed, had been vastly overappraised. When an appraisal is done for donation purposes, the IRS requires that a qualified appraiser is used and that comparables are given. If the price is over $20,000, an eight-by-ten-inch photo must be submitted as well. (If you would like detailed information about the requirements for charitable donations of artwork, please see chapter 9, "Doing Well by Doing Good—Donations to Charity.")

Jim and Lee on horseback, by P. J. Crook

Stanley was in his eighties and still actively traveling all over the world buying Chinese antiques when he went to an art exhibition displaying works by English artists at the Royal Academy in London. He saw some works by P. J. Crook, an artist who lived in Cheltenham, England, in the Cotswolds. Stanley was so impressed with her work that he called her up and drove over two hours to her home to meet her. His exceptional eye was once again at work, because she is a wonderful artist. He brought about seven of her paintings to the United States, four of which he picked for himself. He then called me and asked me to represent her. With a busy appraisal business, this was not something I really wanted to do, but I couldn't say no to Stanley. He was just so enthusiastic. I had to meet him at his apartment to see the paintings. As soon as I saw P. J.'s work, I fell in love with it. Now, many years later, I am still P. J. Crook's U.S. art representative. I have helped her sell many of her works and have many in my own collection. I have seen her become a well-known artist, shown in some of the top galleries in London, Paris, Japan, and the United States. Stanley Herzman had a great eye for quality. It's too soon to know if his prediction that P. J. Crook would become a world-famous artist will be borne out. But given the good judgment of this astute and generous man, I would expect nothing less. There will be a major show of her work in March 2012. All of my readers are invited to attend.

The Adele and Stanley Herzman permanent collection at
the New York Metropolitan Museum

Memorably Stingy—Let Us Discuss Lettuce

So let's get back to the yin and yang. Candy Bergen, Jim Henson, and Stanley Herzman were all incredibly hospitable. Even the brash rock musician could be called hospitable—he offered to share his bed! (I just didn't take him up on the offer.)

Almost all of my clients have been extremely welcoming. I find that people are at their most relaxed state in their own homes. There is a long tradition, in many cultures and religions, of making a visitor to your home feel welcome. However, there are exceptions to all "rules." Years ago, I was asked to do an appraisal at a twenty-room mansion in the Hamptons for someone who *Forbes* reported had just sold his business for over $75 million. The man had a huge, magnificent estate secured by electric gates. It was the first time I had seen electric gates, and I thought they were impressive. When I drove up to the estate, I had to speak into the speaker box. Suddenly the big, heavy gates opened, as if by magic, and I drove through. Wow, I thought, a real Hollywood-type entrance! The house was completely furnished with eighteenth-century French and English antiques, all very sophisticated, elegant, and expensive pieces. There were floral chintz curtains, chintz-covered sofas, and floral, needlepoint rugs. The house was beautiful, and I enjoyed my work, describing and putting a price on each piece. The husband was polite but informed me that they had no staff that day so he could not offer me lunch. I said that was no problem, as I had brought my own tuna fish sandwich. "Could I just take a little lettuce?" I asked him. He said fine and told me whenever I was ready, to go into the kitchen and help myself.

A while later, he left to deal with some business matters, and his small, raven-haired, attractive, and very intense wife showed up. She was a new wife and seemed very impressed with herself and her riches. Very quickly the atmosphere changed from warm to frosty. Within sixty seconds, she made me feel uncomfortable, as if I were a stable hand who had somehow walked into the mansion by mistake. At one o'clock, I went into the kitchen, put my tuna sandwich

on a plate, opened their refrigerator, and took out some lettuce. Ten minutes later, the wife walked into the kitchen and saw that I had taken approximately four leaves of lettuce. She said, "You've taken *so* much lettuce." I responded, "Your husband told me to help myself, but I'll put it back if you like." "Oh no," she said, "don't bother!" and stormed out of the kitchen in a huff.

That night, when I got home, I told my husband the story, and we couldn't stop laughing about the multimillionaire who was so cheap with her lettuce. He asked if perhaps the lettuce was gold plated. I told him, laughing, that it was just four pieces of ordinary, plain, old green lettuce and that after I took my pieces, there was still plenty left on the large head of lettuce. However, not wanting to have another incident, I packed a substantial salad for my lunch the next day.

Usually, it takes me only one day to appraise the contents of a home. But in a large mansion with twenty rooms packed with antiques and fine art, it can take several days. I returned the next day at ten o'clock in the morning after a two-and-a-half-hour drive from my Westchester office. The wife met me at the door of her home, and before letting me enter, she said, "Do you have your lunch? Otherwise you need to go and get it." Fortunately, I was able to reply that I had everything with me. I held up my little lunch bag and pointed to it, as if it were my key to the "palace" of "her royal highness."

I guess her extreme lack of hospitality could have upset me. I think, though, because it was so petty—about a few pennies' worth of food in a multimillion-dollar estate—that it was a really funny incident. The woman's behavior was so "over the top," it just had to make me laugh. Since this incident, I always take my lunch to an appraisal. I'm happy to say that many of my clients ask me to throw out my lunch and join them for a meal, instead. (I occasionally do join them for lunch but usually don't have the time to spend.) As I said, most clients follow the Biblical tradition of welcoming me into their "tent." This lettuce incident makes me appreciate their warm and genuine hospitality even more.

Memorable Airplane Flight with Mrs. Cyrus Vance

Soon after the lettuce incident, I appeared on a number of radio and television shows discussing how to appraise fine arts. One day I received a call from a secretary calling for her boss. (As I have mentioned before, when the first contact comes from an assistant, it is a good sign. It usually means that the boss is well known or wealthy or both.) In this case, the assistant had seen me on TV, and her boss was Cyrus Vance, who had just been named Secretary of State under President Jimmy Carter. The assistant said that her boss and Mrs. Vance needed an appraiser for all of the fine arts and furnishings in their New York apartment. Since Mr. Vance was a senior official with the government, I needed security clearance, which I shortly received. It was strange to get checked out by the serious-looking security team. Today, after September 11, 2001, security is given high priority, and, unfortunately, we have had to adjust to it. But in the late '70s, all these security precautions were new to me. FBI men were wiring security devices and cameras all over the apartment when I was there.

Although I spoke with Secretary Vance several times, I mostly dealt with his elegant and lovely wife, Grace Vance. Their house was comfortably furnished with good furniture. Since Mrs. Vance was a daughter of John Sloan, of Sloan's department store, she had a real interest in decorating. It was interesting to see all of the plaques and trophies around their home, expressions of thanks to Cyrus Vance for the valuable contributions he had made to various groups and organizations. Obviously, he was a famous man, yet Grace Vance could not have been more down-to-earth.

Over the years, I did numerous appraisals for them and once, a little while after Mr. Vance had left public service, I flew up to Martha's Vineyard with Mrs. Vance on a very little plane to appraise the contents of the home they owned there. I remember asking her while we were waiting on line to get on the small plane, "Mrs. Vance, you were so used to having your own government plane at your disposal, never waiting on lines, always being treated as a VIP.

Does it feel odd to wait on a line now?" She answered, "Of course it was great, to have the treatment you get when you're the wife of the secretary of state, but there are also a lot of benefits to having a private life. I don't miss all the hubbub." I certainly can remember the flight with Mrs. Vance back from Martha's Vineyard to LaGuardia Airport in that same little plane. It was a clear, but very windy, day, and during the flight this small prop plane did everything but turn upside down. I have traveled all over the United States and to more than eighty countries and have flown over a million miles. One of the flights I've been on has to qualify as the worst and so far (and, I hope, forever), this flight was it! Somehow, Mrs. Vance and I managed to keep our cool, but I still get a tight feeling in my stomach whenever I think about it.

Naked

About twenty years ago, I was asked to appraise the contents of a mansion in Connecticut. When I arrived, I drove through an electric gate (by then, I was an old hand at security gates and knew I had to announce myself into the speaker and wait for the gates to open) and was met at the front door of the house by a very big, burly, scary-looking guy who was obviously a security guard. He took me to meet the lady of the house, Mrs. B. She was in her late thirties, about five-foot eight-inches tall, slim, and stunning. The house was decorated in shades of bright red and orange. Clearly a great deal of money had gone into the decor, but it was still pretty awful—it looked gaudy and vulgar and fit for a mafia queen. All around the garden were numerous bronze and marble sculptures, all very romantic and overdone, yet of substantial value. There were marble statues of lovers hugging and little boys playing flutes and large carved fountains with cascading water. They had two gazebos filled with wicker furniture and the chairs and settees in each gazebo were adorned with bright orange or red pillows. Mrs. B. pleasantly said, "I was so worried before you came and was nervous getting everything ready for you." I responded, "Why were you nervous? I'm just here to do an appraisal." She said, "I was afraid you

wouldn't like what we bought; that you would think it was over-done." Well, she was my client and it certainly is not my job to make a client feel bad, so I said, "It's lovely; you did a great job." "Oh," she said, "I'm so glad you think so! We don't have too many visitors, and it's important to me that whoever comes over likes the way I decorated my house."

She took me on a tour of all fifteen rooms in the house, which were filled with crystal, Meissen and Capodimonte porcelain figurines, heavily carved furniture from the late nineteenth century, and late nineteenth-century Spanish and Italian paintings depicting elegant ladies and men in dramatic scenes. As usual, I started in the foyer, describing and measuring each piece and then putting a price on it, and went on from there, room by room. In about an hour, Mrs. B. brought her husband over to meet me. In contrast to Mrs. B.'s beauty, her husband was about five-foot four-inches tall, fat, and about sixty years old. He was a wealthy and friendly guy, and she was obviously a stunning trophy wife. Despite their differences in appearance, they seemed very fond of each other. After we chatted for a few minutes, they left me to continue appraising the fine arts and furniture.

When I was nearly finished with the appraisal, Mrs. B. called me into her bedroom and asked me to appraise her jewelry, which she kept in her dressing room, attached to the master bathroom. Her bathroom was huge, with a large Jacuzzi tub, skylight, and sauna. There was a vanity table in her dressing room where I could set up my equipment to appraise her jewelry. When I appraise jewelry, I need a lot of equipment. This includes such items as a 10x magnifying loupe (a small, round magnifying glass that makes things look ten times larger), two diamond gauges for weighing diamonds, a pearl gauge for measuring pearls, two scales for weighing gold and silver, three diamond color graders for checking diamond colors, and two pearl color graders for checking pearl colors. I also need to have by my side the *Rapaport Price List* (which lists the weekly, wholesale price diamonds are selling for on Forty-Seventh Street), and acid for determining if the gold or silver in an item is real. I

obviously need a large surface on which to place all of this equipment, and Mrs. B. graciously led me to a very comfortable counter in her dressing room. She then handed me about twenty-five boxes filled with exquisite jewelry, all presents her husband had given her. She told me she was going to take a shower and that I should start working.

The first piece I looked at was a very fine Cartier ruby and diamond ring. The 4-carat ruby was Burmese and rich pigeon's blood red, surrounded by diamonds. This strong, rich red color is the best color for a ruby. I appraised the ring for $60,000. There were also diamond rings and necklaces, as well as a beautiful, deep green Colombian emerald ring of more than 10 carats. Emeralds often have a lot of imperfections, but this one had very few. By the time Mrs. B. had finished her shower, I had appraised over $500,000 worth of jewelry, with still a lot left to go. When Mrs. B. got out of the shower (which was in the next room adjacent to the dressing room I was sitting in), I could hear the shower door slam. She then walked into the dressing room stark naked and asked me how the appraisal was coming along. Each time I told her the price of an item, she would say, "Well, this little girl has done really well for herself, she's done really well for herself!" She then proceeded to tell me how she had worked as a junior executive at IBM for a few years and then met her future husband. He had begged her to marry him and told her she would do much better with him than working. With each piece of jewelry I appraised, she kept saying that he had spoken the truth. Although I felt a little uncomfortable with her standing there in the nude, I didn't want to seem like a prude, so I said nothing. She knew she was gorgeous and seemed to enjoy her preening. I acted as if it were an everyday occurrence for me to do an appraisal with my client completely butt naked. Except for that little detail, her behavior was completely normal. At the end of the day, she was back in her clothes, and she and her husband, looking very fondly at each other, bid me goodbye.

After the appraisal was finished, I received a call from the husband. He wanted all of my copies and all of my notes and requested

that I not even keep a Rolodex card with his name and address. He arrived at my office with the same burly, scary guard and requested that I hand over everything about him in my files. He said that he had decided not to insure anything, as he did not want anyone, including insurance agents, to know what he had. Although he was very pleasant and talked very politely, it was clear that he was not merely requesting that I give him all the files and information I had on him. I quickly complied, as I surely was not going to argue with him. I never heard from him or his wife again. I say it's all for the best! Today, I don't even remember his name.

Lou Gehrig's Mitt and Other Collectibles

Recently a number of my clients have been buying very high-priced collectibles like baseball paraphernalia. Many of these items go for incredibly high prices. I did an appraisal for a young couple—the wife was a beautiful, tall, shapely woman of thirty, and her husband was a tall and very handsome thirty-five-year-old hedge fund trader. Some of these young men make many millions a year, and it appeared that this young man must have been doing that. At one of the major auction houses, he had just bought Lou Gehrig's baseball mitt for $450,000, as well as a bunch of World Series rings and several signed baseballs and bats. I asked his wife if she minded that he spent so much money on things in which she likely would have no interest. (I have found that most women do not collect these things.) She told me no; she was very happy for him that he could buy things that he treasured. She also said that ten minutes after he bought the mitt at the auction, someone offered him $500,000, so it was obviously a good investment.

Of course, many of these collectibles continue to increase in value, but there are also collectibles that have not been good investments. The Cloud guitar that Prince played on his "Love Sexy" tour in London was auctioned for £10,000 by Christie's of London in 1993. Seven years later, a similar one sold for £2,100. The value probably fell because of Prince's lack of hit records, reclusiveness, and bad press at that time. Values can fluctuate. The black fedoras

that Michael Jackson would sign and toss into the crowds as part of his concerts would always fetch $1,000 at auction. Then, for a number of years, anyone could purchase them for less than $500. Since his death, and with all the media coverage it generated, they have gone up in value. A glove he wore when he premiered his trademark moonwalk dance in 1983 sold at auction for $420,000.

A drop in prices sometimes occurs in areas of fine arts collecting as well. The economic boom in Japan sent prices soaring for French cameo glass, which was highly sought after by Japanese collectors. In 1990, a mold-blown elephant vase by Emile Gallé sold for $170,000. These antique vases are beautiful and unique, with rich jewel-like colors, and have some of the most innovative glass designs of the twentieth century. However, as the Japanese economy declined, the prices for this area of collectibles followed. The Japanese dropped out of the market and this exact vase, from the same mold, later sold for $50,000. Today, the prices have risen, but not necessarily to their 1998 heights.

Probably the most famous story about a drop in the value of collectibles is from more than three hundred years ago. In the seventeenth century, people in Holland started collecting tulip bulbs. As more and more people collected them, tulips that were an unusual color and perfectly formed hit astronomical prices. One story reports that a black tulip, imported from Turkey, sold for the price of a fine house in Amsterdam—at that time, a bulb was an object that could be purchased only by a very wealthy person. Suddenly, the fad ended, and the prices of tulips went back to that of something you could wear pinned to your blouse or jacket buttonhole rather than the price of something you could live in. Three hundred years have passed and tulips have never returned to their "bubble" prices.

Narrowly Avoiding a $900,000 Mistake

While having dinner with some clients one night at a beautiful Westchester country club, one of them, a former Senator, told my husband and me a story. He said his great grandfather had been a sea captain in the 1870s in the China trade. He went back and forth

to China, returning with highly valuable goods that he would sell in the United States. Apparently, one time he brought back a vase that was from the period during the reign of Chinese Emperor Yung Cheng (1722–1735); the vase had beautiful flowers finely enameled on it. In 1992, it was appraised for $40,000. In 2003, the Senator's wife decided that the vase would make a beautiful lamp. So she sent it to a lamp maker. She told him it was a valuable vase but asked him to drill a hole in it in order to make the lamp. The lamp maker was afraid he would ruin the vase and sent it back to the wife with his apologies, telling her he did not think it would be a good idea to drill. In fact, he was right: drilling a hole would have destroyed most of its value. As soon as they got it back, the couple decided to send a photo of the vase to Sotheby's to see what it was worth. They thought they might get a written response in a few weeks, so were very surprised to have the head of Sotheby's Chinese department on the phone with them in just a few days. He told them that the vase was one of the finest he had seen in a long time. Sotheby's did sell the vase in June 2003 in Hong Kong, where they get the best prices for this type of item. It sold for over $1 million. If it had been drilled into, it would have bought less than one-tenth that price, a $900,000 loss in value! Needless to say, the couple were very happy with the results and thrilled they did not make it into a lamp. I didn't ask them, but I certainly hope they took the lamp maker out to a fabulous dinner.

Artwork and Famous Folks Gather at the National Arts Club

In 1993, my husband Jim and I took a trip to North Carolina to see the art produced there. My friend Jim Moon, a well-known artist living in North Carolina whom I have known for years (and occasionally represented), had been telling me forever to come and see the art in the Blue Ridge Mountains, particularly around the Penland School of Crafts. This school is one of the foremost arts and crafts schools in the country. It has classes in art glass, pottery, leatherwork, painting, weaving, and almost every other form of the arts imaginable. The art glass that is produced there is among the

best in the country. Through Jim Moon, we were able to visit artists and their studios and see the work they were doing. We were so impressed with the high quality of work produced there that as soon as I returned, I went to the National Arts Club, at Fifteen Gramercy Park South (the oldest and most prestigious arts club in America), to which I have belonged for years. I asked its wonderful president, my friend Aldon James, if we could run a show at the club about North Carolina artists. I felt New Yorkers really needed to see the beautiful artwork coming out of North Carolina, and it would be great for North Carolina artists to get the exposure that New York would offer. To get maximum exposure, we decided to have a well-known person act as our honoree, and Terry Sanford, the former governor of North Carolina, graciously complied. We set up our date for November 1993, and I then went into full gear.

We got a list of virtually every artist in North Carolina and wrote about the show to about five hundred of them, asking them to send us five photos of works they would like in the show. Since all of the works would be for sale, we asked the artists to put prices on them. I checked all of the prices to see that they were reasonable. From the photos they sent, I picked about 150 artists whose works I felt were the best. I also flew down to Jim Moon's house in North Carolina with my dear friend and art lover Bonnie Eggena, and we went to the Penland School where I had arranged for about fifty crafts artists to show us their work. From that group, I picked what I considered the best artists and their best works. I had to make a lot of tough decisions, since so much of the work was terrific. The next two days we drove from one small, charming, southern town to the next, many with statues erected in the town square honoring long-dead Civil War leaders. We went to as many as ten glass studios in a day to see and pick work done by the top glass artists.

We finally had chosen enough art for a beautiful show, and for three weeks in November 1993, the works of North Carolina artists were on display for New Yorkers at the National Arts Club. We had a great opening party, with Terry Sanford as our honoree, and the famous author and friend of Jim Moon, Maya Angelou, as the

keynote speaker. Maya Angelou is a well-known singer, dancer, poet, and author. Her autobiography, *I Know Why the Caged Bird Sings*, was widely read, praised, and nominated for a National Book Award. She was nominated for a Pulitzer Prize for her 1971 volume of poetry *Just Give Me a Cool Drink of Water 'Fore I Diiie*. In 1993, she recited her poem "On the Pulse of Morning" at President Bill Clinton's inauguration, the first poet to recite a poem at a U.S. presidential inauguration in more than thirty years; and in February of 2011, President Obama awarded her the Prsidential Medal of Freedom. She mentioned the show at the National Arts Club on several television programs, and her support was very helpful in getting us a great turnout for the event. Many New Yorkers came to our beautiful Arts Club and got a good introduction into the art world in North Carolina. This was the first time I had curated a show of this size. It was exciting, glittering, and exhausting!

Shari Belafonte, Terri Cohen, Lee, and guest

At the end of this show, Maya Angelou asked me if I would curate a show by living African-American artists at the National Arts Club. Of course, I was delighted to comply and so was the president, Aldon James, whose able assistance ultimately made both shows—the one on North Carolina artists and the one on African-American artists—possible. This time I also got a list of artists—all of the best-known, living African-American artists in the U.S.—and wrote to them that in November 1994 I would be curating a show on African-American art, honoring Maya Angelou. The name Maya Angelou as well as the name of the National Arts Club seemed to work wonders, because virtually every artist responded by sending pictures of their works.

We had works by the famous and then-living artist Jacob Lawrence, as well as by lesser-known artists; all together, we had over 150 pieces in the show. Just like I did for the North Carolina show, I picked the art from photos and checked the prices to see that they were reasonable. Along with Jo Frappola, the superb head cook and manager at the Club, I selected a fabulous dinner with a choice of stuffed squab or salmon, and a miniature chocolate piano filled with strawberry mousse for dessert.

Lee with Oprah Winfrey

Many famous people attended the show. Rolanda Watts was our master of ceremonies and was a beautiful and exciting speaker. Ruby Dee and Shari Belafonte, two well-known and talented women, came to make toasts honoring Maya. Maya's friend Oprah Winfrey attended the dinner as well. Maya, as always, spoke powerfully, and the room of five hundred people absolutely glittered. Many of the African-American men and women who came to the opening dinner celebration, instead of wearing black tie or gowns, dressed

Lee with Maya Angelou

in fabulous floor-length caftans and dashikis, looking regal and elegant. I had the privilege of walking with Oprah around the show, reviewing with her the art pieces she was interested in buying. My daughter, Terri Cohen, a New York City public school teacher, joined us, taking the opportunity to meet and talk with Oprah. Oprah said the nicest thing when she met Terri: "Oh, you're a teacher of elementary school children— that's the most important job in the

world … much more important than my job." Of course, my daughter positively glowed. The kindness, humility, and love of education coming from this world-famous person moved me so that I will never forget it. She is tops in my book! Oprah found a few paintings to buy, and the artists she selected were very happy to have their works added to the collection of Oprah Winfrey. We had some nice press on this show, and it was a great success.

Because of the show, Maya Angelou invited my husband Jim and me to her home in Winston-Salem, North Carolina, for a weekend and threw a big party in our honor, with over one hundred guests. She invited some fascinating people, and we received numerous toasts, several by African-American ministers who, over generations, have perfected the art of public speaking. Maya, of course, had been the Poet Laureate of the United States, so the toasts and welcoming speeches were beautiful; really poetry and songs without music! My husband and I were very affected by the welcome we were given. My response to their speeches, however heartfelt, could not compare to theirs. I have been on a bunch of TV shows and I am considered to be a pretty good speaker. But in this case, I was truly out of my league! There were all sorts of interesting people there—an interesting mix of white and black artists, politicians, and academics. (Maya, an accomplished poet and author, was also a professor at Wake Forrest University.) Senator Carol Moseley Braun from Chicago was also in attendance. At the end of the evening, my husband (who was a singer before he became a lawyer), the Senator, and Maya, each with a scotch in hand, ended up in Maya Angelou's kitchen at one o'clock in the morning, singing jazz songs!

The Cairo Palace with Anwar Sadat

A number of years ago, my husband and I traveled to Egypt to visit the marvelous museums, pyramids, tombs, and temples for which Egypt is so justly famous. It was a fabulous trip.

At this time, I was writing a weekly column on antiques and art in the U.S. and abroad for the *Gannett* Chain newspapers and had a letter from the editor describing my column and requesting that I be granted press privileges and courtesies.

We had been in Cairo for a few days, traveling with our friends Susan and Sam Cooper, and had a private, highly knowledgeable guide who had a master's degree in antiquities taking us around to the sites in Cairo.

I woke up on the third day we were there and decided that I would really love to meet the then Prime Minister of Egypt, Anwar Sadat, and interview him for my newspaper column. Sadat, known throughout the world as a great man, had just won the Nobel Peace Prize. It was one of those crazy ideas that just came up, but the more I thought about the idea, the more I wanted to give it a try. My husband was already dressed in blue jeans and white sneakers, but I put on a more business-like skirt and jacket, and we went downstairs to meet our guide in front of the hotel. My husband, as well as the Coopers, thought I would not have a chance at getting into the palace, but our guide said that Sadat liked meeting foreign journalists and she was willing to try to help me. We drove to the palace, which was in the center of the city, and our guide showed the guards my press letter. They read it, opened the gates, and let Jim and me through, with our guide as translator. From this point on, we went to four different rooms, where government officials questioned us as to our intent. They were all extremely polite and did not seem fazed by Jim's jeans and sneakers. We walked through long, marble halls with dangling crystal chandeliers until finally we passed the last examination and entered the Grand Salon, the room in front of Sadat's office. There we found a charming man, Sadat's personal secretary, who spoke semi-fluent English and fluent French. As I am fluent in French, we conversed in French.

The room was sensational: decorated with heavily gilded, Louis XV style chairs and tables with cabriole legs and scrolling arms. The furniture was all nineteenth-century French with carved flowers and rosettes on the frames. There were large, gilded mirrors and fine Egyptian and Persian Oriental rugs with floral designs in pink, blue, and green.

I explained to the secretary that I wrote for the *Gannett* Chain newspapers' Westchester section, which had about 300,000 readers.

I also said, since I was thrilled with the collection of antiques in the Cairo Museum, the pyramids at Gaza, and the antiques for sale at the Grand Bazaar, that I would be writing a complimentary article for my paper about Egyptian travel (which I later did). I told him that I thought if I could also say that I met with the Prime Minister, it would definitely make the story more interesting. We had a lovely chat; Jim told him he was a lawyer, and after about ten minutes conversing with us, the secretary said, "Tres bien, the Prime Minister would be happy to meet you. Let's set up a date."

He then told us the time slots that were available for us in the next week. Unfortunately, we would not be in Cairo during those times, so we were not able to make a date to meet. It was so frustrating to be in the outer room, where only a door separated us from the Prime Minister. Nevertheless, we were honored and thrilled at how far we had come. After all, I thought, how many Westchester, New York, journalists and their husbands can get into the inner sanctum of the Egyptian Prime Minister's palace with no advance planning? It was an exciting morning even though we didn't get to the "pot of gold." Tragically, Sadat was assassinated shortly thereafter, and the peace in the Middle East he had hoped for to this date has not been achieved.

Warner LeRoy, Maxwell's Plum and Tavern on the Green

In 1973, I was friendly with a woman named Linda Janklow, whose brother, the late Warner LeRoy, owned Maxwell's Plum, a famous New York City restaurant. They invited me to have lunch with them in that restaurant, and what a treat it was. Warner was so friendly, funny, and generous—truly an outgoing person; so full of life. The whole time we had lunch, the waiters flocked around us, giving the best service imaginable. If Warner saw something that he wanted changed or ate some food that was not perfect, like an overcooked omelet, he called the waiters over to tell them immediately. However, as he did so with such a pleasant manner, nobody minded.

The restaurant was dazzling; filled with fabulous, stained-glass windows and chandeliers. Warner told me about how he painstakingly put

together the magnificent, jewel-like stained-glass ceiling under which we sat and described many of the other antiques and decorations that were in that gorgeous, colorful interior. When he moved to Tavern on the Green in 1976, he took all of those antiques and objects, including the ceiling, with him and continued to add more. Tavern on the Green was an eye dazzler, filled with hundreds of antiques and objects, which over twenty million people visited since its opening. Sadly, on January 13, 2010, by order of the creditors, all of these items were sold by Guernsey's auction house.

It made me, as well as all New Yorkers, sad to know that this once-great restaurant, with its incredible collection of art, antiques, and kitschy decorations, would exist no more.

Senator Joseph I. Lieberman

My husband, Jim Cohen, and I felt privileged to be invited to the Senate and the Senate dining room by Senator Joe Lieberman. The purpose of the visit was to introduce our friend, and Governor of Puerto Rico, Luis Fortuño, and the Resident Commissioner, Pedro Pierluisi (the sole representative to the U.S. Congress from Puerto Rico), to Senator Lieberman. Luis and Pedro both admired Joe Lieberman and thought they and Joe Lieberman could help each other. So with the help of Joe's wonderful, longtime chief of staff, Clarine Nardi Riddle, we arranged the date for a meeting.

When we arrived at Joe's office, he was on the Senate floor arguing an important bill for Homeland Security. (Senator Lieberman is chairman of the Homeland Security Committee.) We were assigned a knowledgeable and charming young man to give us a guided tour of the sculpture, paintings, and furnishings in the Capitol

Lee with Senator Lieberman

building. In the Capitol, there is an incredibly wonderful collection of artwork including, in the spectacular rotunda, famous murals by Chapman, Weir, Powell, Vanderlyn, and Trumbull depicting the development of the U.S. as a nation. It was very exciting having this

Senator Joe Lieberman, Jim, and Luis Fortuno (governor of Puerto Rico) in the Senate dining room

private tour, and I later volunteered my services to do a pro bono (that is, without charge) appraisal of everything in the Senate. Senator Lieberman sent my offer to the curator's department, but since the government self-insures its art and antique collection, they did not need an appraisal. That's too bad! I would have loved the "job." Their curators have, of course, described and inventoried everything in the Senate already, so unfortunately they didn't need my services.

We later sat in the visitors' balcony, above the Senate floor, watching Joe brilliantly discuss the issues for that day. I thought the yellow tie he was wearing was particularly beautiful and wanted, somehow, to tell him. Of course, there was no way to communicate with him from the balcony. As it happens, my husband is good at making paper airplanes. I wanted my husband to make a paper airplane with the words "Great tie, Joe" written on it and sail it down to his desk. We actually talked to each other about doing it, but decided that it would have run the risk of getting us shot as terrorists by the Secret Service men. It gave us a giggle even thinking about it. Later, at lunch, we told the Senator that we thought his tie was stunning and that we almost sent a paper airplane down from the balcony to tell him so. He told

us he appreciated the compliment and, in his typically charming way, smiled, and told us what a very good idea it was that we had decided not to get into our own little paper airplane business.

On a more serious note, we discussed issues of common concern to Puerto Rico and the U.S. Government, such as Puerto Rico becoming the 51st state, while we enjoyed the delicious meal of red snapper in a sweet-and-sour sauce with chunks of pineapple. Apparently, the focus of the food served in the Senate dining room changes monthly on a fifty-state cycle to emphasize a particular state, and every month they place the seal of that particular state on each table. It was the month when Hawaiian food was the focus, and there was a big, impressive circular medallion on the table with Hawaii's insignia.

Governor Fortuño and Resident Commissioner Pierluisi were delighted to get to know Senator Lieberman and he to know them. As Luis Fortuño is spectacularly handsome and charming—like a movie star—all the women in the dining room, including various female Senators, came over to meet him. It was a lot of fun; we certainly had a historic day seeing the great art in the Capitol and meeting men and women whose decisions affect the world.

Luis and Lucé Fortuño Maxwell's

In November 2009, Governor, Luis Fortuño and his lovely wife, Lucé Vela, invited Jim and me to have lunch in the Governor's mansion in Old San Juan. Since we had arranged the lunch for him with Senator Lieberman, he generously wanted to return the favor. This was a real thrill for us, as at the time, Luis and Lucé lived in La Fortaleza (The Fortress), the oldest government building in continuous use in the Northern Hemisphere, built in the 1600s. La Fortaleza is a magnificent palace, painted in sky blue and white. It has white pilasters on

Luis and Lucé Fortuño, and Lee and Jim

Lee at La Fortaleza

the outside and high up in the middle, and all along the front of the building it has a narrow balustrade with a wrought-iron grill. The governor and his wife stood there in front of the crowds during his inauguration on January 4, 2009, and actually danced a salsa to the accompaniment of a mariachi band led by Fernando Allende, a leading South American singer, actor, and good friend of ours.

After crossing the cobble-stone street, we arrived in front of the tall, impressive wrought-iron gates and gave our name to the security guards. They opened the gates to let us in. We were escorted up the stairs by a uniformed guard, walked past the carved and gilded plaque depicting the Coat of Arms of Puerto Rico, and were escorted into a private dining room where there was a comfortable couch, rug and chairs. In this room, there were a few fine, gilt wood-framed oil paintings by well-known Puerto Rican artists, lent by various museums, depicting very fine landscape views of Puerto Rico. The room looked over the harbor, with a magnificent view of the seventeenth-century guardhouse, formal gardens, and ships at dock.

When Luis and Lucé joined us, we had a wonderful meal of chicken breast stuffed with vegetables, pepper coulis, and cassava mojo and strawberry cheesecake. There was a printed menu, which, following a local tradition, the four of us signed as a memento.

Coat of Arms of Puerto Rico

During the meal, Jim asked Luis if there were any ways he could be helpful to Puerto Rico, and he and Luis discussed this topic in some detail. Afterwards, the excellent Fortaleza tour guide, Irmalisse Vega, gave us a tour of the entire mansion. There was a Sevres porcelain vase painted with eighteenth-century figures, which Irmalisse wanted to learn more about. I told her it was definitely a nineteenth-century piece. Then we took off the cover and discovered the signature of J. Pascault along with the Sevres mark of interlaced blue "L's." I later sent her some information on J. Pascault. He painted vases from 1850–1875 and, in fact, a vase by him that was very similar to the vase in the Fortaleza sold at auction very recently. To top off the day, Irmalisse showed us the intricately carved nineteenth-century mahogany four-poster bed that President Kennedy slept in during the '60s, as well as the kitchen used during the sixteenth through the eighteenth centuries. It was an honor and privilege to have lunch with the Governor and Lucé. Jim and I really appreciate their hospitality.

Kitty Carlisle Hart

One day I was asked to appraise the contents of Kitty Carlisle Hart's apartment for insurance purposes. The great lady was ninety-six years old and had not been well. I had a little bit of history with her. Years before, I had been on the TV show *What's My Line?* Kitty was the only panelist who figured out that the person being described was me. When the real Lee Drexler, fine arts appraiser, was asked to stand up, Kitty Carlisle had it right. Seeing her this time, years after the TV show, I noticed a big change in her, as she was now very old and frail. Still, she greeted me warmly and spent a little time asking me some questions about my appraisal work. Her apartment was large and cluttered. Like most elderly widows, she had changed hardly anything in years. Because of her great fame, she had received many awards over her lifetime. Her apartment was completely filled with vases, bowls, plaques, and all types of trophies heralding the excellent work she had done as an actress and leader of various arts councils. About a year later, in April 2007, I was saddened to hear she had passed away.

Russian Tea Room

In 2007, I was asked to conduct an appraisal of the beautiful art collection at the Russian Tea Room for insurance purposes. This wonderful, old restaurant had been closed for a few years and had reopened in 2007 after being completely refurbished, but still retaining its old-world charm. There are literally hundreds of beautiful, late-nineteenth- and early-twentieth-century paintings in the restaurant and over thirty late-nineteenth-century brass and copper samovars (a Russian metal container for hot tea). The restaurant has magnificent mirrors and three huge, gilt bronze chandeliers molded with charming, standing bronze bears all over them—custom-made many years ago just for the Russian Tea Room.

Above the main restaurant are large rooms especially used for private parties. In one of the rooms, there is a twelve-foot-tall, hand-carved, Lucite sculpture of a bear juggling three brass balls. The inside of the bear, which is hollow, is, in fact, an aquarium filled with goldfish. It's amazing! In another private room, there is a very detailed diorama of a Moscow winter scene, complete with moving figures and snow—a unique and fun piece of art. Hasan Biberaj, the owner of the Russian Tea Room, graciously insisted that I stay for lunch. I had blinis with sour cream and caviar to start and the entrée was beef stroganoff. It was fabulous. Of course I was offered vodka, but as I never drink during the day, I refused. I am delighted to say that the restaurant is a huge success in its latest incarnation, and I have returned to eat there many times.

Opera Star Luciano Pavarotti

Soon after the great opera singer Luciano Pavarotti died, I was asked to appraise his personal property in his New York City apartment on Central Park South for estate purposes by Bruce Trauner, the lawyer handling the estate. I have worked for Bruce for many years and always am happy to hear from him. Pavarotti had used this apartment as a pied-a-terre, as his main homes were elsewhere.

The apartment was very simply furnished, but all over were photos and personal mementos and awards given to Pavarotti. I saw his

signature black shirt hanging in a closet. There were touching family photos of him with his beautiful little daughter and pretty wife, and of him riding a horse down Fifth Avenue. It was sad walking around, thinking of the great man whose life had ended when he was still full of life and love. When I got home, I hugged my husband Jim and thanked God for our good health.

Dr. Ruth and Her Philosophy of "Turtle-ism"

Dr. Ruth Westheimer, a dear friend of Jim's and mine, loves turtles and has a collection of forty-seven of them made out of metal, porcelain, wood, alabaster, onyx, mother-of-pearl, glass, and gold; they vary in length from one to twelve inches. The turtles each have their own charming personalities. The ones she likes best are turtles with babies because they represent families and family values. (Of course, the turtle her grandson made from Play-Doh is her favorite!)

Dr. Ruth loves turtles because they represent one of her philosophies of life: that a turtle feels safe and protected in its house—which it carries on its back—when it stays in one place. However, if the turtle wants to get anywhere, it needs to stick its head and neck out and take a risk. If it sticks its neck out too far, it risks getting its head cut off. But if it doesn't stick its neck out from time to time, it won't go anywhere and is like a stone in the road. Dr. Ruth, a family psychologist, took a big risk herself more than thirty years ago, when she started speaking on the radio about sex. She stuck her neck out, but it worked out well for her audience and for her.

Dr. Ruth with Lee and Jim

The turtles are also a link to her past that she lost when she became an orphan during World War II. Growing up in pre-war Germany in the 1930s, she used to have a few celluloid dolls. These dolls had the trademark of a turtle on them and had the trade name Schildkröte stamped on them. On January 5, 1939, when she was ten, she had one of those dolls with her when she was put on a Kindertransport to Switzerland, never to see her parents again. She loved the doll because to her it represented home. Then Ruth noticed that there was another little girl on the train, crying very hard because she had no doll. Ruth gave the little girl her precious doll. So for philosophical reasons, and a feeling of connection to her original home, Dr. Ruth loves turtles and collecting miniature turtles. And, of course, she will never eat turtle soup!

She got her most valuable turtle over ten years ago. It is a rare, Cartier 18-carat, one-inch long, yellow-gold turtle engraved with her initials, "RKW," which she uses as a letter seal. This turtle/seal is set with many tiny diamonds with one bright-green emerald bead at the top and with tiny emerald eyes. The turtle sits on a base mounted with mother-of-pearl, diamonds, and coral. It is very beautiful and quite unusual, and Ruth is delighted to own it.

5. Unusual Appraisals

Since I have been appraising for more than thirty-five years, it is not surprising that from time to time I have appraised some really unusual items and collections.

Crystals at a High Price

Over fifteen years ago, I conducted an appraisal of the sculpture and fine arts in an Indian ashram in upstate Connecticut. The ashram had taken over an existing building and turned it into a religious center, where Americans from all over the country came to meditate and study a form of Hinduism under the guidance of one particular guru. When I arrived, I went through a big, arched gate and then entered the property. Stone and marble statues that were carved in India representing various Hindu gods were everywhere. These were new statues, brought over to adorn the grounds of the ashram. Many of the statues were life size, representing the principal gods in the Hindu pantheon—Shiva, Vishnu, and Brahma. They had all been carved for the ashram in the last five years and had the look of most new Indian religious sculpture—rather stiff, with little emotion or life. However, as they were large and competently carved, they were still of substantial value. I was there to appraise them for insurance purposes, in case they were ever destroyed or stolen.

As I walked around the grounds, I saw mostly women who appeared to be American, cleaning the floors with mops and

brooms or on their knees scrubbing away. They had come to the ashram to learn the religion and, it seemed to me, that in order to earn their keep or to learn humility, they had to clean the place. When they saw me walk past, dressed in a business suit, reminding them of the former life they had led, they turned their heads away from me. I have often wondered if they felt embarrassed to be scrubbing the floor, or if they were taught to look away from any forbidden aspect of the modern world.

After I appraised the collection of sculptures, the administrator took me into a small, inner room to view their collection of crystal rocks. They had beautiful, huge crystal geodes from a shop in a top New York hotel, for which they had paid over $250,000. I checked with various sources and found that this shop was the most expensive in New York that carried geodes; there were others where you could buy geodes for half to one-third the price. The ashram had gone to the fanciest place and paid a very high asking price without checking around.

While I was standing in the room with the head administrator, he said, "Don't you feel the movement of the crystals? Can't you just feel them shaking and quivering with their intense energy?" As I didn't want to offend him, I said, "Oh, yes, I can feel the energy." In truth, the only thing I could feel was quaking and shuddering at the thought of all the money they had misspent on these crystals when they could have bought them for at least $100,000 less. I did not say anything until I had done my research and consulted with a few specialists in this area. But when I told him my findings, the administrator was not happy to hear his purchases were not going to be of financial benefit to the ashram. To this day, you can still buy those crystals at a number of shops for a fraction of the cost the ashram paid for them.

Ancient Glass Ruined

It is amazing how many times my clients have shown me once-valuable items that they've ruined because of some harebrained idea they had and acted on. I once appraised a collection of ancient

glass, which is partly valued for its iridescence. The iridescence, which gives the glass its beauty, comes from being buried in tombs for over two thousand years. The more iridescent the colors in the glass, the more valuable it is. My client, a woman in her fifties, decided to clean up all the ancient glass bowls and vases she had—about twenty of them. Using a scouring pad, she was able to remove all the iridescent colors, as well as the encrusted dirt that was a result of its being buried in tombs for so many years. With this cleaning, she caused the glass to become completely colorless and the bowls virtually worthless. When she asked me if she had done a stupid thing, it took all my self-control to keep from telling her that "stupid" was a word not nearly strong enough to describe her actions.

Given her question, it was incredible to me that she could have acted first and asked after. It was certainly "surprising" that she used a scouring pad to clean the bowls and vases without first checking with an expert. I tried to soften the blow, but there really is no easy way to tell someone that in one simple act, she had turned about $50,000 worth of beautiful artwork into about $1,500 worth of ordinary stuff. I really felt terrible to have to give her this news.

Say No to Poison

I've been asked to do some unusual appraisals over the more than thirty-five years I've been in business. I think one in particular is the winner of the oddball award. Someone asked me to do an appraisal of one hundred bottles filled with various poisons. I turned the job down, both because I have no expertise in poisons, and because it sounded just too strange—and potentially dangerous.

Funeral Home Appraisal

I did an appraisal of the contents of a funeral home that contained a lot of antiques. However, the nineteenth-century Victorian furniture, marble statues, and floral-decorated French vases were all in a room where they had laid out the corpse of an old woman whose wake was to be that evening. I had to do an appraisal all around her.

It was so weird. I asked the funeral director, "Do I have to be in that room all alone with her?" He and his assistant laughed hysterically. "Don't worry; she won't do anything to bother you." Of course, they were right, but I kept imagining her ghost stalking me around the room, and it made it extremely hard to concentrate on the appraisal!

Houdini's Magic

For insurance purposes, I appraised Houdini's Water Cell Torture Chamber, formerly displayed in the Houdini Museum in Texas. The Torture Chamber was actually the metal cage that had been part of Houdini's magic act—he was locked in it, dropped into deep water, and then each time miraculously escaped. Since a fundamental tenet in appraising is to find the sale price of a comparable item, with a unique (one of a kind) item of this type, appraising it requires a lot of research and analysis. Of course, if an item is truly unique, you can never find an exactly similar item that was previously sold. But there is a market for important icons, and with experience one can get a good sense of what a particular item is worth, depending most importantly on the fame or notoriety of the object and/or its previous owner. I valued the Torture Chamber at a considerable price and it was promptly insured at this value.

Houdini's water cell torture chamber. *Library of Congress*

I found something else spooky about the Water Cell Torture Chamber. As soon as I walked into the Leo Baeck Institute where it was displayed, I had the strangest sense that I had been there before. It turns out that the Torture Chamber was being displayed in the same building where, five years earlier, I had conducted another unusual appraisal—for all of Helen Keller's personal memorabilia. That collection belonged to the Helen Keller Museum. However, Helen Keller's memorabilia

had been moved elsewhere before Mr. Houdini's cage and other memorabilia had moved in. In some respects, the two appraisals were similar, since most of the items were ordinary items that got their value because an incredible person had owned them. Although I was surprised to have done two similar appraisals in the same locale, five years apart, I decided it was the spirit of the Great Houdini that had caused an unusual appraisal to happen twice in the same locale.

Rock 'n Roll Appraisal

For an appraisal that "really rocked," I was asked to do a donation appraisal of a collection (lovingly put together over many years) of 4,500 rock-and-roll records, so the owner could perpetuate his collection and get an income tax deduction by donating it to the Rutgers Rock and Roll Collection.

There is a well-established market in used rock-and-roll records, so the only difficulty in appraising the collection was the sheer quantity of it. It was a nice tour of the '60s. It's great to have a locale for people to come and hear virtually every rock-and-roll song ever produced.

Fun with Pistol-Packing DEA Guys

An appraisal I had fun doing was for the Drug Enforcement Agency (DEA). They had confiscated a huge collection of early-twentieth-century Swedish porcelain brought into the United States by an antique dealer. They thought he was doing money laundering and hiding drugs in the porcelain bowls and covered jars, and so they confiscated all of them. I didn't get to know the details of the case and how it ended, but there were literally hundreds of pieces of fine Swedish porcelain, mostly green with a small silver design called Gustavsberg Argenta, some Gallé vases, and small Tiffany lamps, all located in a few self-storage units. I had these young, pistol-packing, DEA guys driving me around in crummy, unmarked cars, and I felt like I was doing film noir in the rough-and-tumble world of police and DEA agents. They told me exciting stories about going

on raids and catching the bad guys, and I had a lot of fun hearing about the lives of drug enforcement men. They were all nice men with families, doing a really tough job, and I enjoyed the day I spent with them.

Caviar and Vodka

A number of years ago, I was contacted by someone who said he was a Russian official. He said he was one of the financial ministers of Armenia. He said I had been recommended to him by some personal contacts, and he had important business he wanted to do with me. He was interested in selling some valuable paintings and wanted my advice. He invited me to go to Petrossian's, a fine Russian restaurant for lunch, where we would talk. It was an incredible meal. For the first course, he ordered for each of us the Petrossian special, three ounces of the best Beluga caviar served with chopped onion, chopped egg, and warm toast, priced at $175 a person. The toast was cut in triangles with the crust removed and waiters constantly were bringing fresh toast so that it stayed warm. Each time they brought the toast, he handed them a tip of $20 or $50, so we had a bevy of waiters around us at all times. The main course, an excellent fish platter, was only $30.

After the hors d'oeuvres, which I finished completely (knowing that I would probably never have a first course like this again), we got down to business. He said he could get late-nineteenth-century and early-twentieth-century paintings by any artist I would specify in order to sell them in the United States. He said these paintings had been kept hidden in Russia since 1917, the year of the Russian Revolution, and now he was able to get them out and have them sold. He insisted they were all legitimate; he just needed someone to then help sell them. He asked me to write down a list of desirable artists, and he said that he would have no problem obtaining paintings by whoever was on the list. He also wanted me to help find a gallery for him in New York where he could sell works by modern Russian artists. We agreed to meet the next week. I was to bring a

list of the artists I knew could sell easily and have some locations where he could set up his gallery to sell modern Russian art.

When we met, I gave him my list of artists, but I also gave him a copy of the *IFAR Journal*, published by the International Forensic Art Research. This marvelous organization is focused upon art research and, among other things, researches paintings to see if they are the real thing or reproductions. It also has a huge, worldwide database that identifies stolen artwork or antiques, going back many years. I told my Russian client that I wouldn't sell anything for him until I checked with IFAR first to verify that the object was not stolen. I also made it clear that I would be extremely careful to obtain a provenance for each piece and not help sell anything that I was not sure was authentic. This client left so fast after I discussed using IFAR that it was almost as if I had seen a mirage in the desert. Happily, I never heard from him again. I believe he was surprised that the caviar or the enormous potential profit did not seduce me. I've had a number of "opportunities" to participate in illegal schemes and, as far as I am concerned, I am just as likely to join Al Qaeda.

Console Tables in London

I had worked for Merrill Lynch for many years doing appraisals of their antiques and elegant, modern, office furniture. Over ten years ago, they were about to move to the World Financial Center and called me in to help inventory and appraise everything they had of value. Merrill had hired a highly qualified, New York architectural and design firm, which did a beautiful job designing the space. The design firm was also working on the design of a very long hall. They needed several really long, Oriental rugs to place down the hall that would fit against the walls. I recommended a top rug dealer I knew, and they picked three long, Persian, early twentieth-century corridor rugs that worked together perfectly. The designers knew exactly what type of console tables they wanted for the hall—antique Regency mahogany tables that would fit snugly against the wall so the tables would not obstruct traffic as people walked along the

hall. They wanted a pair of tables, however, and had no luck find-ing them in New York. As they knew I was going to England, they asked me to keep my eyes open to see if I could find an antique pair.

The first day I got to London, I went to a favorite antique shop of mine on Kensington Church Street. I walked into the shop and there, in front of me, as if by magic, was a pair of beautiful Regency console tables (circa 1810) with two tiers resting on carved paw feet. They had ebony string inlaid on the border and were exactly the right size, eight foot long by twenty-eight inches deep. When I asked the price, I was delighted to find out the console tables were being offered at a reasonable cost. I asked the shop owner for a photo with dimensions and also to hold the pair for ten days. He agreed. I immediately sent the photo off to the interior design team working for Merrill. They loved the pair of console tables, contacted the gallery, and arranged to have them sent to the States. The tables looked really beautiful when they were displayed in the long hall on the executive floor. Later the rugs and table were featured in a large magazine article about Merrill Lynch in *Architectural Digest*. I felt very proud to see the photos, even though my name was not mentioned, only the name of the design firm. I had been an interior designer for a while before I became an appraiser. I much prefer appraising, but I find an occasional art-consultant project like this one to be really enjoyable.

6. Unholy Matrimony: Divorce Appraisals

I do a great many appraisals for divorce purposes, probably more than any other New York appraiser. Many people put a lot of meaning into the things they own, and in a divorce the division of the stuff becomes a powerful metaphor for the split-up of the relationship, with lots of attendant emotion and drama. Some of the worst human behavior I have ever experienced has been, not surprisingly, in connection with these divorce appraisals.

I have been appointed by justices of the New York Supreme Court and hired by many of the top New York divorce attorneys to do these appraisals. I do two types of divorce appraisals: one is a neutral appraisal, in which I work for both parties; and the other is an appraisal for either the wife or husband, in which I am on one side or the other. I feel so sorry for people going through a divorce. They are all so unhappy. For many, it is a grieving process just as if someone had died. Only it's worse than a death, because the divorcing or divorced spouse is usually around to remind you of the loss. Having been fortunate enough to be happily married for more than forty-five years, I understand what these people are missing, and I sympathize with them completely. Many are very uptight about my coming into their homes and examining their things. I try my best to be very understanding and to make the appraisal process as easy and comfortable as I can for them. Usually when I leave, most of my clients thank me for making the process easier than they expected it would be.

Fabulous Finds

When a couple is getting divorced, their "marital property" (a complicated legal concept, different under the laws of each state, but, basically, the assets a couple acquired during their marriage) gets divided as the spouses agree, if they can; otherwise, as a court directs. The starting point for the division is what the assets are worth. At that point, they call me in to appraise the property at "fair market value," which means what it would really sell for, not in a forced liquidation, and when both buyer and seller know everything relevant about the item. Sometimes the spouses are still living in the same residence (usually in separate parts of the house) and the items I need to appraise are there. Often they are living in separate residences, and each one has marital property that needs to be appraised.

One of the first divorce appraisals I did early in my career was in Long Island for an Iraqi surgeon and his Russian wife. The doctor was my client, and he started showing me items of value in the house. He had not told his wife I was coming, and she was understandably very upset. Two minutes after I started looking at her silver, she started hitting her husband, striking him on his hands, which is obviously not good for a surgeon. I, perhaps foolishly, got between the two of them and separated them. I explained to her that the appraisal I was doing was required by law and, after a while, calmed her down. The hatred between them was intense, like an electrical short circuit. Their little five-year-old daughter was watching everything that transpired. She was so sad; it was truly upsetting to see the little girl watching her parents.

The husband took me aside and told me his wife had broken his hands twice, but if he touched her in anger, her three Russian brothers would kill him. "She killed our two-year-old son six months ago!" he added. I was terribly shocked to hear this, but the wife then joined us. She said, "I assume you know our son died. That's when all of our problems started. I was standing in front of the house, which was on a main highway, putting our daughter on the nursery school bus, and I turned my back for one minute. My little boy ran out on the street and was killed." This was such a

tragedy. Unfortunately, the husband refused to forgive his wife, who was still, six months later, completely grief stricken and full of guilt.

The surgeon showed me his sterling silver flatware service, which he had bought in Iraq. Strangely enough, half of the service (all the teaspoons and salad forks) were silver-plated while the rest was sterling. Sterling silver is 92.5 percent pure silver. Silver plate is simply copper or brass dipped in silver and, unless antique, of very little value. I used my acid and performed "the acid test" (the acid fizzes when it contacts silver plate, but does not react to sterling) so there was no mistake. The Iraqi doctor seemed much more upset about being cheated on twelve forks and spoons than by his wife's terrible grief. I, of course, could say nothing. Seriously, it was no fun and perhaps even dangerous dealing with this bereaved and violent woman and her unfeeling husband.

I have never again gone on a divorce appraisal when the two parties were present without bringing along a third person to act as a referee. Of course, I try very hard to have only one of the two parties present at one time, if at all possible, thereby removing that terrible friction. I just don't want to have to separate two people who are fighting ever again. In fact, when I am doing divorce appraisals, if the two parties get too nasty, I turn and say, "Now children (even if they are in their sixties), you will have to behave and be polite to each other as long as I'm here. When I leave, you can call each other every name in the book and do whatever you want, but while I'm here, I expect a certain level of decency. If you're not willing to comply with that, I'm leaving." As they pay me in advance for divorce appraisals, this has always been effective, and my clients have always calmed down immediately.

A judge appointed me to do an appraisal for two lawyers getting divorced. I first went to the husband's new apartment, to which he had moved after the separation. He had rather ordinary furniture and furnishings, which for divorce purposes were worth close to nothing. (For divorce purposes, as I previously mentioned, the appraiser must value all personal property at "fair market value.") I usually use auction value for the better pieces and tag-sale prices

for the less valuable ones. In this case, all of his furniture was tag-sale quality. The couches ranged in value from $100 to $300 apiece as they were over five years old and stained. Everything else was of minimal value, with the exception of one beautiful, late-eighteenth-century English mahogany partners' desk, at which two people could work, one on each side of it. This desk had a beautifully tooled, bright-green leather top and one long drawer flanked by four paneled drawers on each side. It was a lovely piece of furniture, which I appraised for $20,000. As I was appraising the desk, the husband said, "My wife and I worked together at this desk for many years. She studied to be a lawyer at this desk and passed her bar exam one year ago. Now she's got a very good job in a top Wall Street law firm. The firm she works at is even bigger than the firm I work at." I replied, "It seems like you really admire your wife." "I do," he said, "I wish I wasn't going through all this. She's a wonderful woman." I answered, "If you feel that way, can't you stop this process and try to get back together?" "No," he said, "It's gone on too long; too many bitter things have happened. I served her with divorce papers around the time she was taking the bar exam, and she won't forgive me." He seemed so sorry, I really felt bad for him. He was charming and good-looking, and I had trouble figuring out why his wife would not forgive him.

The next day, I went to do an appraisal of the wife's property and found out the *real* story from her. Apparently, he had been fooling around for years, and she finally had had enough. When she asked him to leave, he decided to do what he could to hurt her the most: On the day of her bar exam, he had a process server come and serve her with divorce papers on the steps of the examination center, a mere thirty minutes before she took her exam. "Of course," she said, "he thought this would shake me up enough so that I would fail the exam. I wouldn't let him do this to me, so I tried the hardest I have ever tried in any exam in my life and passed! But I can never forgive him for this. There is no hope for any reconciliation." It was a shame because I had a sense that, at some level, they still loved each other, and there were two children who had already suffered a

lot because of this divorce. It seemed to me these two people could have been happy if they had only realized how much they had had together before they tossed it away.

Another divorce appraisal I did for both parties had me first go to the home of a New York judge. He told me his wife was a fine woman and a wonderful mother, but just not that understanding. He showed me his personal property, which did not amount to much. He said, "I left almost all of my personal property at my former house, where my wife lives with our children." He told me what an important judge he had been, but said now he was semi-retired and not working as a judge, just as a lawyer. He was charming, and he clearly wanted me to feel he wasn't at all to blame for the divorce.

The next day I went to the house of the judge's wife. There was the usual collection of furniture, but she also had a lot of lithographs by the artist Erté depicting very stylish ladies from the 1930s, for which she had paid an art dealer between $800 and $1,500 apiece. At this time, Erté had become very commercial, and upon resale, the lithographs generally only sold for $300 to $500 each. Again, this was a fair market value appraisal, determining what she could get at auction or tag sale if she sold the lithographs. By using Art Net, I was able to get sale prices of comparable pieces.

After I did the appraisal, the judge's wife poured her heart out to me. She said, "I assume you met my husband yesterday, and I assume, also, he spoke in a very charming manner and seemed like a responsible, competent person." I answered, "That's exactly right." She said, "He started fooling around soon after we were married. He had so many girlfriends, his main mistress used to call me for advice as to how to deal with the other women in his life! I wanted to keep our family together [they had three children] and so I put up with all of this for many years. Then he got into drugs and, shortly after, stopped working. He took out a second mortgage on the house to have money for his drugs and women, but he never told me. Two days before my son's Bar Mitzvah, with seventy-five people invited to the reception in our house, the sheriff arrived with an eviction notice. My husband had hidden all the prior notices, so

I had no idea this was happening. You have no idea what I had to go through to save my house!! After this, I filed for divorce. I'm sure you now realize what a conniver he is."

It is interesting how many divorce clients tell me their stories, justifying their position. It is irrelevant to the appraisal process, but it certainly adds human interest to my day (and appreciation for my own marriage)! Each spouse tells the story from his or her point of view. It is not unusual for me to get "turned around" from the first meeting to the second. In this case, when I first met the husband, he seemed like a great guy, and his wife sounded cold and lacking in understanding. Then I met his wife. After I heard her story, as far as I was concerned, she won the "understanding" award of the year.

Soon after that job, I did the divorce appraisal for an extremely wealthy man and his wife. They lived in a huge castle in Westchester and a gorgeous apartment in Manhattan on Central Park South. He was a handsome, charming man in his fifties. I found him to be warm and kind. He was so sad, however, because his wife of twenty-five years had left him. He said they had always had a great relationship. She was a very pretty woman, a college professor, and they had two lovely children. The maid, who was cleaning around us, kept saying to him, "I worked for the two of you for twenty-five years, and I never heard an argument."

However, recently he had a heart attack and went into the hospital for a triple bypass. The day after the operation, as he was lying in his bed in the hospital room, his wife came in and suddenly said, "I'm leaving you for my twenty-five-year-old student with whom I have been having an affair this last year." He said he felt like she was trying to kill him. As I was hearing his sad story, of course, I had to appraise all of his antiques and fine art. He had taken a trip with his wife six months before, and they had bought (with his money) a large number of eighteenth-century Dutch blue-and-white ceramic bowls and vases for thousands of dollars. As I examined each piece, I was very aware of the fact that for every piece I appraised, he would likely have to pay his wife half of the value if he wanted to keep it. That is how "equitable distribution" (the redistribution

of assets in divorce—the law in place in many states) works, but in this case it seemed particularly unfair to me. Notwithstanding the unfairness, I appraised the pieces, as I must, at their "fair market value." I said to him, "You're such a charming, successful man, you'll have no trouble meeting women and going out." He said, "All of my friends have called, and every day I get invitations to go out, but I really love my wife, and she's the only one I want." It sometimes seems to me that a divorce appraisal constitutes a short course in human cruelty and missed opportunities.

It would be helpful, at this point, to explain a little law. (Groan if you must and skip the next couple of pages if technical stuff puts you to sleep!) Tangible personal property is a legal term describing one particular type of stuff people own. Real property means the ownership of land and buildings. Personal property is everything else. If it is tangible personal property, the stuff itself—the painting, jewelry, rug, or whatever—has value. If it is intangible personal property—bank accounts, stocks, and bonds—the thing you are holding in your hand is just a symbol; the bankbook itself is not valuable, but it connects you to a sum of money. I appraise many kinds of tangible personal property: artwork, antiques, furniture, furnishings, rugs, jewelry, and collectibles. But I don't appraise some tangibles, such as rare books, stamps, coins, and machinery. Nor do I appraise any real estate or intangibles.

When I do appraisals for divorce purposes, as previously mentioned, I often act as a neutral appraiser, working for both sides. Generally, taking this neutral approach saves both the husband and wife a lot of money. (Using two opposing appraisers is often a big waste of money for everyone!) To further explain, when an appraiser is retained to appraise tangible personal property in a divorce case, if two appraisers are used (one for the wife and one for the husband), the values the appraisers come up with will be considerably different. Even assuming that both appraisers are experts with top-notch qualifications, there is always some difference of opinion, and it always involves two fees.

Fabulous Finds

Appraisers must use fair market value for divorce purposes. However, because there is a lot of judgment involved, there can be a substantial divergence in value, sometimes by 30 percent or more. This is especially true if two appraisers are used, and the tangible personal property is of high value. Sometimes, if one of the appraisers has not done his or her job well, the difference between two appraisals of the same piece can be much more than 30 percent. As very few judges have any expertise in tangible personal property, they often require a third appraiser, thus tripling the fee, or they split the difference down the middle, guaranteeing that neither party to the divorce will be satisfied.

While going through this process, both attorneys spend a great amount of time on the case, and both appraisers will need to go to court. If two appraisers are used and it becomes necessary to have them go to court, they are usually paid in advance as expert witnesses in order to hold the date. As court dates change very rapidly, it is often necessary to pay an appraiser to hold one or two court days, even if you will only need half a day. The entire process will take many hours of time and unnecessary expense. As an alternative to this costly and time-consuming process, attorneys and their clients may want to consider hiring a single, neutral appraiser. In most instances where a single appraiser is used, it is with the consent of both the parties and their lawyers agree. But there is authority for a court to appoint a single appraiser and apportion the fee between the parties, even over the objection of one of the parties. This happened in Zirinsky v. Zirinsky, 529 NYS2d 298 (App. Div., 1st Dept., 1988), in which a neutral real estate appraiser was appointed to appraise the real estate, and I was appointed as a neutral appraiser to appraise the tangible personal property; we were among the first neutral appraisers appointed by a court.

With a single appraiser, there will obviously be just one appraisal fee (not two or three), and a minimum of appraiser and attorney court time will be spent on the issue of the value of the tangible personal property.

Unholy Matrimony: Divorce Appraisals

So now we return to the marital war zone. Of all the divorce appraisals I have done, the most vitriolic was a number of years ago when I was acting as a neutral witness. Both sides, top divorce law firms, had agreed to use me, which usually means that the appraisal will be relatively calm. The husband and wife had been married fifty years, and the wife decided she wanted the divorce and to get as much from her very wealthy husband as possible. Her sons were so mad at her that they would no longer talk to her, because their father was a sick man, ailing with cancer.

The appraisal was to be held in the Hamptons, first at a warehouse and then in the huge, twenty-room summer house nearby. One of the two young lawyers working for the husband was going to pick me up and drive me to the Hamptons. That arrangement was fine with me, because I hate driving long distances. The night before I was to leave, I received an urgent phone call from the wife's attorney. She told me that I was not to drive in a car alone with the attorney for the husband. She felt the other attorney might use time alone with me to sway my opinion (as if that were a possibility). The wife's attorney was adamant and hired a car to pick me up. She promised me she would call the husband's attorney and tell him that she had sent a car for me, and that the attorney was not to pick me up. The attorney, however, never received the call and unfortunately spent more than an hour waiting for me at my house the next day, wondering what had happened. Eventually, he showed up in the Hamptons rather miffed; I was really embarrassed.

Meanwhile, I arrived at the warehouse, and the elderly wife was walking around hysterically screaming, "Vengeance is mine saith the Lord!" She must have screamed this at least five hundred times, sandwiched between the insults she directed at one of the lawyers representing her husband. (He was a very sweet, young guy, who was there as directed by his boss, a senior partner in the law firm representing the husband.) The young lawyer, who did not know the wife or husband, could not get over her verbal abuse. It became so bad that her own lawyer, a very attractive and charming woman, tried to stop this outrageous behavior, and the wife got mad at her

too. Fortunately, the wife wasn't nasty to me, as she was hoping I would keep the prices low because she wanted to retain all of the personal property for herself. She knew if that happened, she would have to pay her husband half of its value. In making my appraisal judgment, whether my client or opponent is nice or nasty never influences me. But in this case, since it took me out of her firing range, I'm glad she thought that her behavior might have an impact on my decisions.

When we finally left the warehouse to go to the house, we drove in a cavalcade of five cars. The wife had her own car and drove alone, because she was angry and didn't want to let anyone in her car. The wife's attorney took a taxi to the house. I was in my own chauffeur-driven car hired by the wife's attorney, and each of the two attorneys for the husband drove in their own cars. It was really ridiculous! At the house, the wife calmed down for a while. Most of the pieces were expensive, custom-made furniture that she had bought some time ago and that did not currently have too much value, as they were chipped or stained. She also had a few paintings and antiques and a substantial collection of jewelry. After she screamed, "Vengeance is mine saith the Lord," for the five-hundredth time, I pointed out to her that she was not the Lord and shouldn't be speaking as if she were. It shut her up for about twenty minutes, but then she started her diatribe again. The poor young lawyer looked shell-shocked at the end of the day. He had never had anyone attack him like this before. When I finished the appraisal, I was thrilled to leave, because being around this woman was really trying on the nerves. (Twenty years later, I did another matrimonial appraisal of over $30 million worth of fine arts for this same lawyer for different clients, and even after twenty years, we both remembered that difficult day and laughed about this horrific client.)

I later met the husband and the two sons of this impossible woman when I went to the husband's home to appraise what he owned. The husband was quite ill at that time. As he was staying in a rental apartment, he had very little. He and his sons were very polite and well mannered, and I really felt sorry for them. I learned

later that before he died, the wife had regrets and returned to take care of him. However, upon his death, none of his many millions went to her. He had changed his will, and it all went to his sons. ("Vengeance is mine saith the Lord!")

Megamillion-Dollar Art Collection

A legal secretary from Texas called me and told me that a major collection of contemporary art (all painted or sculpted after 1960) was in dispute in a divorce. The secretary told me it was one of the biggest, private collections of contemporary art in the world, worth "megamillions," but the law firm she worked for did not know its value. They had an appraisal from one appraiser and wanted to know if that price was reasonable, or if it was too high or too low. She told me all they needed from me was a general, oral appraisal. I was not told if I would be representing the husband or the wife.

So in a nutshell: They were retaining me to look over the list of works of art, without being able to see them. I just had to do the appraisal, to the best of my ability, from photos of only the most important pieces—the rest would be from written descriptions. As you can imagine, this was a really difficult job. However, since they only needed an approximation, I did the best I could, using my Internet sources such as Art Net and Art Facts. Because many of these pieces were quite famous, I was able to find a photo (even if they didn't supply one) using an old auction catalogue or the Internet. My total came to over $100 million, and it was, as it turned out, a good 30 percent higher than the other appraiser's estimate. After I finished that oral appraisal, they informed me that I was working for the wife; and that the other appraisal had been done for the husband. I was also told that the husband was keeping the art and that the soon-to-be ex-wife had agreed in a prenuptial agreement to accept one-third of its total value. The wife's lawyers then decided they wanted me to go ahead and do a formal, written appraisal. My appraisal potentially represented millions of additional dollars for the wife.

They sent me a lot of photos and a good deal more information, and I was able to proceed. However, until I saw these items "in the flesh," so to speak, the appraisal still wasn't formal, just an approximation. My written appraisal, however, came out higher than the oral appraisal based upon the additional information and photos.

Finally, after months of appraising by photos and descriptions, I flew out to see the collection and do the appraisal by sight in the home and office. The collection was fantastic! It had the best contemporary artists, such as Guston, Warhol, Pollack, Picasso and De Kooning and many others. It was a very comprehensive collection and a thrill for me to see it hung in a huge mansion and in a large private office. (One of the pleasures of my business is to see great art collections up-close and personal.) The husband and wife had agreed upon a valuation date of April 15, 2007, so the other appraiser updated her appraisal to that date, and my formal, written appraisal was a valuation at that date. In litigation, the attorneys for each side usually have the opportunity, prior to trial, to question the other side's expert, under oath. The practice is called an Examination Before Trial (an "EBT") or a deposition. My deposition was scheduled for May 2007.

In the six months since (a) my original, oral appraisal in November 2006, (b) my appraisal based on photos, (c) my formal, written appraisal valuing the collection at the April 15 agreed date, and now (d) the May deposition, the market for contemporary art had continued to go through the roof! The market for fine pieces of contemporary art like the ones in this collection was hot like it had never been before. During the deposition, with lawyers from both sides, I discussed the fact that I felt the May sales coming up the next week at Christie's and Sotheby's would bring up the prices for the pieces even higher. I would not be able to change my values after the May auctions, but I knew that higher prices in May would validate the values I had used in April. My prediction about the auction sales that took place the next week was correct. An Andy Warhol painting, *Green Car Crash*, estimated to sell for $25–$35 million at Sotheby's, sold for $71.5 million, and a Rothko painting

sold for $72 million. These new values helped prove that my prices, which were many millions above the values used by the husband's appraiser, were correct.

At this deposition, four lawyers questioned me for five hours, and they took over 220 pages of my testimony. One of the husband's lawyers asked me if I thought I was a seer, someone who could see the future. I told him that I was closely in touch with the art market and had my hand on its pulse (or in this case, its fevered brow); it was clear that the prices were going up sharply. The deposition was exciting, challenging, and exhausting!

Two months later, when I flew back again to testify in court, I was allowed to discuss the prices that the May auction sales brought, even though the sale took place after my appraisal.

As previously mentioned, appraisals usually are based upon a comparable sale to the item being valued. But you almost never find a comparable sale exactly at the appraisal date. So the appraiser uses comparable sales within a reasonable time before and, when available, a reasonable time after the valuation date. In this case, the May auction sales were just about a month after the appraisal date and were certainly still relevant.

The husband's lawyers tried to keep us from using this information, but fortunately the judge decided, correctly, that these new May prices were relevant. The husband's appraiser and I were now over $75 million apart in our valuations. Clearly, the other appraiser had not updated his appraisal enough to reflect the new values.

In my experience, there will always be a difference in values in a contested appraisal. Appraisals are expert opinions, but they are opinions all the same, and unless there was a sale of the same or a very similar item shortly before or after the valuation date, the appraiser's expertise and judgment come into play. The judge is supposed to analyze the expertise of the experts (they are often both well qualified) and their credibility (really hard to do without some expertise in art). Unfortunately, in these cases the judge, who is usually no art expert, is caught in the middle.

In this particular decision, the judge split the difference between the other appraiser's value and mine down the middle, making the value about $38 million more than the value the husband's appraiser had put on the collection. I guess the judge decided the Solomonic approach (splitting the baby in half) was the best way to resolve the difference between the experts. When a judge is not an art expert, he or she often makes this kind of a decision. My client reaped approximately $12.5 million more because of my efforts, and she and her lawyers were very satisfied with the outcome. I was pleased to be helpful to my client, but was disappointed that the judge took the easy way out.

Litigation is supposed to be an improvement, a more civilized approach, to trial by battle. That's true. It is. But just by a little bit. Like a trial by battle, litigation has an uncertain result, lots of adrenaline flows, and it is an exciting, though dangerous, contest in which to participate. I look forward to my next trial.

Nasty in Brooklyn

An attorney called me and said a Brooklyn judge had picked me to do a neutral appraisal for matrimonial purposes. The attorney told me one of the two parties, the wife, would call me directly to work out the logistics. Two hours later, Mrs. R. called and, at first, sounded pleasant. We discussed where she lived, what would be a mutually convenient time to meet, and my fee. Then she said, "I want to make sure you appraise all eighty items." I explained that the Court had only sent me a list of twenty-six items to appraise, and I could only appraise those items. Mrs. R. then became highly irate and said if I would not be on her side and appraise all eighty items, she didn't wish to use me. I repeated, politely, that I was a neutral appraiser, and as much as I sympathized with her, I could only appraise the twenty-six items the Court had ordered me to appraise. Finally she turned nasty. "Are you Jewish?" she asked. I acknowledged that I was and asked why she wanted to know. She said, "I don't want any more Jews involved in this matter. You are all greedy and just interested in money, but it's nothing personal, you can read

about this on the Internet." I said, "I don't work for anti-Semites," and hung up. I immediately wrote to the Court about what happened and asked to be released from this appraisal, unless it was absolutely necessary for the Court to have me do it. Meanwhile, Mrs. R. called back and left two virulent, anti-Semitic messages on my answering machine. Considering that the judge was Jewish and that, of course, voice mail messages are recorded, this was not wise. Of course, I sent the messages to the Court. The judge returned them to me (without opening them), as she felt by listening to them she could prejudice the case.

I had mentioned at the beginning of my conversation with Mrs. R. that my husband and I were going to an Abraham Fund function with a friend of ours (my husband is on the executive committee—the fund promotes co-existence between Arabs and Jews in Israel). One of her messages on my machine said, "I guess you are going with a 'show Christian' to your Abraham Fund function."

Three months passed, and I thought and hoped that the judge had found another appraiser. However, this was not the case. In May, I received another court order to do this appraisal. Mrs. R., by this time, had retained another lawyer (it was her third or fourth), and so I arranged with her husband, Mr. R., to go to her apartment. I heard that there was a protective order for abuse against her because she had abused her husband and her two young daughters (they were now both in the husband's custody). I decided I needed a police guard before I went and called her husband to tell him. Mr. R. was one of the nicest men I've ever met. He was truly inspiring. As much as he had suffered from his wife's abusive behavior, he kept saying she was emotionally disturbed and could not help herself. He said repeatedly what a wonderful wife and mother she had been and how it was so sad that she had changed after a traumatic operation for cancer. The operation was successful and her cancer was stopped, but she was never emotionally the same again. He agreed that I needed a guard, and I arranged with Joseph (Jo) Soto, who runs Blue Alliance Security, to meet me at Grand Central and then drive to Brooklyn to Mrs. R.'s apartment. Jo was a friendly,

nice guy, who coincidentally comes from Humacao, Puerto Rico, where my husband and I have stayed during winter vacations for over thirty years.

When we got to Mrs. R.'s apartment, we went upstairs, and there in the hall, in front of her door, she had put out two valuable photos by Diane Arbus, a print by Andy Warhol, and various other paintings and photos. I could not believe it. I know she had accepted me under protest and didn't want to meet me (nor I her). But to leave over $500,000 worth of art in her apartment hall seemed rather bizarre. In thirty-eight years, it was my first hall appraisal. Well, I measured and photographed each piece, giving detailed information as to its condition, as Jo stood guard. The entire time, she must have been on the other side of her apartment door because a chain kept rattling and the chained door kept opening and closing a few inches. It sounded like a ghost was on the other side! There was a note on the door that said if we had any questions, to contact her new attorney. Along with the art, she left a tape of the film *The Ten Commandments* and a printout showing the Abraham Fund's financial balance sheet, with all the financial amounts highlighted in yellow. This organization, most of the members of which are Jewish, gives away $2–$3 million a year and does really good philanthropic work. Although she knew this, somehow I guess it didn't register.

Finally, we finished and went downstairs. I was so happy to be out of there in one piece. I called my husband right away to tell him I was safe and then went to Mr. R.'s studio, where I appraised the remainder of the art and photography collection. It still amazes me that Mr. R. was so kind and well balanced. He showed no anger to his wife, despite the fact that he said she tried to kill him, badly abused his children, and stole his money. He kept saying, "I'll be fine." I'm sure he is.

7. Art Frauds and Related Disasters

When I do an appraisal, it is not unusual for a client to discover that they had previously been cheated when purchasing some of the pieces in their art collection. Every year, thousands of people buy paintings they think are by particular artists and later learn, to their dismay, that the paintings are forgeries. There are ways to protect yourself from being taken advantage of, if you are willing to take the time and effort to do so, particularly with respect to valuable items.

Unless a painting is currently listed in a "Catalogue Raisonné" (a book that lists all the known existing works by a particular artist), it needs a certificate, or "cert," as it is called in the trade. A certificate or cert is a guarantee or pedigree that a particular painting is definitely by the artist whom it is supposed to be by. If you buy a painting by a living artist, the gallery that represents the artist can provide you with the certificate. If you are using a secondary source—you are not planning to buy it directly from the artist or artist's agent—you should send a picture with dimensions to the artist or artist's agent and ask them to certify the painting before you buy it. I suggest that you do this if the painting you plan to buy costs $10,000 or more.

For almost every, well-known, deceased artist, there are only one to five acknowledged experts in the world who can give you an acceptable, authorized certificate for a painting. This is important

information to know because nobody will buy that painting at its proper value without the certificate. So if, for example, you have the opportunity to purchase a painting by Modigliani, you must confirm that it comes with a certificate issued by Marc Restellini or Ambrogio Ceroni. Without a certificate from one of them, you will not be able to resell the painting, except perhaps for a few thousand dollars. What you think is a cheap price to pay for the painting might be a very high price indeed, if the Modigliani has no certification. Some experts charge as much as $100,000 for a certification, depending upon the value of the painting. An art appraiser can put you in touch with the specialists who certify paintings. For paintings by lesser-known deceased artists, there might not be any particular specialist who can certify the work. But a qualified art appraiser may be able to either tell you if the work is "right" or put you in touch with someone who knows the work and can tell you if it is right or not. Here are experts who, for a fee, certify paintings of certain master artists: Paul Petrides certifies Utrillos, Daniel Wildenstein certifies Monet's works, Maurice Tuchina and Esti Dunow both certify Chaim Soutine's works, and Maya Picasso certifies Pablo Picasso's works.

Mickey Mouse Modigliani

I worked for the estate of a woman who bought an uncertified Modigliani painting over thirty years ago for over $100,000. All the estate had to verify the painting's authenticity was a bill of sale from a top, well-known gallery guaranteeing the piece. At that time, the painting was also listed in Lantheman's Catalogue Raisonné stating that the piece was authentic. The gallery where this woman had bought the painting is no longer in business. Unfortunately, more than thirty years after she bought the painting, art experts have come to the conclusion that Lantheman made many mistakes in his Catalogue Raisonné. Subsequently, today, the fact that it was in Lantheman's catalogue does not help the value of the painting. My client (the woman's estate) has tried to sell the painting at the value that it would be worth if the catalogue was right, about $2.25

million. Unfortunately, because the painting did not have a clear provenance (a history tracing it back to Modigliani), the estate was unable to obtain a certificate from Mr. Ceroni or Mr. Restellini authenticating the painting, so no one will buy it. At this moment, the painting is worth very little and will never be particularly valuable unless one of the top experts decides to give it a certificate and include it in a new Modigliani Catalogue Raisonné. However, because the top experts have been so pressured, even threatened, by owners of Modigliani paintings who want their pieces authenticated, there are no plans for the next several years, if ever, to publish a Modigliani Catalogue Raisonné.

This is really a terrible problem for anyone who owns a Modigliani. Fifteen years before she died, the lady whose estate I was appraising had her Modigliani examined by another recognized expert. Apparently one expert, whose certificate would have been respected, wanted $150,000 to certify the painting, but my client was unwilling to pay that sum of money.

Today this looks like it would have been a very good investment for the opportunity to sell something worth over $2 million dollars. At that time, fifteen years ago, another expert dealer felt that unless he could sell the painting himself, at a substantial profit, he was not willing to provide my client with a certificate. She did not like his attitude, so she did not use him as the dealer and consequently did not sell the painting. As both of these experts are no longer alive, and for the foreseeable future, this "Modigliani" is not salable. Unfortunately, now the heirs are stuck with the problem. However, they have been able to accept the situation and hope that one day, even if it's fifty years from now, someone will write a new Catalogue Raisonné for Modigliani and include this particular painting in it. On a large estate, the estate tax is around 50 percent. The only happy part of this story is that I valued the painting at $10,000 (costing the estate about $5,000 in estate tax) and not for $2 million (at an estate tax cost that would have been about $1 million).

The Devil's in the Details

A number of years ago, I went to a client's home to appraise a small Bonnard painting that my client wanted to donate to a museum or charitable organization. I took one look at the painting and knew it was not by Bonnard. Bonnard is a French Impressionist artist from the late 1800s who often painted lovely women, using light and shadow and beautiful, pastel colors. This painting, however, appeared to be very muddy, and the girl was not pretty. Using my appraisal, the client hoped to take a substantial income tax deduction by donating the painting to a charity. He told me that the painting should be worth $75,000, which, if the painting had been by Bonnard, would have been about the right value and would have saved about $37,000 of income tax for the client. See Chapter 9, "Doing Well by Doing Good—Donations to Charity," for more information on charitable donations. The IRS requires that for donation purposes, you state where and when you bought the painting and for how much and that you substantiate your deduction with the appraisal of a qualified expert.

At first, my client told me he didn't remember where he had bought the painting and asked why this information was necessary. I had recently been reading a lot about an auction house in upstate New York that had been selling bad paintings. When I asked my client if he had bought the painting at that particular auction house, his mouth fell open. He said, "How did you know? Who told you?" I said, "Well I just put two and two together." I then said, "You've probably taken this painting to Sotheby's or Christie's, and they've both told you the same thing, that the painting is a fraud." He had the most embarrassed look on his face. I assume he had bought the painting at this upstate, country auction house at a "low price" because he figured those "country bumpkins" did not know much about Bonnard. This artist is well known but certainly is not one of the best-known Impressionist artists, like Monet or Renoir. My client then told me he had paid $14,000 for the painting, which, as it turns out, was a lot for a fake worth no more than a few hundred dollars. When he got back to New York, he immediately went to

Sotheby's and Christie's and was terribly upset to find out he had been cheated out of $14,000. He tried to get the upstate auction house to take it back, but in the auction catalogue, it only described a painting of a young girl "signed" Bonnard. It did not say the painting was "by Bonnard" or that it was "signed by Bonnard." If that had been the case, the auction house would be making a representation that Bonnard himself had signed the painting, and thus they would have been liable. But because it was in the catalogue as "signed Bonnard," the auction gallery was not liable and did not have to give him his money back. Just so you are aware, a painting sold as "Signed Picasso" is not at all the same as a painting sold as "By Picasso" or "Signed by Picasso." The devil is in the details, and this particular devil sits on paintings sold as "Signed X."

Auctions are for careful people and this man had not been careful at all. Later the auction-house owner went to jail for a year for selling paintings and bronzes that were not created by the artist who had "signed" them. He was arrested after one of his advertisements described a number of paintings for sale as "by" a particular artist, and the authorities decided that this was sufficient to show an attempt to defraud.

At any rate, my client was now trying to get me to bail him out of a difficult situation. He wanted me to appraise the painting at $75,000 as a real Bonnard, donate it to a small museum, and get the tax-deduction worth approximately $37,000 in his pocket (because he was in the 50 percent income tax bracket). This would (assuming he got away with it) have netted him $23,000 after the $14,000 he paid for the painting. Of course, I had no intention of being used in this scheme and bid him farewell rather quickly. I also warned the client that if he went through with this scheme, he was risking severe tax penalties. If I helped him, I could have been subject to penalties as well. Sometimes, the smartest (and only honest) thing you can do is fire your client!

Buyer Beware

I received a call from a decorator who asked me to go to a shop and look at a Japanese, eighteenth-century, low table that his client was planning to use for a coffee table. Years ago, Europeans and Americans did not put a coffee table in front of a couch the way we do today. That's why there are very few antiques that can be used as coffee tables. Some of my clients make their own coffee tables out of old trunks or antique boxes or trays mounted on modern bases. Other clients have cut down an antique table so it is no higher than eighteen inches so it can be used as a coffee table. (Please note, cutting the legs of an antique table *will* reduce its value.) However, if you want a completely whole, eighteenth- or nineteenth-century antique to use as a coffee table, there is something available. During the eighteenth and nineteenth centuries in a Chinese or Japanese household, families ate their meals while seated on cushions on the floor arranged around a low table. The tables were usually made from rosewood, teak, or some exotic Oriental wood, and as they are usually thirty-five to fifty inches long and no more than seventeen inches high, they fit perfectly in front of a couch.

The decorator who called wanted to be sure that the table was eighteenth-century Japanese and worth at least $10,000. I arrived at the shop, a very fancy one on Madison Avenue on the upper east side of Manhattan. The dealer was waiting for me, hoping I would approve of the piece. The beautifully decorated shop was filled with only European antiques. There were no Oriental items other than the low table, which he showed to me as soon as I walked in the shop. The table, made of rosewood, was very attractive. It certainly would fit very nicely in front of a sofa. However, it was Chinese from the late nineteenth century and worth only $4,500 at retail.

I asked the dealer why he had thought it was eighteenth-century Japanese, which was what the tag on it said. "Oh," he responded, "I don't know anything about Oriental antiques. I got it at an auction for a good price and I did some research and it appeared to be Japanese and from the eighteenth century." I explained to him how the

machine planing on the bottom, as well as the marks were indicative of a later piece. The style, although similar to Japanese tables, was typically Chinese. When I told him that I would tell the client I thought it was worth $4,500 and not $10,000, he said, "That's alright. I really didn't pay that much for it at auction. They can have it for $4,500." He wasn't embarrassed at all. It constantly astounds me how many times things like this happen. Did the dealer know it was a table from the nineteenth century and thus he was perpetrating a fraud, or did he just not give a hoot?! Either way, the client is the one who would have suffered. It really is important to get an expert's opinion when buying a valuable antique.

All Burned Up

Another time, a lovely woman in Westchester called me to check out a pair of eighteenth-century, English marquetry (inlaid, geometric wood of many colors) console tables selling for $25,000 that she was thinking of buying from an antique shop. The tables were correctly labeled as eighteenth-century English, but my client didn't realize that they had been burned in a fire and had been completely redone. The marquetry veneer on the top was new, and the pair of tables had lost most of their original value. It would be difficult to get even $1,500 at auction for this pair of tables, and the retail price at an antique shop should not have been more than $3,500 tops. There was really very little left of the original exterior of the tables, just the base. The antiques dealer was pretty burned up about my advice, but the good news is that my client did not get burned—she opted instead to pass up this so-called "opportunity."

Decorative, But Is It Worth the Money?

Many of my clients buy antiques and fine arts through very expensive decorators. Many of these decorators have no expertise in antiques. However, the careful decorators who wish to protect themselves and their clients call in an appraiser so that they are sure they are selling something that is as old as the shop or auction house they bought it from says it is. When I did an appraisal for a very successful businessman a number of years ago, he had just

furnished his Westchester mansion with expensive antiques and paintings bought through one of the foremost New York decorators. Per his instructions, my client wanted me to check each piece out, which I did. They were all correct as to the date and origin that the decorator had told him. The prices were off the wall, however, because each piece had been purchased from a fancy shop and included a high commission (close to 40 percent) to the decorator. Each piece cost at least twice what it would have cost if my client had gone to an antiques shop, done the requisite bargaining that all antique shops expect (usually reducing the price by at least 10 percent) and avoided the 40 percent charge. In this case, he could have purchased the $2 million of furnishings for just $1 million.

This particular client was upset that he had overspent, but since he liked everything he had bought, he decided not to return it. In truth, it all fit very beautifully in the house and you could argue that saving this very busy and super-successful man lots of time and making everything look great was worth $1 million; it was to him anyway. There is a legal concept called "let the buyer beware." The term means that buyers need to protect themselves. There are limits to this concept—if items are wrongly described, there may well be a legal remedy. But here, all the pieces had been properly described—they were just sold at extremely high prices.

However, I did find something that I could not excuse. One of the items was a sculpture of a seated cat with a bronze and green patina (a shine on the surface) that made it took as if the cat was made of bronze metal. The bill of sale from the decorator described the piece as "late nineteenth-century bronze cat, $1,000." As soon as I saw this cat, I knew it was a fraud. It was a modern, plaster figurine with green and brown paint that someone had tried to make look like an old, bronze metal statue. Its value was perhaps $20. When I told my client, he did not want to believe it. "My decorator could not have done this," he aggressively said. "How do you know it's not bronze?" I took a knife and scraped a mark on the bottom of the statue so that he could see the white plaster underneath. Convinced, my client called the decorator. The decorator's excuse was

that his assistant bought the piece at a country auction, and the catalogue had described it as bronze. (Of course, he no longer had the auction catalogue.) At any rate, because this decorator had sold my client over $2 million dollars worth of furnishings, he did not want to anger him. When he got off the phone with my client, the decorator zipped out of his office in New York City with a check for $1,000 and immediately drove north to the client's little town in Westchester. In less than one hour, he was at the house, where he tendered profound apologies and the $1,000 check to my client. As you can imagine, the decorator did not look happy to see me!

Appraisal Technique—Spit on a Tissue!

One day I received a call from a husband and wife who wanted to buy a pair of large Chinese porcelain jardinières (plant holders) that the dealer described as nineteenth-century, approximately 150 years old. The price was $10,000, a fair price for large, nineteenth-century jardinières. The shop was in downtown New York, in the World Trade Center, obviously some time before September 11, 2001, and opened at ten o'clock in the morning. I met the clients at about a quarter to ten and joined them for a cup of coffee. They asked me how I could tell whether porcelain was new or old. I told them it was a matter of my many years of experience. After seeing so many old pieces in the United States, China, Hong Kong, and Singapore, I told them, I could tell the difference. However, some of the differences are not so subtle and are easy to spot. So I gave my clients a short and informal course in appraising old china. Many Chinese reproductions today use a porcelain base of pure white instead of the off-white color of the older pieces. Also, many of the older pieces have tiny flecks of black and slight indentations on the porcelain that new pieces made in modern kilns with high technology do not have. Lastly, to make the porcelain look old, a lot of modern, Chinese-porcelain reproductions have a thin coating of brown paint on them, which gives the reproductions an antique look. This brown paint comes off on a tissue and is easy to spot.

When we entered the shop and I saw the pair of floral-decorated jardinières from across the room, I knew immediately that they were not antiques. I had seen virtually identical jardinières at a shop in Chinatown selling as reproductions for $1,000 for the pair. I wanted my clients to be convinced, however, so I turned the jardinière over so we could look at the undecorated base. It was a perfectly flat base, with none of the indentations or marks typical of antique pieces; as I had just taught my clients, this was a good indication that it was a modern reproduction. However, the base had a light brownish color making it look old to an inexperienced eye. I took out a tissue, spit onto it, and wiped off the whole base. By the time I finished wiping off the paint, it was completely pure white underneath, and the tissue in my hand was brown. From our discussion earlier that morning, my clients knew, without my saying a word, that this was a "flim flam." The dealer, knowing he had lost the sale, said to me in a nasty way, "Do you clean windows also?" I said, "No, I just try to keep my clients from buying cheap reproductions at antique prices." We left quickly, as I knew we were not the flavor of the month with this dealer.

Outright Fraud on a Nice Old Lady

A lovely woman called me years ago to appraise her art and jewelry in Mamaroneck, in Westchester County, New York. The woman was petite and still very attractive when I met her as a "young" and outgoing eighty-eight-year-old. She and her husband had an exquisite house on the water, with their own dock jutting out into the Long Island Sound. In the living room there was a huge Monet oil painting of water lilies painted in 1905. Monet did a number of paintings of water lilies in a pond at his home studio in Giverny, a town about one-and-a-half hours from Paris. They became his best-known paintings. My clients later sold their Monet water lilies painting at a major, New York auction house for over $2 million dollars. As evidenced by her home, the Monet, and her extensive jewelry collection, she had lived a privileged life. When I met her, she had been married for over fifty years to a husband who adored

her. But all was not well. Unfortunately, my client was going blind and she knew it. The grace with which she dealt with this was impressive. She did not complain but factually stated to me that within two years she would be completely blind. While I was in her home, I appraised all of her jewelry. She had diamond necklaces, earrings, rings, and bracelets, as well as ruby and emerald pins and rings, all gifts from her husband, who had given her fine jewelry for every occasion. She had an impressive collection! In the collection was a magnificent pearl necklace. It was comprised of fifty-five large, South Sea pearls, each about the size of a grape, ranging from 13 to 20 mm in width. (If you are not good at the metric system, that's about one-half to three-quarters of an inch in width.) The pearls, a crème rose color, were perfectly matched and virtually flawless. It is very rare to get pearls of this size, matched and nearly flawless. At that time, they were worth $100,000. They were exquisite but my client could only appreciate them through touch, as she could barely see them.

A year later, when she was in Florida, her friend told her that the silk string holding the pearls together was weak, and so my client took the pearl strand to a fine jewelry shop to have the fifty-five pearls restrung.

A number of years later, this nice woman passed away, and her son asked me to appraise the jewelry for estate purposes. When I appraised the pearl necklace, I noticed there were now only forty-eight pearls! The jeweler had obviously removed the seven most valuable large ones when he restrung them, guessing that my blind client would not realize this. The necklace now had pearls ranging from 13 to 16 mm—seven approximately 20-mm pearls were missing! This reduced the value of the necklace to $50,000. It would be very difficult to find pearls of that quality to match the size and color of the remaining forty-eight pearls. My client's heirs asked me to write an appraisal for loss, and after I did, they received a check for $50,000 from the insurance company for the loss they sustained. It is amazing to me that a reputable shop was willing to do this to

an old, sweet, blind woman. It is sad but true that sometimes crime does pay.

The family and the insurance company felt that they could not prove a claim against the shop, so the matter was dropped.

Look Out for Fake Lithographs

Lithographs are handmade copies (usually a limited number) of an original art work, which the artist creates on a metal or stone master, called a "plate." Even though the lithograph is a sort of copy, signed by the artist and numbered (for example, "10/100," which means the tenth out of a total of one hundred copies made from a particular plate), it is considered an original work of art and can be quite valuable. A photo reproduction of a work of art, by contrast, may be decorative but is essentially worthless.

Buying lithographs, much to most people's surprise, can be fraught with danger. Three artists whose lithographs are very widely faked are Dali, Chagall, and Miro. There are so many reproductions of their works available that anyone can be fooled unless someone is a specialist in this area. There is a man who used to be a lieutenant on the New York police force's fraud department who specialized in these three artists. In fact, the forgeries are so difficult to detect that the top auction houses themselves often used this detective to determine whether a lithograph was original or not. The problem is that art forgers are not only trying to pass off easy-to-detect, photo-reproduction prints of these three artists, but also actual lithographs, which they refer to as "original lithographs." The truth is they are lithographs, as well as "original" (yes, some person created the original plate), but they are *forgeries* of these artists' works. This semantic play on the word "original" can cost you a bundle. How can you tell if the lithographs are authentic or forgeries? The answer is, you can't. So many of Dali's works were forged or improperly reproduced that Sotheby's and Christie's will not sell any of his works from the last thirty years because they cannot be sure themselves of what is real and what is a forgery.

To protect yourself, never buy works by these artists at church, school, synagogue, resort-hotel, or cruise-ship auctions. It isn't that the institutions are trying to cheat you; they aren't. However, the floating auctions that go around from church to school to synagogue to resort hotel to cruise ship are often fraudulent concerns. In fact, if you bought a Miro, Chagall, or Dali lithograph at one of these auctions, it probably is a fake. Even if you bought such a lithograph from an art gallery located on Fifth Avenue or one that sold it through the mail, it is also likely that it is not authentic. The only place you can be sure the lithograph you purchased is correct is if you bought it at a fine art gallery that was in business for a number of years, that still is in business today, and that gives you a full receipt of your purchase with a guarantee that the piece is authentic. You can also be assured that your lithograph is not a fake if you purchased it from a top auction house that gives you a guarantee. You must remember if the art gallery is no longer in business, the guarantee is worthless. You cannot make a claim on a defunct business. New York State, for example, has a statute that helps to protect the public from art fraud. In it, the gallery must give guarantees and assurances. But if the gallery is a fly-by-night operation, it can still get away with this kind of a scam.

Buying authentic lithographs by other lesser-known artists is also fraught with problems. When you buy a lithograph by a little-known artist, you are paying partly on the assumption that the artist will become well known and his or her work will go up in value. This does not always happen. In fact, the chance of the unknown artist you have picked becoming famous is just about equal to the chance of your winning a lottery. Buy your lithograph, enjoy it, let it be a decorative item, but don't imagine that you will be able to sell it for what you paid for it or more.

I once did an appraisal for a major New York based bank that had bought a small bank in Puerto Rico and acquired one thousand lithographs. They had originally been appraised at replacement value (what it would cost to purchase in a shop) of $500,000. This was correct, as I later found out when I checked, because the

lithographs had all been selling for $400–$600 apiece in a number of galleries. The same appraiser later put a fair market valuation of $100,000 on them. He determined that each piece would bring $100 if they were sold. The bank tried to sell them at this value, found it could not, and asked me to appraise the lithographs and then see if I could advise the bank on where to sell them.

I contacted every major gallery and auction house in New York. Nobody wanted the lithographs. All of them had been created within the last seven years. Many of the galleries that had formerly sold those artists no longer carried works by them. Also, the works were very bright and somewhat abstract. At the time I did the appraisal, paler pastel colors were in vogue, and a figurative (nonabstract) design was the current style. I found a few galleries that still carried works by the same artists, but they were not interested at any price. After much effort, I finally found one gallery that carried one of the artist's lithographs and was regularly selling his new works for $600 to $900 apiece. The lithographs the bank owned by this particular artist were five years old, and the gallery finally agreed that they would take them for $10 each (we had one hundred of them). For the rest of the lithographs, they were willing to pay $2 to $5 each. My fair market value appraisal for everything was under $5,000; it had originally been appraised at $100,000 fair market value. I recommended to my client not to sell the works and to use the lithographs to decorate its many banks throughout the United States, which is exactly what they ended up doing.

Beware of Floating Art Auctions

I received a phone call from a client of my husband who had just taken a cruise and bought two lithographs by a well-known artist. The artist has become very famous but has produced so much that he is overexposed and thus, too commercial. He is best known for his oil paintings of New York City. These still bring good prices, but most of his lithographs, when they come up at an auction house, go for $300–$500 apiece. My husband's client had been on a cruise ship where they had a big art auction. At that auction, he bought

two lithographs by this artist for $3,500 each and was now considering buying four more at what he thought was a bargain price of $12,000. I told him that he could sell the two lithographs, which he had purchased for $7,000, for a maximum of $1,000 total, and similarly, he could sell the four he was considering buying for $12,000 for a total of no more than $2,000. As you can imagine, he was none too happy to have bought about $2,000 worth of lithographs for $7,000, but was pleased that he avoided doubling his mistake. He could not return the two lithographs and get his money back. The cruise-ship auction properly described the two lithographs in the auction as signed, original lithographs by this artist. As long as the item is properly described, auction fever on a cruise ship is completely legitimate—let the buyer beware!

In July 2007, I received a phone call from a Connecticut doctor. He and his neighbor (who, the doctor said, was a capable businessman) went to one of the floating auctions, this one by a New Jersey based auction house. The auction was advertised in the *New York Times* and took place on Long Island. At this auction, there were a vast collection of beautifully framed prints by Chagall, Miro, Picasso, and Dali for sale. The doctor spent $55,000 at the auction and his neighbor spent $13,000. Neither were rich men and they had used their retirement money to purchase these pieces. The doctor got suspicious and called me. His neighbor thought everything was fine and was annoyed with the doctor for calling me. When I walked into the doctor's home, I saw numerous lithographs hung on the wall—each with a heavily gilded or silver frame and looking quite stunning. In truth, since some of the most famous artists of the twentieth century beautifully designed them, they were most impressive to the eye of a novice.

However, from across the room, I could see that the colors were too strong, the white of the paper too sharp, and the look of the pieces, with their brand new frames, was incorrect. I could see that all of them were recent copies of no value—done within the last forty years. On the back of each print was a beautifully printed certificate of authenticity from a non-existent art gallery. I tried

calling the gallery, but it was not listed in the phone book or on the Internet, and the phone number on the certificate did not work.
I went to the gallery's place of business, listed on the certificate as Forty East End Avenue, New York, New York. It was a building with no doorman, a Gristedes supermarket downstairs, and the name of the art gallery was not on the register. I knew that this gallery no longer, or perhaps never, existed. Even if the gallery had been in business, it would not have mattered. Their certificate of authenticity was worthless, since they were not recognized experts on these particular four artists. After I told the doctor my conclusion, he called the auction house and demanded his money back. He threatened to tell the district attorney's office about them. The next day a van arrived from the auction house to take back the prints, and the doctor cancelled the charge on his American Express Card. It was very helpful that he had charged the artwork on a credit card, instead of paying for it by check or cash. No business wants a credit card company to think they are involved in selling bad prints.

His neighbor also got his money back when he returned the pieces, but was terribly upset with what had happened. He had trouble accepting the fact that as smart and financially careful as he had always been, he still had been cheated. His doctor friend kept telling him that he should be celebrating instead of feeling bad because at least they had a happy ending to *their* story.

Diamond or CZ

When I do an appraisal, it is really a lot of fun when I can surprise people with an unexpectedly high value for something they own. "Oh, that old thing," they exclaim. "How could that be worth all that money!" It's like being Santa Claus. Unfortunately, there is a flip side to this story, and from time to time, I am the bearer of some very sad news.

A beautiful woman in her forties had me come to her home to appraise her jewelry. Five years before, she had received a 5-carat, emerald-cut, diamond engagement ring from her fiancé, whom she married. He had paid $100,000 for it. She said the stone was magnif-

icent, with great brilliance. Four years later, she was in Paris having dinner with her husband at L'Amboisie, a wonderful restaurant in the Place de Vosges, and she looked at her finger. The diamond was missing from the setting!! She looked down on the floor and, miraculously, she saw the diamond, which must have just fallen out of the setting, perched on top of the shoe of the man sitting to her right, at the next table. With apologies to the man, she bent down, picked the diamond up off his shoe, and considered herself very fortunate indeed. Her husband and the man at the next table both joked about how forward she was, grabbing the leg of a complete stranger and, of course, both congratulated her on her great good luck.

The next day, she went to one of the most famous jewelers in Paris. In fact, this store is one of the most famous jewelers in the world. She handed the platinum setting to the saleslady along with the diamond and asked if it could be set immediately, since she was returning to the States in a few days. The saleslady said it could not be done that day, as it was the diamond setter's day off, but that my client could return the next afternoon to pick up the ring. The saleslady gave her a receipt and my client left the shop, taking great care to put the receipt in a safe spot in her wallet. The next day, she returned, picked up the reset ring, and handed the receipt back to the saleslady. She paid in cash for the $50 charge to reset the ring.

When I came to do the appraisal of her jewelry collection a year after the ring had been reset, I did not yet know anything about her diamond engagement ring. I appraised her collection, which had a lot of beautiful and valuable pieces, including a large number of blue sapphires she had bought in New York. (People think sapphires are always blue; we even name a color "Sapphire Blue" after the stone. But sapphires come in many colors—yellow, green, pink, and even red. Rich blue sapphires are the most valuable. Many sapphires sold today are heat-treated to improve the color. This heating process, which started being used about seventy years ago, turns pale blue sapphires into rich "sapphire blue" sapphires. Unfortunately, these heat-treated sapphires can often fade and are not as valuable as the naturally deep blue stones.

Fabulous Finds

The beautiful Kashmiri and Celonese sapphires this client had are considered the best in the world because of their highly prized, cornflower-blue color. She had bought them at a store that guaranteed they were over sixty years old, before the heat treatment process started being widely used, so that their color would never fade. After I gave her the good news that these beautiful sapphires were top quality and even more valuable than she had thought, she showed me her diamond engagement ring. Unfortunately, the stone was CZ (cubic zirconium) and worth about $150! As you can imagine, this news was a huge shock to her. She immediately told me the story of how the stone had fallen on the man's shoe and had supposedly been put back in the setting by the fine Paris jewelry store. She called her husband, who called the Paris shop right away. The saleslady my client described was no longer in their employ. She had left the shop one year ago, right after my client had the ring fixed. As my client had no receipt since she had given the receipt to the saleslady when she got her "diamond" returned to her, she had no proof against the store. Luckily, the husband had proof that he bought the ring for $100,000, and it was insured for that amount, so they received a check from the insurance company for $100,000. However, this story has only a partially happy ending. In the intervening five years, the ring had gone up in value and would have cost $125,000 to replace (some insurance policies have a rider, provided for an additional charge, that covers increases in value. But, as is usually the case, this particular policy did not have a rider, so my client "lost" $25,000). Besides, it was my client's engagement ring and she felt it could never really be replaced.

Always Appraise after Lunch

A few years ago, I went to lunch with a very good friend. As we sat down at the table, she showed me a half-carat diamond set in a 14-carat, yellow-gold ring she had just bought for $400, which she thought was a great deal. It's funny that the word "carat" has two uses: the weight that measures the size of a jewelry stone, and the measure of the purity of gold: 24-carat gold is pure gold, so 14-carat

gold is 60 percent pure gold and 18-carat gold is 75 percent pure gold. The $400 purchase price for the ring would have been a great bargain if the gold was real. She asked me to examine it. Unfortunately, I did this just before the waiters served us our lunch. When I told my friend the diamond wasn't real and the band wasn't even gold, she decided she had to return it that very second! She asked me to write a one-page appraisal on my letterhead (luckily, I had blank letterhead in my attaché case). I wrote that the ring was not real and was only worth $5. My friend got up immediately and ran back to the shop, leaving me all alone for lunch. She got her money back and didn't suffer any loss, but I ended up with a stomach ache. I guess I learned that being the bearer of bad tidings can also cause indigestion. There must be a good Latin expression that means "don't do appraisals for friends until after dessert is served!"

His Cup Runneth Over

An attorney asked me to appraise a large collection of jewelry belonging to the estate of a man who died in Westchester. The man who had died had a huge mansion on the water. He had always been a very astute businessman; however, when he reached his eighties and retired, he had very little to do with his time, so he started buying jewelry to give himself something to do. Unfortunately, not knowing much about jewelry, he bought expensive pieces from a small jewelry shop in Westchester and did not bother to have them checked by an appraiser prior to purchase. He visited the shop every day and the owner even had a porcelain mug with the man's name on it made, so when he came by, the shop owner could give him a cup of tea. Over time the man spent $1.5 million at this shop.

When I appraised this collection at fair market value after his death, the total came to $150,000. His children, who sat with me during the appraisal, were miserable. They had tried to get him to stop going to the shop, but to no avail. They had even gone to the jeweler and threatened to sue him to get him to stop selling jewelry to their father, but nothing worked. Their father would not

stop buying jewelry. Most of the items were of very poor quality. The emeralds were pale green and filled with imperfections. The rubies were pale pink; some were synthetic. You can easily detect a synthetic ruby, because a real ruby is a highly dichroic stone. This means that when you look at it, you can see two or even three colors of red that are often visible to the naked eye (although they are always more easily visible with an instrument called a dichrometer). In contrast, a synthetic ruby will display only one red color.

Instead of opals, the shop owner had sold the poor man opal doublets, doctored stones of little value. An opal doublet is a thin slice of high-quality, fiery stone glued on top of a dull white stone—a thin facade over a cheating heart. It is usually mounted in a "gypsy setting" where the dull, white back of the stone is enclosed in gold so it is not visible. Opal doublets, upon resale, are barely considered to be worth more than costume jewelry. To be valuable, an opal must be of strong color with fiery, bright glints of red, blue, or green color within the stone. Another example of this man's unfortunate purchases was a strand of opal beads with a price tag of $3,000 still hanging on it. Unfortunately, these were opal synthetics and were worth $300, not $3,000. Today, there is still no lab test available to detect whether an opal is synthetic or natural. However, an experienced jewelry appraiser can usually tell the difference. He also had some foil-backed opals. In that case, someone has placed metal foil underneath the opal to increase the brilliance and color of the stone. The way to tell if an opal is a foil-backed stone is when you look through the top of the opal, you see all the color gathered at the base of the stone and an unusual metallic color glistening through the stone. These kinds of "opals" also have virtually no value. The man's large collection was really a short course on how to get cheated buying jewelry.

With each price I gave for each piece in the man's jewelry collection, the children groaned or cried with horror. Understandably, they were terribly upset that their father, the brilliant businessman, had thrown away over $1 million buying commercial jewelry of no quality. His wife had never worn most of it, and many of the pieces

still had the price tag hanging on them. They were unable to make a claim against the jeweler because, as far as the family knew, he had never represented that the pieces had any particular value.

In ancient Rome, the messenger who brought bad news was sometimes beaten or killed. I hate being the messenger who brings bad news. Nevertheless, I comfort myself that we are many centuries past ancient Rome and are, at least in some respects, more civilized.

No Good Deed Goes Unpunished

Almost every day I receive a phone call or e-mail from someone who wants me to do an appraisal that I know I absolutely should not do. For example, I don't like doing an appraisal for an individual where my fee is more than or even close to the value of the item I am appraising. In cases where I feel the item is a very low value, I try very hard to discourage the client from coming to see me by saying, "It's not worth your while to have me appraise this," as I can usually tell over the phone whether an item has some value. For example, if they tell me it's a dining room set, or a bedroom set from the 1970s or 1980s, it usually will not be worth much. It is really upsetting for me to receive a fee and afterwards have the client say, "I really didn't need this appraisal. I thought it would be worth more. By paying you I'm just throwing my money out." The last time a client said that to me was over ten years ago, and I vowed I would try my hardest not to have it happen ever again. However, I find the more I discourage people, the more they are interested in using my services. In fact, when I say it's not worth their while, they often become irate. People have actually cursed at me over the phone in my attempt not to have them waste their money on an unnecessary appraisal. As they say, no good deed goes unpunished.

Just Say No

I received a phone call one day from an Indian man with a thick accent who told me he had a collection of six, Indian, carved stone statues dating from the sixteenth to the seventeenth century. My

client said these sculptures had been in his family for many years, and he had brought them to New York from India. He wanted to know if I would appraise them for insurance purposes. He wished to insure them first at replacement value and said that in a few years he might sell them. I told him since I had studied Indian sculpture in the United States and when I was in India, I could do the appraisal, but perhaps would have to consult with someone else. He said that was fine, but he had a full provenance on each sculpture, and so he thought that it would not be necessary for me to confirm my opinion with a specialist in this area. We made a date to meet.

He arrived at my office in Westchester, driving a small truck packed full of the statues and a few muscular assistants. The six statues were large and nicely carved (about four to seven feet in height), but the gray stone did not have the aged look that it should have had. This client and his assistants were very aggressive, and the client informed me that he wanted an instant appraisal, stating that the sculptures were antiques and worth at least $50,000 each. I found the way they were acting to be a bit frightening. I kept saying I could not be positive about the values; that if the statues were indeed from the sixteenth to seventeenth century, they could be worth more than $50,000 each, but I needed to consult with a specialist. The client then showed me a provenance on each statue from an Indian art gallery, stating that each statue was finely carved from a particular area in India and was from the sixteenth to seventeenth century. Each provenance gave a value ranging from $30,000 to $60,000. The provenances were over five years old and looked authentic. I asked if he had shown the statues to anyone else and he said no; I was the first. He really put huge pressure on me to put something in writing while I was standing there. I kept insisting that he would have to wait for my conclusions. Finally and reluctantly, he agreed. He handed me a check for my services and asked me to get back to him as soon as possible. I took photos of the statues, made measurements, wrote down detailed descriptions, and said I would give him my conclusions within the next two weeks. Then I started to work on the project.

First, there was something that I did not like at all about the look of the statues, and second, my client's antsy behavior made me suspicious. On a hunch, I contacted the head of the Asian-art department of a major auction house and asked him if he had seen these statues and if so, what he thought of them. My hunch paid off because he told me he had seen these statues, and he agreed with me that something was off. He thought that the statues were carved recently—at most, they were no more than 100 years old but quite possibly even brand new. Interestingly, the auction house had already turned down my client's offer to sell the sculptures. The major auction houses try to be very careful with what they sell. I find them often much stricter than many art galleries or antique shops. They wish to protect their reputations and don't want people to sue them for selling bad property. If they feel something is not "right," they won't touch it, as they could be responsible if it proves to be a reproduction. The client had lied to me when he told me he had not spoken to anyone else; in fact, he had tried to sell the pieces through the auction house. He had known all along that the statues were not authentic, but was trying to get me to say that they were the real deal. The auction house's Asian-art expert and I agreed that the documentation showing that the pieces were old was also a pack of lies! After my conversation with the auction-house specialist, I was sure my client was planning to use my appraisal to sell the statues right away and had no intention of insuring them. I returned my client's check with a letter saying I was not able to appraise these sculptures at a price anywhere near the price he was seeking since I did not feel the statues were very old. I asked him not to contact me again as I was not willing to discuss the matter any further. Fortunately, I never heard from him again.

One of my jobs as an appraiser is being able to just say "no," making sure that others cannot use my expertise for improper purposes. If I had appraised these pieces at high prices and the client had sold them using my appraisal, I might have been held responsible when the buyers eventually discovered the truth. In any event, I have no interest in helping anyone perpetrate a fraud.

Don't Pick these Flowers

Sometimes particular rip-off scams will become popular and spread, like a disease. In the last few years, I have seen a large number of late eighteenth- or early nineteenth-century bookcases and tables that were originally plain and undecorated, but have recently been gussied up with typical Adam-style floral and leaf painting. A beautiful, late eighteenth-century Adam bookcase, with finely painted flowers, leaves, and romantic figures, would be worth $50,000 to $150,000 at retail. A phony Adam piece with a similar floral design painted on top of a plain, English, late eighteenth- or early nineteenth-century bookcase within the last twenty to thirty years, should sell for only $10,000–$20,000 at retail. Unfortunately, when dealing with a scam artist, people buying the items who are unable to tell the difference can get cheated.

A Benbo Is Certainly NOT a Utrillo

I was sitting in my office one afternoon when I got a phone call from a Mrs. Garrit. "Miss Drexler," she said, "you don't know who I am, but we need your help desperately! My husband is down at the White Plains police station. He bought some paintings the other day, and it seems they were hot. Anyway, the police have arrested him for possession of stolen property. If the paintings are worth over $500, he'll be booked on grand larceny. If they are worth less than $500, they'll only book him for petty theft. Can you please come down and appraise the paintings?"

Well, I paused for a bit before I answered her. Here was a new and bizarre field in which I could apply my expertise, and I had absolutely no interest in doing so. But the woman sounded very nice and terribly upset, so I decided that if she would agree to my conditions, I'd help her out. I said to her, "I'll come, but you must understand before I get there that I'm going to give you an honest price. If these are valuable paintings, I'm not reducing the price by one penny, whether your husband is looking at being charged with petty theft or grand larceny." Mrs. Garrit said, "Yes, an honest

appraisal is all my husband and I are looking for." I agreed to meet her the next day at 12:30 P.M. at the police station.

When I walked into the appointed room, I saw, lined up against the wall, four of the ugliest, most amateurish oil paintings I've ever seen. I immediately told the Garrits and the police sergeant with them, my opinion, and the Garrits' look of relief was gratifying. The sergeant said, "Well, we didn't think these three paintings were very valuable; they're not even signed. But the owner, from whom the paintings were stolen, says this painting over here is by Utrillo."

I really had to laugh. It was signed "Benbo." If Utrillo heard anyone say he had done it, he'd turn over in his grave so fast they would call him "whirling" Utrillo! The colors were garish, and the style and the brush strokes were clumsy and very poor. The subject matter was a French street scene, which apparently had given the owner the idea it was by Utrillo. The incredible thing was that the police, Mr. and Mrs. Garrit, and their lawyer had all needed me to confirm that the painting was not by Utrillo—this was unbeliev-able because the signature was in dark black ink, one inch high, and clearly legible. I put the value of all four paintings at $100. Most of the value was in the frames.

All that Flickers Isn't Gold

A client of mine had a large gold nugget he had inherited from an old relative who mined it years ago from a gold mine out West. Large chunks of gold, when they are not burnished, look quite ugly and not at all like gold. The chunks of gold are often encrusted with dirt and irregular in shape, with no luster or beauty. This large nugget weighed over 300 ounces, and at $600 an ounce (the price at that time), it was worth approximately $18,000. My clients did not know where to hide it or what to do with it. Eventually they put it on top of their nineteen-inch TV to hold down papers, and it functioned as a sort of paperweight. Then one day, when my clients were out of town, a thief broke into their apartment and took the TV. When my clients returned home, they found that their TV was stolen. But the thief had taken the big gold nugget off

the TV and put it on the floor next to where the TV used to be. No doubt the thief thought it was a worthless rock. As an old, used TV is worth virtually nothing (under $50), those thieves really lost a golden opportunity!

Check Out Your Paintings

One day, I received a phone call from a lawyer telling me his client had spent $4 million on furnishings and art that he had bought in Europe, but now was worried that he might have been cheated. (The man is a brilliant businessman, an Englishman who started with nothing and today is worth megamillions.)

He had bought a large collection of nineteenth-century paintings by French and English artists, a substantial amount of French and English furniture, and varied French objets d'art. There were over 250 pieces in the collection, and he had thought, when buying everything for over $4 million dollars, he was getting a great deal. After seeing his purchases, the lawyer and a few friends got suspicious and called me in for an appraisal.

The seller had provided a list of each item, with its age. I used the list as I went around the warehouse where they had placed all of the items in preparation for my appraisal.

The purchase had been a disaster! The paintings were almost all new; those that were not completely new had used old canvases on which the new image was painted. Known artists had supposedly signed the paintings, but not one was by the artist who supposedly signed it. Each was a forgery. In many cases, brand new canvases had been painted on the back a light beige to simulate age. The forgers were so sloppy that they neglected to use the beige paint under the stretcher at the back of the canvas, leaving exposed two stripes of natural white canvas. To see this, all you had to do was pull the stretcher back. I could tell from ten feet away that the paintings were badly reproduced. The colors were garish and the craftsmanship was poor. As far as the furniture, most of it was what the description stated—eighteenth- or nineteenth-century—but it was country quality and not worth very much. There were some fine reproductions

of seventeenth- to eighteenth-century furniture and objets d'art, but instead of being worth hundreds of thousands of dollars, I could value them only in the low thousands. This was a real shame for my client, who had thought he could buy an important collection on his own although he had no training in art valuation or history. He told his lawyer that in the future, he would always use an appraiser before he made any large purchases. This case is going to court, but it will probably take years to work out. He has a great claim and hopefully he will get most of his money back.

Sky Jones and the Credit Company

One of the most interesting legal cases I ever handled was the case of a credit company against a man, Mr. B., who collected over 400 paintings by an artist called Sky Jones (the artist had been known as Mr. Whipple before he changed his name); you can still find references to Sky Jones on the Internet. Mr. B. borrowed $4 million dollars from the credit company and gave the paintings as collateral for the loan. I later appraised the paintings as unsalable and worth nothing.

Sky Jones was an abstract artist. He painted his work in oil paint on photocopy paper and signed and dated most of them. He then placed each painting in a plastic sleeve. He used his fingers as well as paintbrushes, and the finished work looked like finger painting. He promoted his work by himself and sold his paintings on the Internet. (I never could find a gallery that handled his work.) He had a small painting—eight inches by twelve inches—for sale at half a million dollars and very similar paintings, three times the size, priced at $20,000. It was so strange! On his website, he stated that his works were in a museum in Los Angeles, but when I went to check out that address, it was just a shack on the beach being used as a beauty parlor; certainly not a museum.

Mr. B. had his 400 Sky Jones paintings appraised by an uncertified appraiser in Las Vegas who appraised them at 20 million "barter dollars." By "barter dollars," the appraiser apparently meant the value of some objects, however determined, that a person

would trade for the paintings. Accordingly, a "barter dollar" is worth pretty much anything you want it to be. A simple bar glass that costs one dollar in a store could be worth 500 barter dollars if someone would trade something for the glass that the buyer and seller agreed was worth $500. There really is no valuation standard for "barter dollars." I did find out that someone had bartered two of Sky Jones' paintings at $8,000 and $10,000 a number of years ago. However, the Las Vegas appraiser had valued the 400 paintings at about 50,000 barter dollars each. When I asked him about it, he said, "I was helping out a friend; I hope no one got hurt." Then when I asked him if he knew anything about art, he said, "I know about art; I've been in a few museums!" Unfortunately, the credit company used his appraisal and loaned $4 million to Mr. B., secured by what the credit company believed was $20 million worth of art. I stated that the fair market value of these paintings was $0 and that they were unsalable, and so the case went to court. The judge read my memo and gave a summary judgment for the credit company; he completely agreed with my appraisal! He ordered the defendant to repay the $4 million, with no offset for the paintings. My client, the credit company, was very happy with the results.

8. Keeping It in the Family: Estate Appraisals

It seems unfair to many people that after a person has worked throughout his or her lifetime and paid income tax, that upon his or her death there is *yet another* tax to pay. That tax, called the estate tax, must be paid by the estate. Like it or not, estates over a certain value (generally over $5 million in 2011 and 2012 and probably over a smaller amount in 2013 and thereafter) may be subject to federal estate tax on the fair market value of everything the person who died (the decedent) owned at his or her death. There may also be tax imposed by the state in which the decedent resided at his or her death.

As an estate gets larger, the federal estate tax rate gets higher and, if the estate was large enough, reached a rate of approximately 50 percent (half for the government and half for the decedent's family!) on the fair market of the decedent's assets. At the present time (for years 2011 and 2012), the top rate is 35 percent but will go back to 55 percent in 2013 unless the law is changed between now and then. The value of the decedent's assets is determined as if all of the assets were to be sold, in an arm's-length sale, on the date of death, in a situation where no one was forced to buy or sell and both parties had knowledge of all the relevant facts. For bank accounts, the fair market value is the cash balance at death. For frequently traded items, like most stocks and bonds, their value can be determined by looking in the newspaper. But items like art, antiques,

jewelry, furniture, and furnishings need to be valued at fair market value by an appraiser. With respect to estates, that's my job and I am often hired by the estate executor or attorney for the estate to do this job. In a large estate, it's a high-stakes job, since the estate may have to pay the government a check for about half the value I determine. The estate tax is complex—property passing to the surviving spouse or to qualified charities is generally not subject to estate tax. But even so, in most large estates, particularly if there is no surviving spouse, the estate tax bite can be huge.

I have appraised the contents of some of the nicest homes in the world. But I have also been in some amazingly grungy homes. For estate purposes, I have appraised the contents of some very small apartments that haven't been painted or cleaned in thirty years. Some of these places are so dirty that I have to wear jeans and plastic gloves when I visit them. Of course, as I've previously mentioned, usually these apartments are owned by old people who can't stand to throw out anything. In 1947, people found the bodies of the two eccentric Collyer brothers in a jam-packed, cluttered mansion. There were "antiques" and "junktiques" in an atmosphere only compulsive clutter bugs could stand. I have appraised the contents of a number of apartments for estate purposes that compete well with the Collyer brothers' mansion for their contents of antique filth and exotic junk, but that also sometimes have a fabulous find.

I did an appraisal many years ago for the estate of a bag lady. She had lived in a large, important house in Brooklyn, which she had filled with her trash. Before I arrived there, a cleaning crew had already taken out five dumpster loads of garbage. By the time I got there, it was clean enough for the lawyer and me to go through it without donning gas masks. On the upper floors, this bag lady had kept a large collection of late nineteenth-century German and French dolls that were worth over $75,000 in relatively clean condition (there was only a little dust). It was surprising that someone could not only live in such filth but still be an active collector who took such good care of her collection.

One Good Painting

In one apartment I was in recently, I went with a young lawyer and the place was so dirty that we had to wipe our shoes off when we left. We were surprised when we found collections of silver, jewelry, and fine porcelain that the owner never sold, hidden in the desk and on the closet shelves. In one filthy house in Larchmont, New York, the entire household contents were worth $500, with one exception. There was one rather dark painting of a woman's head, signed Botello, one of the most famous Puerto Rican artists, hanging on a bedroom wall. Obviously, no one had paid any special attention to it for decades. The heirs did not realize it had any value. I recommended to the estate that they contact the Botello gallery in Puerto Rico, and they sold it there for $24,000.

Prendergast's Worst Student

Similarly, twenty years ago I appraised the entire contents of a house, including dishes, silver, paintings, the fair market value of which, again with one important exception, came to only $2,000. The contents of this house were all Danish Modern and because the style was not very popular back then, it was hard to sell. There were also hundreds of paintings done by the deceased owner, whose work, unfortunately, was destined for oblivion. Her amateurish paintings were not salable. However, she had one painting by Maurice Prendergast on her wall (see my photo at right), surrounded by thirty of her own amateur works. No one in the family knew this painting was there. Prendergast, an American painter

Maurice Prendergast painting

(1861–1924), is one of the highest priced American artists. He had painted this piece on a wood panel, approximately ten inches high

and sixteen inches long; it was of a charming, idyllic scene in a parklike setting, depicting men and women walking together.

I saw this painting from across the room and got so excited I could hardly speak. I said, "I think that's a Prendergast, but we're probably going to have to do a lot of work to prove that it's his painting." I wrongly assumed there was no provenance. As soon as I crossed the room, I took the painting off the wall and turned it over. There was a sticker from the Corcoran Art Gallery in Washington, D.C., showing that the painting had been in a show there in 1923. No research was necessary and the painting later sold at Christie's for $176,000. As it turned out, Prendergast had been the deceased woman's art teacher years before.

A Treasure Was Found

Many people have observed that we humans are a squabbling lot. We find an almost endless variety of ways to fight one another. One way in which appraisers get involved is in a dispute over the value of property. One such dispute led to one of my most interesting appraisals. It was for a multimillion-dollar estate in Connecticut. The man's wife, Mrs. Van Ausdale, had died, leaving an estate valued at about $10 million. Mr. Van Ausdale was her third husband, and she had married him only five years before her death. He had waived any interest in her estate before they married, and she was not legally obligated to leave him anything. However, she made an unusual provision for him in her will, giving him a bequest in cash equal to one-third of the value of the personal property located in her home. This included all of her fine art, furnishings, and clothes. Her son was to receive the balance of her estate.

When she died, her son was not on good terms with her husband. Her son called in an antique shop owner to appraise the contents of the mansion. This "appraiser" did not belong to any recognized association of appraisers and had very limited appraisal experience. The son instructed his appraiser to keep the prices very low. He wanted to give as little as possible to his stepfather, despite the fact that Mr. Van Ausdale had very little money of his own, had been a

devoted husband to the son's mother, and the mother had loved her husband very much. In any event, Mr. Van Ausdale was entitled to one-third of the real value and not some made-up low value. The son's appraiser went through the eighteen-room mansion in about three hours and put the value of the entire contents of the home down for $60,000. This meant that Mr. Van Ausdale would only be entitled to $20,000 from the estate. The so-called appraiser didn't even bother to examine the signatures on the paintings, and he gave little value to paintings by Rembrandt, Miro, Gainsborough, and many other extremely valuable items. Mr. Van Ausdale realized what was happening and asked me to do a real appraisal of the contents of the home.

It was an extremely demanding and interesting appraisal. Usually, when a quantity of very fine art is involved, someone in the family has a good deal of information about it. But Mr. Van Ausdale had not purchased anything in the home. The furniture and art had all been bought by his wife and her prior husbands, and Mr. Van Ausdale had never been interested enough to ask any questions. There were no records or information on anything she had bought.

The first piece I examined was a bronze head of a man with a contemplative look on his face, carved with strength and vigor. The head was fourteen inches high and mounted on a black marble base. Beautifully sculpted in an Impressionist style, the piece was typical of the great French sculpture artist, Rodin. Artists often work their signature into a piece of art so that it is an unobtrusive part of the overall artistic design, and it is often difficult to find. I searched for a signature, and after examining the piece very closely for several minutes, I gave a shout of excitement. It was signed by Rodin! I later did some research on the piece to make sure that it was an original, and it was. I appraised it at $20,000, because I knew that a comparable Rodin of similar size and artistic quality had sold recently at auction for $20,000. Of course, the value of anything depends upon when it was valued. I did this appraisal in the 1980s. Today, the same Rodin would be worth at least $100,000.

As for the rest of the Van Ausdale appraisal, in one study there was a grandmother clock (a stand-up clock just like a grandfather clock, but smaller) housed in a rich brown walnut case. In the front door there was a concave piece of green glass called "bulls eye" that is typical of English clocks of the seventeenth century. The clock's face was bronze with beautifully etched roman numerals. It was a signed piece, made in 1650 in London by Edward East, the clock master for King Charles II. I valued it at $60,000.

Mrs. Van Ausdale owned a platinum ring that contained a round, brilliant-cut diamond of 5 carats. Now, diamonds are an unusual commodity. We judge diamonds by the four "C's": Color, Clarity, Cut and Carat. Color: Diamonds vary from D color, which is pure white, pretty rare and the best, getting more and more yellow and less and less valuable from colors J through M. The D–J colors are the most desirable; K–M are too yellow to be attractive. For colored diamonds, which are not graded in this way, pink, blue, and strong canary yellow are the most highly sought after colors. Clarity: how many imperfections are in the stone, the fewer the better with IF (Internally Flawless) being the most desirable. Cut: How well cut a stone is affects its brilliance. For example, the table or top of the stone should be 54 percent to 62 percent of the diameter of the stone; the angles at which the facets are placed will determine how beautiful the stone appears. Carat is a measure of weight that indicates the size of the stone. All these things affect the value and in fact, a really good, small diamond can be much more valuable than a large, flawed stone.

Today, diamonds can vary from as much as $700 for a poor-quality, one-carat diamond to about $23,000 for a D-color, flawless, one-carat stone.

Mrs. Van Ausdale's diamond had been "appraised" for $3,000 with no description of its quality. I provided a detailed description of its cut, measurements, color, and imperfections. It was a top-quality diamond—brilliant cut, pure white (D) color and VVSI (very, very small imperfection)—worth every bit of $150,000. Today, it would be worth at least $300,000. (By the way, throughout this book, the

values mentioned are those at the time of the appraisal; in some cases, many years ago, as I have been doing appraisals since the early 1970s. The values of the same items today could and usually would be very different. It takes lots of experience to be able to develop accurate sources of information about the sales prices of a broad variety of property.)

The list of things I found goes on and on. It was like a treasure hunt. I kept on finding valuable items that Mr. Van Ausdale had no idea existed. We opened a silver closet that Mr. Van Ausdale didn't even know was there. It produced over $500,000 worth of silver!

An abstract painting in vibrant reds and blues hung in the living room. The expert use of line and color suggested a fine artist had done the painting. The son's "appraiser" had not even bothered to turn it over and check if there was a signature. He valued it at $50. The artist had signed it on the back!! This very vibrant gouache was by Joan Miro and I valued it at $100,000.

Mrs. Van Ausdale had been a collector of fine clothing. In the last year of her life, she had spent over $150,000 on dresses alone. She had closets and closets overflowing with the most gorgeous designer clothes I had ever seen. It seemed more like the warehouse of an haute couture firm than the closets of a private individual. I was told that she had been the main source of revenue for a number of shops and couturiers and that after her death, some of them had to go out of business. Most of the dresses had never been worn or had been worn only once. Most still had the price tag on them and had cost more than $1,000. In all, there were well over 1,000 dresses and 250 pairs of shoes. Fifty pairs of Bally shoes had never been taken out of their boxes. You can get comparables for clothes by going to eBay, Doyles Auction House (they sell used designer clothes), and Sothebys.com.

When I appraised the furs, I was no less amazed. Mrs. Van Ausdale had thirty-five fur coats—six of them had never been worn. All the furs had been purchased in the last five years. They ranged from sable and chinchilla to mink and fox. All I can say is, I never saw a collection of clothes like that in my life.

I appraised all of the property in the house at $3 million dollars. To say the least, Mr. Van Ausdale was very pleased. He was able to inherit $1 million dollars instead of the $20,000 he would have inherited under the first (so-called) appraisal.

Ada

Some years ago, I did an appraisal of the contents of a Victorian house that Ada Tompkins, a wealthy old lady, had lived in for over eighty years. I don't think the house had been cleaned for the last thirty of those years. She had just died at ninety-five years of age, and I was there to do an appraisal for her estate, for estate tax purposes.

In the entrance hall, hardly any lightbulbs worked, and it was very dark. I felt like a coal miner without benefit of a miner's hat with the light on it. I walked over to a marble mantelpiece in the darkest corner of the room and noticed what appeared to be a dirt-encrusted, old bronze urn sitting squarely in the center of the mantel. The urn was extremely ugly and covered with dust. Without closer inspection, I would have described it as a two-handled, bronze urn, eighteen inches high, with a value of $200. But objects, just like people, can leave a deceiving first impression. I cleaned the piece off and took it over to a window in the next room. When the light hit it I saw the truth. It wasn't a bronze urn at all. It was a black basalt Wedgwood vase, made c. 1870. Once I cleaned the dust off it, I could see that the vase was beautifully carved and decorated with acanthus leaves. A figure of Bacchus was perched on the handle wearing a wreath of flowers on his head. The unpolished black stoneware had a depth and beauty that is typical of Wedgwood's best work. In my opinion this marvelous vase was worth $3,000.

Ada Tompkins' niece, Mrs. Merritt, was there and was, of course, very happy with my discovery. Soon she started telling me stories about her aunt. Ada sounded like a nut! Mrs. Merritt told me she was the meanest old lady she had ever known. Every night after dinner, she told me, Ada would make the maid pack up all of the silver flatware in a basket after Ada had counted it meticulously. Ada would then carry it upstairs and hide it under her bed for

the night. The joke to it all was, although the flatware was indeed sterling silver, it was very poor quality and not worth a great deal. On and on Mrs. Merritt went about how terrible Ada was. It was hard to reconcile these stories with the picture of the beautiful child I saw, taken of Ada when she was five. In the picture, she has long curls and is wearing a starched, white, high-necked, pleated dress, her hands primly folded in front of her. And then there was a picture of her taken soon after her marriage in the 1920s, with her hair cut short and a dazzling smile on her face. She was wearing a beautiful, beaded, long-waisted, afternoon dress in satin and silk. She looked happy, rich, and contented. Why, then, had she changed so? Clearly she had lived in wealth and comfort.

The sixteen-room house was large and contained beautiful English furniture; the floors were covered with Persian and Turkish rugs. There were Isfahan rugs with their scrolling foliage; and pale gold and beige Oushak rugs. Their lustrous colors gave a beautiful sheen to the rooms. On a carved teakwood shelf were fine Chinese porcelains—blue and white Ming vases, monochrome Chien Lung bowls, and one Tang camel (AD 618–906). The camel, glazed in brown and green, was in a vigorous, caught-in-mid-motion stance that gave it a distinct and very lifelike personality. It was an extremely well-appointed house. Mrs. Merritt explained that Ada had a contentious marriage, that her husband died early in their marriage, and her only son was retarded. This apparently embittered her terribly. There were pictures all over the house of a smiling young man with a rather vacuous look. Despite his disability, Ada felt he could and should still appreciate his station in life.

Mrs. Merritt described how he acted. "When I took him riding in the car, he would just sit there when we stopped and wait for someone to open the door for him. You see, his mother had taught him to stay still until the chauffeur let him out. He wasn't a bad boy. I told him when I was driving the car, and when we stopped, he should open the door for himself, and come around and let me out. He was so excited about the opportunity to do something physical that he had his foot out of the door almost before the car

had stopped. Anyway, he died at the age of sixty-five, just two years before his mother's death. He was completely dependent on his mother, and it was a blessing for him that he died before her. But it was terribly hard on Ada. He was the only one in the world she had ever loved. Her bitterness isolated her from the rest of her family, and she died without a friend in the world."

The last photo I saw of Ada was taken shortly before she died. She had lost her beauty and her face and expression no longer had any charm or sweetness. She looked like the unhappy person she had become.

Artist's Estates

If an artist's estate is large enough, it too, is subject to estate tax. And the more successful and more high profile the artist was, the larger the tax levied. I have been fortunate to appraise the art collections of a number of well-known artists for estate tax purposes, including the estates of Louise Nevelson, Jim Henson (I certainly think of him as an artist), Gonzalo Fonseca, Paul Cadmus, and numerous others. This is particularly interesting work because I get to spend time in the artist's studio, see a large collection of fabulous paintings, sculptures, or other works of art, and find out a lot about the life of a person whose works may live forever.

An artist's estate may save thousands or even millions of dollars of estate tax if the advisors to the estate—the attorney, accountant, and, especially, the appraiser—are familiar with the rules of blockage. The concept applies when an artist dies owning a large number of his or her own works. First, a little background on how estate taxes are paid will be helpful. Nine months after a decedent's death, the executors file a federal estate tax return and pay the tax. Many estates, particularly large estates, get audited by the Internal Revenue Service (the IRS, the same "friendly" government agency that audits income-tax returns). If the IRS auditor thinks something is worth more than the value at which the estate reported it, usually he or she and the executor of the estate agree on some higher value, and the estate pays additional tax. But sometimes the estate and IRS

can't agree. In those cases, there are a number of formal administrative procedures for working out the dispute. It if can't be worked out, it usually ends up in the U.S. Tax Court, which hears only tax disputes. The decisions of this court become precedents for how particular tax issues must be handled.

The blockage rules, which are so important to artists' estates, originated with a tax court case of the estate of David Smith. He was a well-known sculptor who died in 1965, owning 425 pieces of his own creation—mostly very large abstract sculptures. The IRS and the estate's appraiser both agreed upon the value of each piece of sculpture if all of the pieces had been sold one by one. However, the estate's appraiser felt that if all the sculpture were sold at the same time, it would reduce the value by 75 percent. Based on a similar concept when a large block of stock is sold, the estate called this a "blockage discount." Because the estate tax is based upon a pretend sale on the date of death, the lawyer representing David Smith said there should be a big discount in the value, because if the estate really sold all 425 pieces at the same time, the price would be much lower. The reasoning of the lawyer was that people would pay much less if they knew so many pieces were being sold at once. As the aggregate, one-at-a-time value was $4,284,000, a 75 percent discount would have been a huge savings in tax. However, the IRS didn't feel there should be any "blockage" discount and valued the pieces as if they had been sold one at a time.

Fortunately for the estate, the tax court disagreed with the IRS, determined that a 37 percent discount was appropriate, and valued the full amount of the art work at $2.7 million, saving the estate hundreds of thousands of dollars in taxes. For the mathematically minded, 37 percent of $4,284,000 reduces the estate by about $1,572,000, which, at about 50 percent, saved the estate about $786,000 in taxes. Judge Tannenwald, who wrote the tax court's opinion, said he was taking a "Solomonic" approach, splitting the "baby" between 0 percent and 75 percent, to determine a discount halfway between the two amounts. Since this case was reported, the concept of "blockage" has been used constantly in estate taxes.

The Estate of Paul Cadmus

I appraised the estate of well-known American artist Paul Cadmus, whose draftsmanship is very well respected and whose paintings and drawings are widely collected. He died owning a large number of his own works. Many of the works had been up for sale for over ten years and had not sold.

I followed another important tax court case, "the Estate of Georgia O'Keeffe," a famous artist whose estate tax was disputed with the IRS. I divided all of Cadmus's works into those that would sell in less than seven years and those that would require more than ten years to dispose of, with 25 and 75 percent discounts taken respectively, the same method for determining the blockage discount that was adopted by the tax court in the O'Keeffe case. The IRS and the state estate tax bureau in Connecticut, the state where the artist died, accepted the appraisal. The estate tax savings was very substantial, and the attorney-executor wrote an appreciative thank you note, a copy of which, with his permission, is posted on my website, www.EsquireAppraisals.com, and repeated here:

> PULLMAN & COMLEY, LLC, Attorneys at Law
> July 13, 2001
> Lee Drexler
> Esquire Appraisals, Inc.
>
> Dear Lee,
> I am happy to inform you that both the Connecticut Department of Revenue Services and the Internal Revenue Service have accepted the Succession and Estate Tax Returns filed on behalf of the Estate of Paul Cadmus.
> Your superb appraisal undoubtedly played the principal role in leading the Service to conclude there was no point in auditing the return.
> Thank you very much for all your help.
> Very truly yours,
>
> Herbert H. Moorin

Paul Cadmus painting

One anecdote about the estate of Paul Cadmus was that the artist's heir and partner of many years had also been the artist's model. He is a good-looking man and the paintings and drawings of him, particularly in his youth, show a beautiful, well-muscled body depicted completely in the nude (like in the photo I took of the drawing above), often with full-frontal views.

I appraised all of these works with the artist's model standing by my side. He wasn't in the least bit embarrassed, so neither was I. All I could say was, "You really look great here!"—which he certainly did. He seemed pleased with my comment, and I said nothing more as I described and catalogued the hundreds of works, so many of which were of him in various poses in the buff. He had a good sense of humor and was fun to work with.

The Estate of Gonzalo Fonseca

I used a similar blockage approach in appraising the estate of the well-known sculptor Gonzalo Fonseca. I conducted this appraisal in New York and Italy. It is always exciting when I am sent to some unusual spot, and I did an important part of this appraisal in the mountains of Italy, in an area famous for its marble, called Pietra

Santa. There were large collections of sculptures in New York and Italy. At first the estate wanted me to appraise the sculptures in Italy by photo, without traveling there. This decision ultimately was changed, and I went to Italy, much to the benefit of my client. The photos, which had been taken a few years before the artist died, made the stone sculptures appear to be in acceptable condition; in fact, almost all had been kept outside and were in poor condition because of either the weather or vandalism. After seeing these sculptures, I was able to determine values much lower than I would have determined from the photos. Some of the pieces were in such bad condition that they had become unsalable, and I appraised these badly damaged pieces at no value. The estate-tax savings to the estate paid for my trip many times over.

All of the sculptures in Italy were in a compound in Pietra Santa, high over verdant, rolling hills. This is a well-known locale for Italian sculptors because it is near Carrara, a source of very fine marble. It was a beautiful setting; a memorably peaceful spot. There was a warm April breeze and seeing these tall sculptures silhouetted against the skyline made me feel privileged to be in this magical spot. When I finished the appraisal, the couple in charge of the place asked me and my dear friend Helga Sulger, who had accompanied me on the trip, to sit and have a glass of wine. It was a nice end to a memorable three-day visit to Italy.

Parakeet Poop Can Hide Art

Some time ago, I got a phone call from Mr. T., an attorney for whom I have enjoyed doing appraisals for many years. He had been involved in the art world for a long time and thought of himself as an art connoisseur. His mother, who had recently died, had at one time owned an important art collection, but Mr. T. believed she had sold all of her valuable pieces before she died. However, since she had a substantial estate, Mr. T. thought I had better come to her apartment to check everything and write up an appraisal for IRS purposes.

Keeping It in the Family: Estate Appraisals

This is what many lawyers do. They use me as an "insurance policy." I do an appraisal, detailing the value of all the tangible personal property, and then the IRS has the proof for tax purposes. Many times, people who have very large estates have very few tangibles (art, antiques, etc.) of any value. However, without an appraisal, the IRS does not always believe the lawyer or executor's statement that there were few, if any, physical things of value, particularly with respect to an estate with lots of bank deposits and securities. Without proof of this assertion, the IRS may make the estate jump through hoops to prove that a wealthy person had "no good stuff" in his or her home. With a certified appraisal, there is documented proof as to value. So even if the appraisal shows that there is nothing of value in a home, it is still worth having it done because it is the proof needed to keep the IRS happy.

Mr. T. was sure there was no artwork of any value, so for him, with respect to this estate, the "insurance" was primarily intended to keep the tax authorities happy. But in many instances there are additional risks an appraisal prevents, such as someone throwing out a valuable piece thinking it was "just junk" or selling it for pennies. In other estates, where there is more than one beneficiary, an appraisal also helps beneficiaries make intelligent choices about how to divide up the stuff so that one beneficiary does not end up with a piece worth many times what another beneficiary has selected.

As I walked into Mr. T.'s mother's apartment, which was dingy and dark and had plastic on the couches, I saw something of interest in the corner. It was a watercolor depicting vaudeville entertainers, rather pale, but still very beautiful. The glass covering the painting was badly spotted because it was next to the parakeet cage. This bird was dirty and active and for many years had sprayed bird seed and bird poop on the glass covering the painting. (Fortunately, the glass had fully protected the picture.) I really liked the painting and looked carefully to see if I could find a signature. On the lower right-hand side, at the bottom of the stage upon which the vaude-villians were performing, was the signature "Charles Demuth." I

knew this artist's work very well, as I had appraised his paintings numerous times over the years. He lived from 1883 to 1935. An American, he was an exciting and skilled formalist and is known for his subtle, light colors and meticulously drawn work. This was a piece of some value.

On the other side of the room, there was another small water-color. It was by Milton Avery depicting his daughter, March, on the beach. Milton Avery is also a well-known, mid-twentieth-century American artist whose work is very valuable. Mr. T. was thrilled that I found these two valuable works, but was shocked that his mother had never told him that these two artists were well known or that the works had value. He said obviously she never knew that they were worth something, or she likely would have sold them herself. She certainly would not have left one of them for her para-keet's target practice! These two works were later sold at auction— the Demuth for $17,000 and the Avery for $15,000.

Mr. T. always tells his clients this story when he is administering an estate. He tells them he is hiring me as their "insurance policy."

9. Doing Well By Doing Good: Donations to Charity

The Tarrytown Historical Society, in Tarrytown, New York, called me to appraise a painting by Asher Durand in which the society was interested. Durand is a nineteenth-century American artist who generally does not bring very high prices. That is, with the exception of two of his paintings, *Mountain Stream* and *Picnic in the Country*, both of which sold for over $250,000 in the late 1980s. The painting in which the Tarrytown Historical Society was interested depicts a very important historical event for Tarrytown, when, during the American Revolution, American patriots caught Major Andre, a British naval officer, in Tarrytown and denounced him as a spy. This became a "cause célèbre" because Major Andre was a very handsome, young, and popular British officer whom many people loved. He had been on his way to meet Benedict Arnold and unfortunately for him took off his naval uniform and changed into civilian clothing. He had plans in his shoe when he was captured. If he had been in uniform, they would have treated him as a soldier and, likely, would have put him in jail or possibly even traded him for an American soldier held by the British. But because Major Andre was not in uniform, they considered him a civilian spy and ultimately hanged him. George Washington supposedly said, enforcing the decision to hang Major Andre was one of the most difficult things he ever had to do.

A dealer representing some people who owned the painting approached the Historical Society of Tarrytown. The dealer felt the painting was worth $250,000, but the owners were willing to accept an appraisal of $250,000 and then do a part sale, part gift to the historical society. The plan was that the historical society would purchase the painting for $125,000 and the owners, for tax purposes, would be shown as donating a half-interest in the painting to the historical society. If this all worked, the Tarrytown Historical Society would have acquired a painting of historical interest to Tarrytown at a great price, and the owners would have made about $185,000, part from the $125,000 purchase price and part from about $60,000 in reduced income tax by taking a $125,000 charitable donation deduction. Unfortunately, the plan did not work and turned out to be the second time poor Major Andre was hung up.

The historical society did not plan to retain me to do the appraisal. They first heard about me from another museum and they suggested to the dealer that he have his clients retain me to appraise the picture. Before he retained me, the dealer wanted to know if I would go along with his value for the painting of at least $250,000. I would not ordinarily work on a matter without a retainer. However, I am a history buff and was familiar with the famous story about Major Andre; plus, I live in Westchester (the county where Tarrytown is located) and wanted to be helpful to this local organization. I looked at a photo of the painting they had given me and did some preliminary investigation.

I found out that the only acknowledged expert on Durand was David B. Lawall, an art historian living in the South. I called the dealer to say I would need a certification from Lawall before even considering giving the painting a value of $250,000. The painting had no artist's signature on it; it seemed quite stiff and not that finely painted. I thought there was a good chance it was not by Durand or was just a quick study done by him that he used as the basis for an engraving. I told the dealer that in the absence of a signature by Durand and absent a certificate by Lawall, in my opinion, the value of the painting was not worth anything near $250,000. I

also told him that I would appraise the painting if he got a certification by Lawall and offered to give him Lawall's name and address. "No need," he said. "I already have a letter from Lawall. I'll fax it to you." Understandably, from the way the dealer had presented it, I expected that the letter would confirm that the painting was by Durand. Unfortunately, the letter, which was several years old, said that it was an outstanding example of American painting, but stated that he could not attribute it to Durand with absolute certainty. Just to be sure, I showed the photo of the painting to my friends at Sotheby's American Painting Department. They confirmed my opinion that, in the absence of a certificate by Lawall, with no artist's signature, and considering the stiffness of the subjects, they also would estimate a great deal less than $250,000 if it was sold at auction.

I called the dealer and told him I would not do the appraisal. His clients had never retained me, so I contacted the historical society and told them of my findings. They were most appreciative of my work and did not buy the painting. It was nice to be "paid" in thanks by an organization in my neighborhood and to add one very small footnote to the case of Major Andre.

William Floyd in Long Island

Early on in my career, the then owner of the William Floyd estate on Shirley, Long Island, hired me to appraise a painting by the famous American artist Ralph Earl—a portrait of William Floyd. There is a highway on Long Island named after William Floyd, but William Floyd did not actually give his name to a highway. He is one of the signers of the Constitution. The painting was going to be donated to a museum, and the owner was going to take an income tax charitable deduction of the value of the painting, based upon my appraisal.

This painting, done before the Revolution, had hung in the same spot in the house since the early 1770s. The painting is a picture of a serious man with a landscape scene behind him. It now hangs in Constitution Hall in Philadelphia with all the other portraits of the

signers of the Constitution. My client owned the house. She was a very lovely woman in her seventies who was leaving the house and a large amount of acreage to a charitable organization. At one time, William Floyd had owned close to half of Long Island. After I did the appraisal, we wandered through the house, which was still very close to its original state. The room where the painting of William Floyd hung was filled with furnishings (some American and some English) ranging in dates from the 1750s to the 1790s. There was also a Victorian room furnished with red plush couches and chairs from 1850–1890. Upstairs, there was a spinning room with spinning wheels from the nineteenth century. The bobbins still had the wool on them! Up in the attic, there was a large, old, wood pen that was once used for keeping slaves that the master felt were not behaving properly, and outside, near the house, was a graveyard for the family and another one for the slaves. Despite the sad connotations, it was a fascinating house to see and be able to wander around in. My client gave me a lovely lunch in the formal dining room and told me how, as a little girl, whenever it snowed, she rode in a sled pulled by horses all around the estate. The well-preserved house had each room furnished so consistently for its period that I almost expected William Floyd to join us for dessert!

For appraisal purposes when evaluating paintings, you must take into account the size of the painting, the medium (whether it is an oil painting, watercolor, gouache, pastel), the date painted, and the subject matter. These factors are all relevant and affect the value of the painting.

In the early 1970s, getting a comparable value for fine art was much more difficult than today, as we did not have the Internet, large computer databases, nor the other information we now have easily available. We did have Mayer's *International Auction Records*, which still are used and which list the price, size, medium, date, location, and sale of everything sold at a major international auction house that year. However, the records did not include a picture of the item sold, so after getting the information, you would then need to check the auction catalogue to see the differences

between the painting sold by the same artist and the one you were appraising. Of course, getting the catalogues was not always easy (particularly if the auction was held in Europe) and Mayer's prices were always one year late. Nowadays, the relevant information is so much easier to obtain. In addition to Art Net and Art Facts, I also use Sothebys.com and Christies.com, which fortunately for appraisers give comparables for jewelry and antiques, as well as paintings and sculptures.

In this particular appraisal, back when getting relevant data was more of a treasure hunt, I heard that a top New York art gallery was selling a good painting by Ralph Earl, and I went to the gallery and asked to see the painting. That painting was being sold for $110,000, but it was a bit larger and more finely painted than the Ralph Earl painting owned by our client. The subject in that painting was also more famous than our subject, William Floyd. I ended up pricing the William Floyd at $85,000, using as my comparable the painting from the New York gallery. The IRS accepted this valuation, so the owner got an $85,000 tax deduction.

When someone gives artwork to charity, he or she can take a charitable deduction for the fair market value of the donated art, as my client did with the William Floyd painting. To substantiate the deduction, an appraisal is required. When a valuable item is lost, stolen or damaged, sometimes an appraisal is needed (especially if no appraisal was done when the policy was taken out) to make a claim with the insurance company. When one family member gives a valuable piece of art to another family member, a gift tax return is required, again with an appraisal of its "fair market value." Finally, as I mentioned in Chapter 8, "Keeping It in the Family—Estate Appraisals," there are a

Ralph Earl painting

number of additional requirements for estate or donation appraisals. First and most important, a qualified appraiser must be used. He or she must belong to one of the appraisal societies like ASA (American Society of Appraisers), AAA (Appraisers Association of America), or ISA (International Society of Appraisers) and must be completely impartial. The appraisal must be made based on "fair market value." The appraiser must show comparable prices of similar items sold, auction prices being acceptable. For charitable gifts of art, antiques or other tangibles, it is advisable for the donor (the person making the gift) to make sure that the recipient of the gift (the "donee") is a qualified charitable, religious or educational organization to which gifts are income tax deductible. This can be done by checking with the organization and, for large, gifts, also checking with a tax advisor. It is also advisable for the donor to keep the appraisal for at least three years after filing the tax return on which the gift is deducted (the time during which one can be audited). If the charity sells the item during the three-year period after you donate the gift, it is required to notify the IRS, and you will likely be audited. If it has sold for less than the appraised value, it is very likely you will not receive the deduction based on the appraised value, but rather on the subsequent sales price. It is important for you to have owned the piece for at least a year and to find a charity that will "use the item for the use for which it is intended" (IRS regulation) in order, for technical tax reasons, to get the full fair market value as a deduction. As well, the charity should agree with you to keep the piece for at least three years for you to avoid the audit risks mentioned above. Also, the appraiser, the donor, and the donee need to fill out IRS form 8283. It is not always easy to find a charitable organization that will use your donation and not sell it. For household furnishings, I have found hospitals, schools, churches, and synagogues are good choices. For artwork, I recommend museums or the National Arts Club.

Doing Good for Its Own Sake

Several years ago, I appraised the contents of a former client's apartment in which was eighteenth- and nineteenth-century American furniture. I had appraised the contents of that same apartment for divorce purposes several years earlier, when the man was married to a different wife. During that appraisal, the wife had cried the whole time I was doing the appraisal because she was so unhappy that her husband was leaving her. As I examined her pewter plates, eighteenth-century cherry wood American highboy, starburst quilts, and Staffordshire china, she told me how her marriage of twenty-five years had ended inexplicably. She loved her husband, had always loved him, she told me, and he had suddenly left her for a younger woman. She was in bad shape and I felt terrible for her. A few weeks after the appraisal, she called me hoping I could console her, but unfortunately, I could not help. I did suggest that she consult with her priest or a therapist and get some help, as she was literally driving herself crazy.

I never heard anything about her again until a few years later, when I got a phone call from the man's new wife. She asked me to do a reappraisal of all of her husband's things, as well as all the new things she had brought into the marriage, for insurance purposes. When I first met her, I was surprised. I was expecting "arm candy!" She was nice looking, but not at all beautiful, about ten years younger than the first wife, but not spectacular looking in any way. She was quiet and low key. At first, I admit I thought negatively about her because, after all, she had caused great unhappiness to the former wife, with whom I had sympathized.

As I was appraising her diamond ring, I asked her what had happened to the former wife. She told me that she had been stricken with cancer and died from it only three months ago. "I'm still getting over it," she said. "I don't understand," I responded. "How did it affect you?" She then told me her story.

She had met her husband when he was very unhappy with his wife of twenty-five years. He felt they no longer had anything in

common, and he wanted out of the marriage. There were no children. However, he always felt guilty about leaving her. A year after he married the new wife, the first wife called to say she had cancer and would die within a year. As they had no children and she had virtually no friends, she needed someone to care for her. She asked him to help. He went to his new wife of one year and explained that this was something he had to do. If she wished to help, he would really appreciate it. If she did not, he would certainly understand. However, he was going to devote himself to his first wife for the remainder of her life. Because his new wife loved him so much, she agreed to help.

For the next year, they both went to the dying ex-wife's apartment every day. The new wife stayed downstairs in the lobby to pick up the ex-wife's laundry, which she washed and brought back the next day. Every day she cooked lunch and dinner for the sick woman, brought it over to her apartment with her husband, but stayed down in the lobby while her husband took it upstairs. The former wife never knew the new wife was helping and never saw her. She was so sick that she either forgot or fantasized that she was not divorced. She acted like she and her ex-husband were still married. She was too sick to make love, so the new wife had no cause for jealousy in that area. The new wife consistently, every day, did whatever she could do to help out her new husband and he truly appreciated it. At the end of about a year, the first wife died, and the new wife's ordeal of caring for a sick woman she had never known was over. She was exhausted physically and mentally, after one year of running errands, calling doctors, doing the laundry, cooking and consoling her husband, but she felt her marriage was stronger than ever. Her husband's guilt was gone, as he had done a very generous thing, and he truly loved his new wife for her great generosity. Not too many wives would have made this sacrifice for their husbands. I still think of it, many years later, as a very special example of great love, understanding, and kindness.

10. Advice About Buying and Selling Art, Antiques, and Jewelry

Throughout this book, I have sprinkled advice about buying and selling fine art, antiques, and jewelry. But for this last chapter of the book, I am putting down my advice-sprinkling can, putting on my art consultant's hat, and laying down the advice point by point. The goal is not to entertain, but rather to save you money and help you avoid major, expensive mistakes. If neither you nor any relative or friend will be buying or selling art, antiques, or jewelry, you may want to skip this chapter. In that case, it has been fun sharing my stories with you, and I hope you have enjoyed them. But if you may be buying or selling any of these items, and want to avoid disaster, I think you will find this chapter helpful.

General Advice about Buying and Selling

Before we get into advice about specific items (like diamonds, gold jewelry, and modern art, etc.), let me start with some general input, gleaned from my more than thirty-five years as an art consultant and appraiser. People often ask me questions about buying antique furniture, jewelry, and art for investment purposes. Unfortunately, many nonprofessionals who try this form of investment would do better at the roulette table. As an example, a client of mine bought a large, carved, Victorian mahogany two-tier sideboard, circa 1870, for $5,000, at one of the most famous antique shops in Manhattan. The salespeople at the shop told him he could never lose money on the purchase. Well, two years later, when he tried to sell it, he

could not find anyone who would buy it at a price near his $5,000 purchase price. He had twenty dealers come and look at it, and the highest price he could get for it was $500.

For the amateur interested in antiques, jewelry, or art, it is not easy to buy and sell profitably. You must realize that most dealers sell items for two to three times what they paid for them. Likewise, if a dealer buys something from you, he usually will pay only one-half to one-third of the amount he thinks he can sell it for. For example, if you buy an antique snuff box (currently very much in vogue) from a typical dealer for $1,200 and try to immediately sell it to another dealer, you should expect to be offered no more than $400. Of course, you can always try to sell something privately. This can sometimes be very successful. But unfortunately, more often than not, you won't be able to find a private buyer who is interested in buying your particular piece the minute you want to sell it, at or above the price you paid for it.

Buying Valuables

If you are buying an item that you don't consider expensive, then the best approach may be to buy it, enjoy it, and not worry too much about its value. But if it is an expensive item, then some advice is in order about where to buy.

If you're looking for a good buy, your best bet is to go to a reputable auction house. There you generally can buy things at good prices and sometimes can get incredible things at very low prices. I've bought for a client the same Oriental rug at an auction for $400 that was selling in a shop for $4,500. For another client, I bought a sterling silver bowl on a pedestal base by George Jensen for $350 that sells at retail for $2,000, and an eighteenth-century French armoire for $700 that sells for $3,500 in antique shops. A large percentage of people at auctions are dealers, and thus your competition will generally not bring the price to more than half of what it would sell for in an antique shop. Of course, dealers never talk about this because if too many people bought at auctions, they wouldn't buy in shops. However, a few words of caution when buying at auction:

BUYING AND SELLING ART, ANTIQUES AND JEWELRY

1. You must always examine the item you are planning to buy at the exhibition, which is generally held at the auction house at least one or two days before the auction. Touch the object, look under it, look behind it—thoroughly examine the piece you intend to buy! While you can sometimes return a misdescribed item to a shop, generally it cannot be returned to an auction house.

2. Some "antiques" sold at auction are mislabeled and are not actually antiques at all. Recently, an auction catalogue listed a Chippendale-style mirror made by my friend's father, a fine English furniture maker, as an eighteenth-century mirror. My friend called to tell the auction house they had made a mistake. He told them that his father had sold the mirror thirty years before specifically as a reproduction of an eighteenth-century piece. On the day of the auction, he expected to hear the auction house announce the correction before they sold the mirror. The auction house never made the correction, and someone ended up paying a very high price for what he or she thought was a valuable eighteenth-century Chippendale mirror.

Before purchasing any expensive piece at auction, bring an appraiser to the exhibition, prior to the sale, to make sure the item is accurately described in the catalogue. Auction houses sometimes make mistakes in the descriptions of items up for auction. Sometimes they label items as much older than they really are, and sometimes they don't credit the item as being old enough.

3. Go in knowing the top price you are willing to pay and don't exceed it. Auction fever can make you pay more than you planned. Don't do it! You might think that because it's just dealers you are bidding against, you can keep bidding and still get a great price. Sometimes, as the bidding goes up, the professionals drop out and only other non-professionals are bidding against each other. Remember that you don't end auction fever with aspirin but rather by writing out a much higher than expected check. You may think that anything sold at a fine, prestigious auction house is worth whatever price it goes for. However, the truth is, IT IS NOT.

I attended one auction at a top auction house when two women, bidding against each other, bid a table up to a price of $1,000, at which price one of the women "got it." It was a small, Louis XV fruitwood-style table with cabriole legs terminating in brass sabots with acanthus leaves carved on the shoulders. After the winning bid, a dealer, out of form for normal auction behavior, shouted out, "Lady, $1,000! I'm selling that same table in my shop for $400." I later went to the dealer's shop and saw that same table with a $400 price tag. So, keep in mind, if you are going to get a good buy at auction, you need to know what you're purchasing—know what price you will bid up to, and do not go over it.

4. If you get expert advice, get it in a way that eliminates any conflict of interest. If you get advice from a decorator who is paid a percentage of the purchase price, you run an obvious risk. In addition, you should pay appraisers based on their time and not based on a percentage of the item they have appraised.

5. Finally, you are better off buying at a reputable dealer's shop if the items you are buying are not valuable enough for you to use an appraiser. This also applies if you are buying without an appraiser's advice, and you are not knowledgeable in the particular area in which you plan to purchase (for example, you don't know the difference between an original Hepplewhite and a hand-me-down, an oil painting and a print, or a diamond and a zircon).

Selling Valuables

There are basically six ways to sell your art, antiques, and jewelry: (1) general auction; (2) private sale at an auction house; (3) dealers; (4) eBay and other online sellers; (5) tag sale; and (6) consignment.

General Auction

Selling at auction is generally only a good idea for more valuable items. Sotheby's and Christie's take only items over $5,000 and you, as the seller, must pay for insurance, moving costs, photos in the catalogue, and, if the item sells, will generally also pay a commission of 25 percent of the first $50,000, and then 20 percent up to

$1 million, and then 12 percent thereafter. The buyer must also pay 25 percent of the first $50,000 and then 20 percent up to $1 million and 12 percent thereafter. As you can see, this becomes a very substantial amount. However, for a top piece, the costs turn out to be worthwhile, because the attention and exposure to potential purchasers at one of these auction houses is incredible. Every person in the world interested in the particular type of art object you are selling will see it and hopefully bid on it, in person, by telephone, or online.

So is there any downside or risk to selling at auction? Sure. The biggest risks are that the piece may sell below your expectations or may not sell at all. The major auction houses allow or even require you to set a "reserve," a price below which the piece will not be sold. So a piece you hope will sell at auction for $10,000 won't be sold for $1,000 if that is the highest bid because you will have a reserve price on the piece that must be achieved for the sale to go through. If the bidding never gets to the reserve price, the piece is "bought in," another way of saying the piece did not sell. But the reserve is a two-edged sword. It keeps you from selling the piece "dirt cheap." But of course, if the piece does not sell, you'll get it back and will have wasted some time and money (the cost of photography, insurance, and the auction house buy-in fee). The fee paid to the auction house is far less than the fee you would pay if the piece had sold, but you still suffer the indignity of paying something and not accomplishing anything but delay. But the cost of not meeting the reserve price is even worse than that.

If the piece is estimated at a price such as $30,000–$40,000, you are strongly encouraged or made to set a reserve of two-thirds below the low estimate. So in the case where the painting you hoped would sell for $40,000 or more only brings $20,000, you would have to sell it at that price. After the auction house takes its 25 percent, you would be left with only $15,000. If your painting does not sell, because no one bids at least $20,000, this fact will be shown on Art Net or a number of other Internet providers, and the piece you tried to sell at auction will be considered "burned." In this

situation, it will be difficult to sell for over $20,000 for a number of years, because everyone will know the painting did not sell for the reserve. On the other hand, at a major auction house like Sotheby's or Christie's, remember that if an auction sale goes well, it may achieve an incredible price that you could not get anywhere else.

Private Sale at an Auction House

Many people like private sales, because of their fear of auction failure. As I've previously mentioned, Sotheby's has a private-sale department headed by Stephane Connery, which has had great success. You can specify the price you want for an artwork and if it seems reasonable, they will take it and hopefully sell it at that price. If it doesn't sell, no one will know. I managed to sell the bronze bull on One Bowling Green in New York City for a client (see Chapter 2) who was very happy with the results. These auction houses have thousands of clients and likely know a great many people who may be interested in your object.

Dealers

If the major auction house estimate is not what you want, you can always go to a private art or antique dealer and offer your artwork to them. If you know a dealer who specializes in your item, you can sometimes get the highest price this way.

If you are handling an estate or a household full of varied types of art and antiques of medium quality, first get the item or items appraised. Then call at least two to four antique dealers and get a bid for the entire amount from each one. You should not tell any of the dealers who the others are so they do not collude with each other and offer a lower price. Consequently, have them come to meet with you at separate times. Generally, if you call three different dealers, you will probably get three different prices.

Once you pick the highest bid, make sure to get a signed contract and get them to agree to give you a certified check or bank check before they take anything out of the house. Usually they will agree, as well, to broom clean the home before they leave. In effect, you

are holding a silent auction in the home without having to pay for moving costs. When the dealer takes everything, the moving cost is his responsibility.

eBay

Another way to sell is on eBay, although there is a caveat: often things don't sell for the price you would like, or at all. You also have to arrange for shipping, insurance, and getting payment. But even so, this can be a good way to sell less expensive items. You can set a reserve price (the lowest price it can sell for).

Tag Sale

Tag sales can be a very good way to sell, if you are selling the contents of a home. The sale usually lasts three days. There are many experienced people who run tag sales, and if you decide to work with one of them, they can make your sale a huge success. However, in New York City at least, most apartments won't allow tag sales. Also, sometimes the checks the buyers give you will bounce. Also, although you may hope and expect to receive good prices, if items still haven't been sold by the third day, you might end up selling them for practically nothing or having to keep them. You also have to give the tag-sale people 20–25 percent of the total. Of course, you can always run the tag sale yourself, but it is a lot of work.

Consignment

If you decide to sell goods via consignment, you bring your antiques, jewelry, or art work to a shop or gallery and leave it there for them to sell. If the dealer sells your piece, he will take an agreed-upon commission (often negotiated at between 30–50 percent), and you will receive the balance. But you take a risk. Many people who left things at Salender O'Reilly or certain other galleries did not get either their money or their artwork back. Although most galleries are honest, some are not, and even it they are, it can take a very long time to sell goods this way. If the gallery is not willing to pay for your object up front, and instead requires you to sell on consignment, I would recommend that you provide them with a photo

with dimensions instead of the actual goods. They can try to sell it just by using the photo. If you keep possession until the shop sells your item and you receive a bank or certified check before handing over the item, you will not get hurt. However, most shops selling on consignment will not allow this.

So now that we have been through an overview of buying and selling, let's take a look at five specific areas where many people collect and where there are lots of "opportunities" to get cheated: modern art, bronzes, silver, gold jewelry, and colored stones.

Modern Paintings

Many people think they are making a great purchase when they buy oil paintings at reputable, large art galleries in Manhattan on Madison Avenue, Fifty-Seventh Street, or in Tribeca. Oil paintings by unknown but decorative modern artists sell easily for over $10,000 each. However, if you try to re-sell these paintings, you may receive far less money than you paid. Generally, the only way to sell these works is to accept one-half of the sale price or possibly much less than what you paid in the gallery. Sometimes the gallery is willing to sell the painting on a consignment basis and will only take one-third or one-half of the sales price. This is a better arrangement if the work sells. But it could take one to two years before it does; or it may never sell.

If an artist does not have an established track record at auction, the cost of the modern artist's work rests entirely on what the gallery decides to charge. Keep in mind that what the gallery decides to charge does not have to have any relationship to reality. Just because the gallery owner thinks that a particular artist's work is good and will increase in value does not mean it will. I have seen people pay as much as $30,000 for a painting by an unknown artist hyped by a gallery, only to find, to their dismay, when they went to sell it sometime later, that they could sell it for only $2,000.

An art gallery dealer whom I know regularly sells a minor artist's work for $6,000–$8,000. She is the only one who sells his works and thus constitutes the entire market for his artwork. One time I was

handling an estate appraisal, and I asked her what she would pay for one of his paintings. She answered that the most she would pay was $400. Unfortunately for my client, I could not find anyone else who would pay more. Just to make sure you are doing the math, the proposed sale price to the dealer was between one-fifteenth and one-twentieth of the price my client had paid to buy the piece from the same dealer five years earlier.

On the opposite side of the coin is the couple who bought Jasper John's *American Flag* for $1,000 at Castelli Gallery and sold it twelve years later for $1 million. They were lucky, perhaps astute, but you can't count on this happening to you by any means.

The safest way to buy art is at Sotheby's, Christie's, or a top auction house, where if you go to resell, you will usually be able to get close to what you paid. But you must know what you are doing or have an expert guide you.

If you have a great eye, the way to make the most money buying art is to buy a relatively unknown artist's work at a gallery before the artist becomes famous and while the prices are still low. If you hit it right, you can have an astronomical increase in value. You have to have a good enough eye, a deep enough pocket, good luck, and the patience to succeed.

Bronzes

Countless people get cheated when buying bronzes. This is because bronze factories all over the country are pouring out reproductions by well-known artists such as Remington, Mene, Bonheur, and Barye, etc. It is very easy to buy an original bronze, make a mold from it, and turn out a copy. It is far easier to do this than to make a copy of a painting or antique. The difference between reproduction bronzes and the originals is in the finishing process. When an original bronze comes out of the mold, the artist spends a great deal of time polishing, finishing, rubbing, and making the definitions stand out. Generally, the artist will cast a limited number of editions from the mold so that the sculpture's highlights and outlines show up clearly. On reproductions, virtually no finishing takes place. When

the figure comes out of the mold, it is attached to a piece of marble (virtually *all* reproductions are mounted on marble, unlike originals). In fact, so many bronzes are reproduced from one mold that there are very few definitions visible, there are rough edges all over the pieces, and the finished product is mushy looking.

Reproductions cost the bronze maker a substantial amount to cast and are rather costly to purchase. Usually these cheap reproductions are sold as reproductions; unfortunately, too often they are sold as the real thing. Sotheby's and Christie's avoid them like the plague, and you should too. They have very low resale value, and it is best to stay away from them completely.

There are groups of people producing these bronzes who regularly send them to country auction houses that sell them every week. If you ask the country auctioneer if the items are originals, the answer may be, "I don't know, buy at your own risk. I am not a bronze man." However, many of these auctioneers know exactly where the bronzes are coming from, how much they cost, and that they are buying them new at the factory.

An auctioneer in upstate New York was indicted by the New York district attorney and eventually sent to prison for selling bad bronzes. His mistake was to advertise that the bronzes were by a particular artist, such as Remington or Mene, two very well-known bronze sculptors. For many years, he advertised the pieces as "Bronzes after Remington" or "Signed by Remington." His actions were unethical but legal. But then he made the mistake that led to that unfashionable striped suit! He advertised the bronzes as "By Remington."

There is an outfit in New York that sells reproduction bronzes, fully listed as reproductions, after Chiparus, a famous bronze maker. The salesman explained to me that Chiparus had numerous workmen helping him make his bronzes in his day, and that the bronzes made today in the same way are *as good as the originals.* All of this attention to detail has a cost. Consequently, the price of these reproductions is often the same or higher than the cost of the

originals, if purchased at auction. But, whether it is mystique or reality, the artist's hand makes a difference. I do not feel that these completely genuine copies, not made by the artist himself, make good art investments.

Silver

People sometimes get cheated buying silver. As an appraiser, I have heard of some incredible mistakes people have made both in the United States and abroad. First, it is necessary to know some relevant facts. Sterling silver is 925 parts silver and 75 parts alloy. That is why sterling silver is often marked "925," particularly if you buy it abroad. Silver items made in Italy or Germany are marked "800," which means they are 800 parts silver and 200 parts alloy. Danish silver is often marked "835" with 165 parts alloy. Modern silver items are worth less if they are 800 or 835 rather than 925. However, if it is a well-made piece, the differences are very slight.

As has been the practice for hundreds of years, all silver is marked with either a hallmark, number, or inscription. If you know how to look for it and what to expect, you will find it. In England, the mark is a running lion, along with a letter for the date on which they made each piece of silver. In France, there is a mark consisting of a helmeted man. In old Russian silver, which is quite valuable, the mark "84" is used. A great deal of silver plate is marked "E P N S" (electroplated silver on nickel), or with varied letters or numbers. However, sometimes silver plate is passed off as sterling silver.

The problem is that it is very difficult for the layperson to tell if something is sterling silver or silver plate. "Real" silver, as indicated above, is usually 92.5 percent, 83.5 percent, or 80 percent pure silver—marked "925," "835," or "800" respectively. But silver plate is a coating of silver over another metal, and unless it is a fine antique, it is worth only a small fraction of real silver. In Mexico, silver called Alpaca is actually silver plate, but some merchants try to fool you by calling it Mexican silver. When my friend was in Mexico, sitting on a beach, a peddler offered her a pretty silver bracelet marked with "925" and the government stamp "Hecho en Mexico."

She was sure it was silver and so she bought it for $100. When she returned home, the bracelet's color had started to change, and she brought it to me for a test. I cut into the bracelet (in a place that would not show), put a little hydrochloric acid on it, and it fizzled away, showing the green color that indicated there was copper underneath. Within a week, the color of the bracelet had changed completely to an ugly green, making it unwearable. A word to the wise: When in Mexico, do not buy silver from street peddlers!

Gold Jewelry

Jewelry of all types, particularly gold jewelry, is one of the most popular things to buy personally and as gifts. Unfortunately, in the vast majority of jewelry purchases, people pay far too high a price. The average jewelry sale is figured at "triple keystone" price, which is what the trade calls triple cost. In other words, if a jeweler shows you a book with an item listed at a price of $3,000, he probably has paid $1,000 for it. He might offer you a "bargain" of a 20 percent reduction bringing the price all the way down to $2,400. Don't feel that you're taking unfair advantage of him, as he will be making $1,400 on an item he purchased for $1,000—a profit of 140 percent.

The best place to buy jewelry anywhere in the world, with the exception of Burma and Sri Lanka, is Forty-Seventh Street between Fifth and Sixth avenues in Manhattan (also known as "the Street"). The gold jewelry regularly sells for only 20 percent to 40 percent over the weight, which is far less than almost anywhere else. Unlike other jewelers, these people often make approximately only a 10 percent profit.

There is a code of ethics on the Street that regulates everyone, as well as a board of jewelers that disciplines and controls everyone on the Street. Anyone who sells something as gold that is plated, or as a genuine gem that is synthetic, is blacklisted if found out and can never buy jewelry again. He will be out of business forever, as no one will sell to him anymore. Luckily there aren't too many transgressions, since the rules are so stringent.

There are so many jewelers on the Street that the competition is extremely keen. Everyone bargains, so be prepared to walk away if necessary. The jeweler will probably bring his price down. If he doesn't, you might like something better in the booth next door.

Many of the stores ask if you are in the trade; however, most don't seem to care as long as you pay in cash. Many refuse to take checks or credit cards. Jewelers from all over the world come to buy here. Certainly, jewelers from every state in the Union buy on Forty-Seventh Street, then charge at least two or three times the prices.

In buying jewelry, it is a good idea to have a 10x loupe and a scale, both of which you can buy at a nominal price at I. Kassoy, a jewelry equipment shop on Forty-Seventh Street or from its online catalogue.

It is important to know certain basic things about gold jewelry. If jewelry is stamped "750", it means 750 parts gold with 250 parts alloy, so it is 75 percent pure gold. That is the same purity as 18-carat gold. Gold marked "585" or 14-carat is about 60 percent pure gold. Similarly, "375" or 9-carat gold are both 37.5 percent pure gold. Although in England they sell 9-carat gold and think highly of it, in the U.S. it is considered just costume jewelry, and is therefore not a good investment. You would probably never be able to resell it for anywhere near what you paid for it.

Generally, you can expect to sell a piece of gold jewelry for the pure gold weight. To figure out the base value of your gold jewelry, you need to weigh it on a jeweler's scale. Whatever it weighs, you must make deductions for the amount of alloy in the gold: for example, 18-carat gold is 75 percent gold, so deduct 25 percent from the value to figure its gold weight. So, if the current price of gold is $1,000 an ounce, and an 18-carat piece weighs four ounces, the value of the pure gold in the piece is $3,000, the price that you could expect to receive if you sold it. On the other hand, if you buy the same 18-carat bracelet on Forty-Seventh Street, you should be able to find a shop that would sell it for approximately $4,000, about a third over its weight. Outside the jewelry district, triple keystone

is the standard, and you should expect to buy the same piece for approximately $9,000. None of the above holds true for pieces being made today by top-name designers like Bulgari, Buccellati, or Cartier, where a gold bracelet that has three ounces of pure gold could sell for as much as $30,000 (ten times its weight). Of course, these are particularly well-designed pieces by famous jewelers, so you are paying a very substantial premium for the design and for the "name." But if you were to sell these designer pieces, while you will definitely get some premium over weight, it will not be vastly more than the weight that an ordinary gold piece would bring.

Colored Stones

The most valuable colored stones are rubies, emeralds, sapphires, and cat's-eye chrysoberyl. As their scarcity continues, their value continues to rise. Accordingly, many fake stones are made and sold. For example, rubies and emeralds are filled with imperfections almost all of the time. If you look closely at them, you can detect internal cracks, carbon spots, and all sorts of inclusions. Thus, if someone shows you a flawless emerald or ruby, it is quite likely to be synthetic. (Of course, there are flawless emeralds and rubies, but these are generally only seen at the most expensive jewelry shops. So if you are in an ordinary shop and are shown a perfect ruby at a "good price," it probably is an extremely overpriced synthetic.) As previously mentioned, rubies are highly dichroic stones (when you look at them, they have two or three colors of red that are visible to the naked eye). A synthetic ruby will show only one red color.

The best place to buy colored stones is in New York or the stone's country of origin: emeralds in Colombia and rubies and sapphires in Sri Lanka, Myanmar (Burma), or Thailand. The problem is that there is internal strife in Sri Lanka and my friends who are colored-stone dealers are afraid to go there. This definitely raises the price of these stones. Although prices for gemstones are much lower in these Asian countries than in New York, you must know what you are doing. I know dealers who have bought batches of stones in the jungles of Sri Lanka, only to find that a few synthetic stones had

been included in the batch. To spend a lot of money on a gemstone in Asia, unless you are an expert or have an expert with you, is generally a big mistake. However, if you have enough guts, you can make a lot of money.

I have a wealthy Belgian client, Mr. Darid, who is in the clothing business, but knows nothing about jewelry. He happened to be in Thailand a few years ago, looking in a jewelry shop for jewels to buy for his wife. He overheard a French jeweler trying to buy a large number of rubies and sapphires for approximately $30,000. This jeweler had spent an hour bargaining with the shop owner before arriving at this amount. The jeweler told Mr. Darid he had just arrived in Thailand that day and thought this was a good deal, but said he wanted to look around in a few other shops before making any final decision. He then left the shop. Mr. Darid decided to risk all on a speculative investment and offered the shop owner $25,000 if he would make the deal. The shop owner agreed; Mr. Darid spent $25,000, took his jewels, and boarded an airplane back to Belgium. As soon as he landed, he went directly to a Belgian jeweler, who immediately offered Mr. Darid $60,000 for the stones. In this particular case, it turned out quite successfully. However, there are many more stories where just the opposite happens. In addition, Mr. Darid was in the financial position to risk $25,000 without losing one minute of sleep.

A client of mine was in Australia and bought an opal doublet. As I mentioned previously, an opal doublet, or triplet, is a thin slice of fiery, highly-colored opal that is glued to a poor-quality, solid white opal of virtually no color, beauty, or worth. My client had spent $1,000 on the ring only to find out she could not sell it for more than $150 in the United States.

Opal synthetics can have great similarity to real opals. Again, unless you are an expert, do not think you can detect the difference. But you probably can detect one popular scam: foil-backed opals, in which foil is placed underneath the opal artificially to increase the brilliance and color. As I mentioned earlier, when you look through the top of the opal, if all you see are the colors

gathered at the bottom of the stone and an unusual metallic color glinting through, it probably is a valueless foil-backed stone.

Cat's-eye chrysoberyl is one of the most desirable and valuable stones. Because of its rarity, it is not well known. It is a phenomenal stone and does something special: it appears to move. In fact, it has a white line running through it like a cat's eye, and when you move the stone back and forth, it "winks" as if it were opening and closing its eye. However, tiger's-eye quartz, a very ordinary and inexpensive stone, can also "wink" and look virtually identical to the cat's eye. Of course, a gemologist can tell the difference with a refractometer.

Each stone has its own refractive index—its own number on a scale. However, the layperson must be careful not to be cheated. A careful buyer will make sure, with any valuable stone he has bought, that he has a certificate from the Gemological Institute of America (Forty-Seventh Street and Fifth Avenue in New York City), which gives a complete identification of the stone. The GIA provides certificates for all gemstones. It costs at least $50 per stone but is well worth it. In fact, your stone is more valuable with a certificate, because anyone who wishes to buy it knows exactly what it is, its size, how many imperfections it has, the color—all the necessary facts. The certificate is not an appraisal of the stone's value; in fact, it doesn't provide any financial values. But it provides an accurate, universally accepted, technical description of the stone upon which an appraiser or anyone who is knowledgeable in the jewelry business can determine the value.

Sapphires have become very rare and costly. However, virtually all sapphires coming out of Asia today are heat-treated, a process that improves the color of the stone, deepens it, and makes it look richer. Sometimes, heat-treated stones can fade over time. Because of this, when a sapphire over fifty years of age comes up for sale at auction, the prices go sky high. The dealers all know that such a stone, produced before the heat-treatment process became so widely used, won't fade. Thus, in buying new sapphires, it would be

a good idea to get a guarantee from the seller that the color won't change dramatically over the first five years.

Topazes are precious stones. They range in color from blue to pink to light brown. Most of the blue topazes sold are not a natural color and generally sell for very low prices. The light-brown colored topazes are usually the original color of the stone. These topazes have a velvety non-glasslike sheen and sell for relatively high prices. In contrast to this is smoky-colored quartz (often called topaz-colored quartz), which looks almost identical to the topaz. It is an inexpensive stone but can fool most people other than gemologists. To avoid getting cheated, look for a stone with a low-shine, non-glassy, velvet-like, rich brown color. Get a guarantee in writing from the seller that the stone is not quartz and buy from a jewelry store that looks substantial. There is nothing more annoying, after buying an expensive item you think is valuable, than to find out it is worth virtually nothing.

Conclusion

It has been fun sharing more than thirty-five years of my appraisal career with you—the Fabulous Finds, the famous and interesting people, and the energy and excitement of the art market. Hopefully, I have given you a few useful tips along the way. I hope we meet some day, and that you have the good luck and I have the thrill of helping you to make a Fabulous Find at an auction, or perhaps even in your attic!

Index

ABOUT THE AUTHORS

L ee Drexler and Jim Cohen have been married for over 45 years.
J. Lee Drexler has been President of Esquire Appraisals of
Bedford, New York and New York City for over thirty- five years.
She has appraised fine arts, furniture, antiques, and jewelry for
estate, insurance, donation, and matrimonial purposes. Her clients
include top law firms, insurance companies, and many well-known
people. Her website is www.EsquireAppraisals.com.

Jim Cohen is a founding partner at Kleinberg, Kaplan, Wolff and
Cohen, P.C., 551 Fifth Avenue in New York City, which he helped
start over forty years ago. He co-heads a ten-attorney tax and estate
department and is listed as a "Super Lawyer." As an aside, Jim is
a songwriter/singer, whose song "Tikun Olum" was published by
Cherry Lane Music Publishing Company. He has co-written a musi-
cal called "Soldier's Story" that will be produced in April 2011 (Jim
wrote the music and Lee wrote the script). Jim's firm's website is
www.kkwc.com and his music website is www.JimCohenMusic.com.